A Passion for Performance

A Passion for Performance

SARAH SIDDONS

AND HER PORTRAITISTS

ROBYN ASLESON, EDITOR

SHELLEY BENNETT

MARK LEONARD

SHEARER WEST

THE J. PAUL GETTY MUSEUM LOS ANGELES

© 1999 The J. Paul Getty Museum
1200 Getty Center Drive
Suite 1000
Los Angeles, California 90049-1687

www.getty.edu/publications

Christopher Hudson, Publisher
Mark Greenberg, Managing Editor

Project staff:
John Harris, Editor
Kurt Hauser, Designer
Elizabeth Chapin Kahn, Production Coordinator
Lou Meluso, Photographer

Cover: Joshua Reynolds. *Sarah Siddons as the Tragic Muse* (detail), 1784. The Huntington. (See fig. 10, p. 114.)

Endpapers: Unknown maker, England, Spitalfields. Dress (detail), ca. 1760. Silk satin damask. Los Angeles County Museum of Art, Gift of Mrs. Sheila S. Thompson.

p. i: From *Seven Attitudes by Mrs. Siddons*, 1806. (See p. ix.)

pp. ii–iii: Robert Edge Pine. *Sarah Siddons as Euphrasia* (detail), n.d. (See fig. 17, p. 63.)

This page: Drury Lane Theatre, viewed from the stage. From Walter Thornbury's *Old and New London* (London and New York, 1887–93), vol. 3, p. 222.

Library of Congress Cataloging-in-Publication Data

A passion for performance : Sarah Siddons and her portraitists / Robyn Asleson, editor; Shelley Bennett, Mark Leonard, Shearer West.
 p. cm.
 Includes bibliographical references and index.
 ISBN 0-89236-556-0 (cloth). — ISBN 0-89236-557-9 (paper)
 1. Siddons, Sarah, 1755–1831—Portraits. 2. Siddons, Sarah, 1755–1831. I. Asleson, Robyn, 1961– .
 II. Bennett, Shelley M., 1947– . III. Leonard, Mark, 1954– . IV. West, Shearer.
 PN2598.S5P37 1999
 792'.028'092—dc21
 98-53976
 CIP

All images from Walter Thornbury's *Old and New London* courtesy Getty Research Institute, Research Library.

In the captions in this book, the words "The Huntington" stand for the Huntington Library, Art Collections, and Botanical Gardens in San Marino, California.

Contents

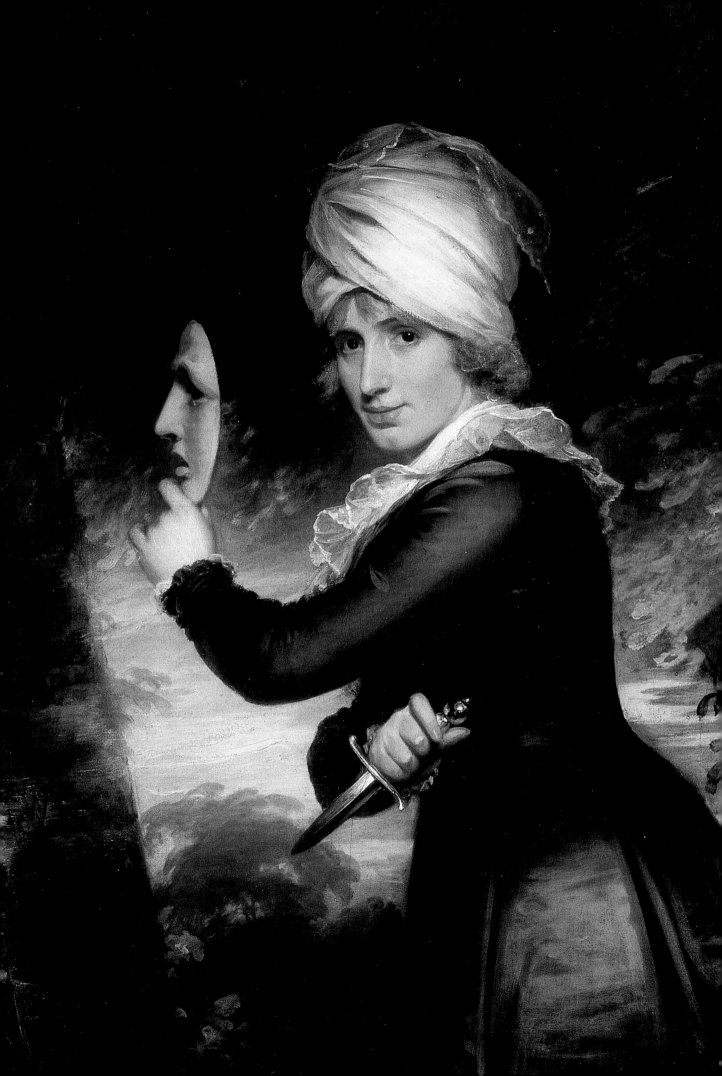

FOREWORD

SARAH SIDDONS, THE RENOWNED TRAGIC ACTRESS WHO dominated British theater during the late Georgian era, thrilled audiences throughout her fifty-year career with performances that seemed to surpass human ability. Portraiture played a crucial role in launching Siddons's fame and securing her legendary status, and the leading painters of her day vied for supremacy in capturing her elusive beauty and sublime presence.

This volume of essays was inspired by an exhibition, held at the Getty Museum in the summer of 1999, which brought together ten of the most compelling portraits of Sarah Siddons. The exhibition had begun to evolve in 1995 as the result of conversations among Giles Waterfield, then Director of the Dulwich Picture Gallery; Shelley Bennett, Curator of British and European Art at the Huntington Art Collections; and Mark Leonard, Conservator of Paintings at the Getty Museum. These conversations led to a unique reunion: in the summer of 1998, two versions of Sir Joshua Reynolds's monumental *Sarah Siddons as the Tragic Muse* (from the Huntington and from Dulwich) were brought together, after two hundred years, for study and treatment in the paintings conservation studio at the Getty Museum.

Robyn Asleson, Research Associate at the Huntington, developed the initial proposals for an exhibition at the Getty and for a companion exhibition at the Huntington. She not only edited but served

Opposite: WILLIAM BEECHEY.
Sarah Siddons with the Emblems of Tragedy (detail), 1793.
(See fig. 30, p. 76.)

as the thoughtful guiding force behind the present volume; she also contributed an essay and wrote the introductory chronology of Siddons's life. I know that the other authors—Shearer West, Mark Leonard, and Shelley Bennett—are grateful to her for the exhaustive research that she provided, as well as for her development of the underlying themes that prevail throughout the volume.

Thanks are also extended to staff members at the Getty Center as well as the Huntington and the Dulwich Picture Gallery. At Dulwich, Desmond Shawe-Taylor and Ian Dejardin, the current Director and Curator, respectively, supported the original conception for the exhibition and essays. Edward J. Nygren, the Director of the Huntington Art Collections, generously enlisted the support of the Trustees and Overseers for the study and eventual loan of the Huntington's great Reynolds portrait of Siddons. At the Getty Museum, Jennifer Helvey assisted with curatorial duties for the exhibition and was supported by David Jaffé, Irene Martín, and Quincy Houghton. Narayan Khandekar spearheaded the technical studies at the Getty Conservation Institute, where he was aided by Michael Schilling and David Scott. Also at the Getty, John Harris, Kurt Hauser, and Elizabeth Chapin Kahn saw the book through editing, design, and production, respectively; Cecily Gardner assisted with photographic research; Yvonne Szafran created the infrared assembly of the Huntington painting; and Lou Meluso provided splendid new photography of the Huntington and Dulwich paintings, in addition to taking the photographs of the X-rays. The index was prepared by Kathleen Preciado.

This volume represents a unique tribute to the collaborative spirit of a number of people from diverse fields, representing a variety of academic, technical, and theoretical approaches. Their interdisciplinary efforts have not only made important contributions to scholarship but should also have appeal to a broad readership, adding yet another dimension to the portrait—and portraits—that we have of Sarah Siddons.

Deborah Gribbon
Deputy Director and Chief Curator
The J. Paul Getty Museum

Opposite: GILBERT AUSTIN (British, d. 1835). Detail of *Seven Attitudes by Mrs. Siddons*. From *Chironomia* (London, 1806). Cambridge, Mass., The Harvard Theatre Collection, The Houghton Library.

pp. x–xi: EDWARD DAYES (British, 1763–1804). *Drury Lane Theatre*, 1795. Watercolor on paper, 55.3 x 37.8 cm (21 3/4 x 14 7/8 in.). The Huntington.

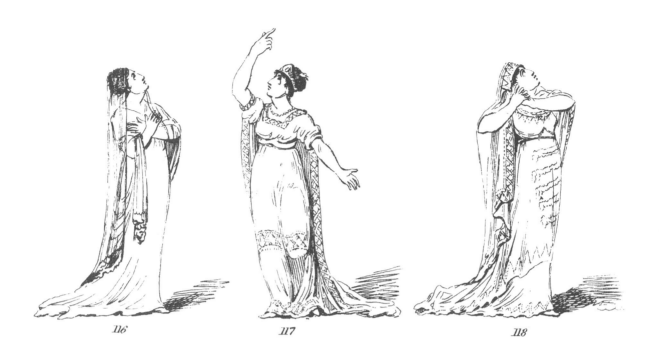

116 117 118

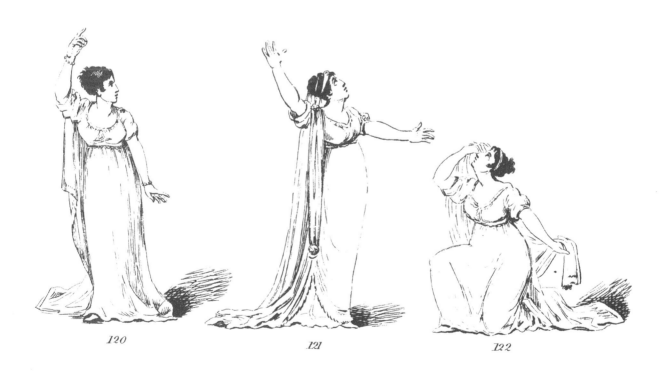

120 121 122

A Sarah Siddons
CHRONOLOGY

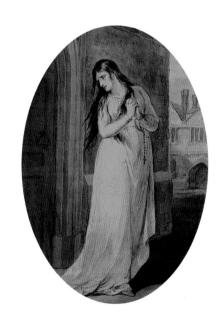

ingenue

EARLY CAREER

1755 **5 July** • Birth of Sarah Kemble at the Shoulder of Mutton public house, Brecon, Wales, where her parents, the actors Roger Kemble and Sarah Ward Kemble, are touring with a strolling theatrical company.

1766 **22 December** • First documented stage appearance of Sarah Kemble. Aged eleven, she plays Ariel in *The Tempest* with her father's company at Coventry.

1767 **12 February** • William Siddons, a handsome twenty-two-year-old actor, makes his first appearance with the Kemble company (then at Worcester).

1770 Hoping to thwart the relationship between their daughter and William Siddons, the Kembles send Sarah away to serve as maid to Lady Mary Greatheed. She reportedly spends her free time reciting passages from Milton and Shakespeare in the servants' hall.

1773 **26 November** • Aged nineteen, Sarah weds William Siddons at Holy Trinity Church, Coventry. The next month, she returns to the stage as Mrs. Siddons, performing with her father's company at Wolverhampton and Leicester.

1774 **Summer** • While based at Cheltenham and in an advanced state of pregnancy, Siddons performs the role of Belvidera in the tragedy *Venice Preserv'd*. She moves several aristocratic members of the audience to tears and they subsequently recommend her to the premier actor-manager of the day, David Garrick.

4 October • Birth of Siddons's first child, Henry. She returns to the stage within four months.

1775 **August** • At Garrick's request, the Rev. Henry Bate observes Siddons perform at Cheltenham and Worcester. His enthusiastic notice of her skills as Rosalind in Shakespeare's *As You Like It* results in an invitation to perform with Garrick's company at the Theatre Royal, Drury Lane (London).

5 November • Birth of Siddons's second child, Sarah (known as Sally), midway through a performance at Gloucester.

29 December • Still weak from her pregnancy, Siddons commences her Drury Lane season, appearing as Portia in Shakespeare's *Merchant of Venice*. A string of comic and tragic roles follow, in most of which she is vociferously condemned.

1776 **Summer** • During the off-season at Drury Lane, Siddons earns her livelihood through peripatetic performances in northern cities. At Birmingham, she is shocked to receive notice that her services are no longer required in London. She spends the next two years honing her skills while performing a staggering range of roles with various touring companies.

1778 **27 October** • Engaged at £3 a week at the Theatre Royal in Bath, Siddons makes her debut as Lady Townly in the comedy *The Provok'd Husband*. Within months, her astonishing dramatic powers—particularly in the pathetic elements of tragedy—make Siddons the talk of the town.

1780 **1 May** • The first painting of Siddons appears at the Royal Academy of Arts: William Hamilton's monumental *Mrs. Siddons in the Character of the Grecian Daughter*.

LONDON TRIUMPH

1782 **21 May** • Eight months pregnant with her fifth child (the fourth had died in infancy the previous year), Siddons plays both Hermione in *The Distrest Mother* and Nell in *The Devil to Pay* at Bath. The same night, she delivers a farewell address to the audience in which she asserts that the necessity of providing for her children requires her pursuit of a career in London.

10 October • Siddons's triumphant return to Drury Lane Theatre (now under the management of Richard Brinsley Sheridan) in the title role of the tragedy *Isabella*. Her pathetic embodiment of domestic woe creates a sensation, flooding the audience with tears and exciting critics to hyperbolic praise.

30 October • Siddons's second role at Drury Lane is as successful as her first. As the heroic princess Euphrasia in Arthur Murphy's tragedy *The Grecian Daughter*, she catapults her audience from one emotional extreme to another.

8 November • The actress secures her success with her third appearance at Drury Lane in Nicholas Rowe's tragedy *Jane Shore*. The ravages of the character's physical and emotional decline reportedly induce illness and fainting spells in several members of the audience.

14 December • Siddons's profits from a benefit performance of the tragedy *Venice Preserv'd* total £650, lavishly supplementing her moderate £10 a week salary.

Opposite: WILLIAM HAMILTON (British, 1751–1801). *Sarah Siddons as Jane Shore*, 1791. Watercolor on paper, 24.2 × 15.9 cm (9⁵/₁₂ × 6⁵/₁₂ in.). London, Victoria and Albert Museum.

Above: Portrait of David Garrick. From Walter Thornbury's *Old and New London* (London and New York, 1887–93), vol. 3, p. 217.

Above: MARY SACKVILLE HAMILTON (British, fl. 1763–1804). *Sarah Siddons as Hamlet*, 1805. Watercolor on paper, 26. × 20.3 cm (10¹/₂ × 8 in.). London, The British Museum.

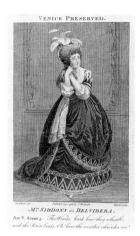

VENICE PRESERVED.

*M.*ᵉ *SIDDONS as BELVIDERA.*
Act V. Scene 5. *The Winds, hark how they whistle,*
and the Rain beats Oh! how the weather shrinks me!

queen

1783 January • Overcoming their usual antipathy for the stage, George III and Queen Charlotte weep through five Siddons performances in a single month, and the queen reportedly sends the actress a gift of over £100. Shortly thereafter they appoint Siddons Reader in English to the royal children.

May • Crowds throng William Hamilton's studio to see his painting of Siddons as Isabella, and Thomas Beach exhibits portraits of her at the Society of British Artists. Around the same time, Siddons begins sitting to Sir Joshua Reynolds.

16 June • Arriving in Dublin to commence a performance tour, Siddons searches the rainy streets until two o'clock in the morning but finds "[t]here is not a tavern or a house of any kind . . . that will take a woman in."

9 October • Siddons opens her second season at Drury Lane in the role of Isabella. Three opulent state canopies have been added to accommodate the frequent presence of the royal family.

1784 May • Reynolds exhibits *Sarah Siddons as the Tragic Muse* at the Royal Academy and the picture is instantly proclaimed a masterpiece. In the same month, Siddons embarks on a grueling performance tour of Scotland and Ireland.

June • Enthusiasm for Siddons sweeps Scotland. Commentators coin the word "Siddonimania" and describe her weeping and hysterical audiences as victims of "the Siddons Fever." On one occasion, there are 2557 applications for the 630 places available. She leaves Edinburgh nearly £1000 richer.

26 July • In Dublin, an irate audience pelts Siddons with apples and potatoes during her performance as Lady Randolph in John Home's *The Tragedy of Douglas*. They charge her with selfish and miserly behavior for failing to participate in a benefit performance, but in fact exhaustion and poor health have incapacitated her.

5 October • The summer's vicious rumors follow Siddons to London, where she is hissed on her opening night while appearing as Mrs. Beverley in Edward Moore's tragedy *The Gamester.* Pandemonium reigns for forty minutes, during which the actress faints. She ultimately appeases the audience with a moving protestation of innocence. Tempted to abandon her profession, she decides to continue for her children's sake.

MATURITY

1785 2 February • First London appearance as Lady Macbeth, a role Siddons had honed in the provinces. Her dress in the banquet scene is reportedly designed by Joshua Reynolds. The psychological nuance and innovative staging of her performance set off an avalanche of praise.

30 April • Critics pan Siddons's performance as Rosalind in Shakespeare's *As You Like It*, considering her too majestic for comedy and too matronly to be disguised as a boy. She had enlisted the artist William Hamilton to design her masculine costume.

Summer • During her annual tour of provincial cities, Siddons collects handsome profits from performances at Manchester, Liverpool, Edinburgh, Glasgow, and Belfast.

Above left: James Heath (British, 1757–1834)
after THOMAS STOTHARD (British, 1755–1834).
Mrs. Siddons as Belvidera in "Venice Preserv'd," Act V, Scene 5, 1783.
Engraving, 10.2 × 15.2 cm (4 × 6 in.). The Huntington.

18 December • Drury Lane revives Garrick's Shakespeare Jubilee. Siddons, eight months pregnant, appears as the Tragic Muse in a re-creation of Reynolds's painting.

1786 **14 August** • Siddons confides to a friend that she has amassed the £10,000 on which she had originally planned to retire. But she adds, "My riches will be incredible, for I will go on as long as I am able."

1788 **Early April 1788** • Siddons suffers a miscarriage and the sudden death of her six-year-old daughter, Elizabeth Ann. She cancels performances of *The Regent*, a new tragedy by her friend Bertie Greatheed, but returns to the stage within the month.

25 November • A lavishly staged revival of *Henry VIII* at Drury Lane features Siddons as Queen Katharine and her brother John Philip Kemble as Cromwell. Accentuating the actress's majestic bearing and dignified manner, Katharine becomes one of Siddons's signature roles.

1789 **11 May** • Dressed as Britannia, Siddons recites an ode on George III's recovery from illness during her benefit performance at Drury Lane.

October • Depressed and weak following another miscarriage, Siddons entertains herself by making clay sculptures, convinced that she can do better than many of the professional artists who have represented her.

November • Siddons temporarily abandons Drury Lane in order to embark on a lengthy provincial tour, which she hopes will offset unpaid wages held up by Sheridan.

1790 **7 December** • Frenzied shouting and clapping greet Siddons on her return to Drury Lane after an absence of nearly two years, but illness prevents her from performing more than a half dozen times that season.

1792 **7 February** • Siddons plays Queen Elizabeth in *Richard III* for the first time in London. The performance is at the King's Theatre, where she continues to appear while awaiting the completion of new premises at Drury Lane.

1794 **21 April** • Her brother John's company makes its debut at the enormous new Drury Lane Theatre with a lavishly revamped production of *Macbeth*. Siddons plays Lady Macbeth while five months pregnant. Her friend Hester Piozzi worries, "People have a Notion She is covetous, and this unnecessary Exertion to gain Money will confirm it."

25 July • Aged thirty-nine, Siddons gives birth to her seventh and last child, Cecilia.

1797 **24 March** • Siddons creates another dramatic sensation with her first appearance as Mrs. Haller in Friedrich Kotzebue's Gothic tragedy *The Stranger*.

November • Siddons returns to Drury Lane after an absence of several months, reneging on a vow not to perform until Sheridan pays the £2000 he owes her in back wages.

LATE CAREER

1798 **7 October** • Death of Siddons's nineteen-year-old daughter Maria, whose poor health has collapsed under the strain of a disastrous love affair with Thomas Lawrence. The highly strung artist had jilted Siddons's eldest daughter, Sally, when his affections turned to Maria, only to reverse himself again.

1799 **11 December** • Siddons debuts another sensationally successful role as Elvira in Sheridan's play *Pizarro*.

1801 Depressed by personal misfortune and painful, chronic illnesses, Siddons begins taking laudanum. Despite her poor spirits and negligent remuneration by Sheridan, Siddons's performances are as brilliant as ever and her regular tours of the provinces enable her to amass a fortune estimated at £53,000.

This and opposite page: Portrait of Joshua Reynolds and view of London. From Walter Thornbury's *Old and New London* (London and New York, 1887–93), vol. 3, p. 145; vol. 2, p. 13.

1802 **April** • Siddons narrowly escapes being burned alive when her drapery catches fire during a performance of Shakespeare's *Winter's Tale*.

May • Unable to extract her wages from Sheridan, Siddons journeys north alone for a year's performances in Ireland.

27 July • Siddons appears at Dublin in the title role of *Hamlet*, a part she had played on several previous occasions. Acclaim for her convincing performance focuses on the fencing scene for which she had trained with the expert Galindo.

1803 **2 April** • Having received word of her father's death and her daughter Sally's grave illness, Siddons sails from Dublin to England. While she is still at sea, her son George sets off for India to seek his fortune; she never sees him again. Siddons reaches England and journeys as far as Shrewsbury before learning that Sally had died on 24 March.

1804 **1 May** • Thomas Lawrence exhibits his grand, full-length portrait of Siddons at the Royal Academy. Siddons describes it as "the finest thing that has been seen for many years . . . more like me than any thing that has been done."

December • William Siddons advertises a £1000 reward for information concerning the originator of a rumor charging his wife with an adulturous liaison with Lawrence.

1805 **10 April** • For reasons of mutual convenience, Siddons moves to Westbourne Farm, a rural cottage within commuting distance of Covent Garden, while her invalid husband remains at Bath. The arrangement fuels rumors of marital discord, but the couple exchange long and apparently harmonious visits.

1807 **9 September** • At the close of her habitual summer tour of provincial theaters, Siddons has acquired sufficient funds "to retain my carriage in case of inability to continue acting—which I fear will not be a very distant period, for I am extremely rheumatic."

1808 **11 March** • William Siddons dies at Bath while his widow is performing at Edinburgh.

20 September • Shortly after Siddons's return to the stage, fire guts Covent Garden Theatre, killing two dozen and destroying all the professional costumes and jewelry that the actress had amassed over her long career. She estimates her personal losses at £1200.

1809 **February** • Catherine Gough Galindo, wife of Siddons's Dublin fencing master, publishes a pamphlet accusing the actress of seducing her husband. Publicly maintaining a dignified silence, Siddons is privately distraught over one of the few scandals to tarnish her sterling reputation.

16 May • Siddons draws up an official agreement that the 1809–10 season will be billed as her last.

18 September • On the opening of the new Covent Garden Theatre, a mob attacks Siddons as she steps from her carriage, and she performs *Macbeth* "amid hissing and hooting." Riots break out in protest against the raising of ticket prices to cover rebuilding costs. Siddons vows to perform no more, for "nothing shall induce me to place myself again in so painful & degrading a situation." Nevertheless, she eventually returns to the stage and postpones her retirement yet again.

Above left: DAVID MARTIN (British, 1736–1798). *Study for a Portrait of Sarah Siddons*, n.d. Black chalk touched with white on blue paper, 34.9 × 27 cm (13 3/4 × 10 5/8 in.). Edinburgh, National Gallery of Scotland.

Above right: Sarah Siddons's house in 1800. From Walter Thornbury's *Old and New London* (London and New York, 1887–93), vol. 5, p. 216.

Opposite: *Bette Davis in the Role of Sir Joshua Reynolds's "Tragic Muse,"* 1957. Courtesy of the Laguna Beach Festival of the Arts Archives. Photo: Pete Fulmer.

legend
RETIREMENT AND BEYOND

1812 **18 January** • With her abilities in obvious decline, Siddons determines to leave the stage at the end of the season and sets out for a series of farewell performances at Edinburgh.

29 June • Having appeared fifty-seven times that season, Siddons makes her official farewell performance at Covent Garden in her signature role of Lady Macbeth. She is visibly distraught while taking her final leave of the audience.

1813 **February** • Impatient with her retired existence and eager to supplement her finances, Siddons commences a series of dramatic readings from Shakespeare and Milton.

25 May • Siddons returns to the stage for a performance of *The Gamester* benefiting the Theatrical Fund. Over the next six years, she makes several more benefit appearances, undeterred by the obvious deterioration of her physical and dramatic abilities.

1814 **September–October** • Siddons journeys to France with her daughter Cecilia, intent on seeing "all the wonders of art collected there."

1815 **10 April 1815** • Death of Siddons's eldest child, Henry. She journeys to Edinburgh and gives ten performances ("such as are suited to my age and appearance") for the benefit of his widow and children.

1816 **8 and 22 June** • At the request of Princess Charlotte, Siddons appears in *Macbeth*. William Hazlitt observes: "The homage she has received is greater than that which is paid to Queens" but urges her not to jeopardize her reputation through continued performance.

1817 **1 May** • George Henry Harlow creates a sensation at the Royal Academy with his monumental group portrait of Siddons and her family, *The Court for the Trial of Queen Katharine*.

1822 Siddons publishes her own abridged version of John Milton's poem under the title *Story of Our First Parents, Selected from Milton's Paradise Lost: For the Use of Young Persons*.

1823 **26 February** • Death of Siddons's brother John Philip Kemble.

1830 **20 January** • Death of Sir Thomas Lawrence.

1831 **31 May** • Death of Sarah Siddons, aged seventy-six, at her house in Upper Baker Street (London). She is buried at St. Mary's, Paddington, on 15 June. Five thousand people attend her funeral.

1841 **26 June** • Charles Dickens announces the launch of a fund to erect a statue of Siddons by the sculptor Francis Chantrey in Westminster Abbey.

1849 The actor William Charles Macready and other admirers of Siddons erect a colossal statue of her by Thomas Campbell in the Abbey.

1897 **14 June** • At Paddington Green, the actor Henry Irving unveils Leon Chavalliaud's life-size marble statue of Siddons, inspired by Reynolds's *Tragic Muse*.

1903 **1 May** • The painter John Quiller Orchardson exhibits his tribute to Siddons and her most famous portraitist, *Mrs. Siddons in the Studio of Sir Joshua Reynolds*.

1922 **17 October** • The actress Ellen Terry places a commemorative plaque at the house where Siddons once lived in Bath.

1950 Anne Baxter portrays an ambitious theatrical ingenue battling for the coveted Sarah Siddons Award in the film *All About Eve*. That same year, the Sarah Siddons Society is founded in Chicago for the purpose of recognizing outstanding stage actresses.

1957 Bette Davis portrays Sarah Siddons in a tableau vivant re-creating Reynolds's *Tragic Muse* at the thirty-fifth annual Pageant of the Masters in Irvine, California.

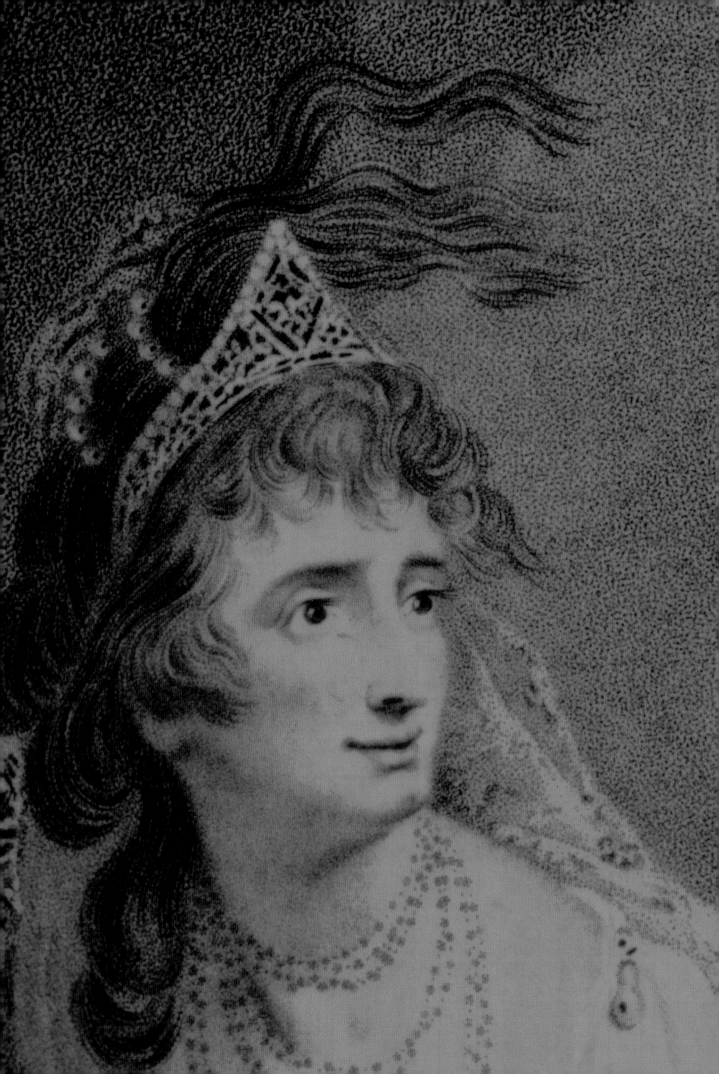

The **Public** AND *Private* Roles
OF Sarah Siddons

SHEARER WEST

Well perhaps in the next world women will be more valued than they
are in this. [1]
The true actress is in every thing an artist. [2]

W HEN SARAH SIDDONS DIED IN 1831 AT AGE SEVENTY-SIX,
over five thousand people attended her funeral to celebrate what was
not only a successful and lucrative career but the life of a woman who
had been seen to embody timeless ideals of both acting and feminin-
ity. Although she had performed only sporadically since her official
retirement in 1812, Siddons maintained an iconic status into her old
age—an object of awe and admiration even to those who had seen her
perform only once or twice. The enthusiasm that audiences felt for
Siddons is familiar in the late twentieth century, with our fascination
for famous film actresses, supermodels, and internationally recog-
nized female pop idols. However, in the late eighteenth century, the
meteoric rise of an actress to such a level of fame was unique.

Beginning as a timid and unknown provincial player, Siddons
ended her career as a household name, an object of cult worship, and
a living embodiment of Melpomene, the mythical muse of tragedy.

Opposite: Carolyn Watson
after ROBERT EDGE PINE.
Sarah Siddons as Euphrasia (detail),
1784. (See fig. 16, p. 62.)

From the time of her second London debut in 1782 until her official retirement in 1812, she dominated stages throughout England, Scotland, and Ireland, despite her many personal trials and professional rivals. Siddons was both a phenomenon and a spectacle, and the many written and visual representations she inspired provide a complex and sometimes contradictory picture of her character and abilities. This essay attempts to assess these various public and private roles by examining the ways in which Siddons's life and career related to issues of gender, aesthetics, and class during her lifetime.

Siddons is often written of as an exceptional actress in the history of theater, but in many respects, her career pattern and life history are unexceptional for an actress of her period. She was born into a theatrical family (the Kembles) and spent her teenage years as a provincial strolling player—the origin of increasing numbers of metropolitan actresses in the late eighteenth century.[3] Like many actresses, she married a fellow performer (William Siddons), and her career was punctuated by the birth of seven children. She had the usual disputes and misunderstandings with London managers (David Garrick in 1775–76 and Richard Brinsley Sheridan in the 1780s and 1790s). Although she had a huge repertoire, as did most provincial actresses, she became associated with a handful of star roles that she played repeatedly throughout her career. She specialized in tragedy, which was a common strength of actresses.

What made Siddons exceptional in relation to her predecessors and contemporaries was not the basic facts of her life, or even her undoubted skill as an actress, but the extent of her fame, success, and ultimate respectability. Her career was anomalous during a period in which actresses—however notable—were seen as less important than actors, were considered dispensable or interchangeable, and were rarely, if ever, credited with private virtues. The ways in which Siddons transcended these expectations were unusual. First, having failed to gain recognition when she performed in London in 1775–76, she did not disappear into obscurity but consolidated her skills on the provincial circuit and returned to Drury Lane Theatre in 1782, stunning audiences with her enthralling and unexpected interpretations of familiar roles. Second, although working in a public space, Siddons was not subjected to the usual disparagement of actresses as little more than prostitutes. Finally, although her private life attracted the same prurient public scrutiny experienced by other performers, she emerged unscathed from scandals.[4] To an extent, Siddons's stage roles as wronged queens and distressed women (combined with her private persona as a dutiful and devoted mother) allowed her audiences to renegotiate their notions of what constituted ideal femininity.[5]

It is, however, important to recognize that Siddons's public and private roles were not discrete: they collapsed and blurred together in a period during which a monolithic view of woman's character and abilities was being challenged more frequently and consistently.[6] These debates often worked against stereotypes of the ideal woman as primarily domestic, intellectually limited, and morally pure. Clearly all women were operating within social and cultural expectations of what they should be and how they should behave, but the ideas of what a woman could or should be in the late eighteenth century need to be read against the real experiences of individual women.[7] Part of Siddons's modernity and success lay in the fact that much of her behavior on and off the stage conformed to contemporary notions of desirable womanhood, even while other aspects of her life and work challenged and subverted the expectations of her public, her friends, and her family.

To understand why Siddons was such an important figure both for the history of the theater and for women's history generally, it is essential to examine her private and public roles as interlocking components. Her private life, as much as her stage roles, was a kind of performance, enacted with the knowledge that she was constantly being observed, admired, or envied. At the same time, her public stage roles had resonances for the private lives and ideals of her audiences.

When attempting to come to terms with the tremendous power of Siddons as an individual and an actress, it is difficult to avoid the panegyric but patronizing tones that have too often accompanied biographies of actresses.[8] Actresses were working women, wives, and mothers, but their associations with subversive behavior, the sex lives of the aristocracy, and the admiring but often voyeuristic gazes of theatrical audiences have, until very recently, dominated their biographies.[9] Without the actresses themselves to observe and assess, any historian is in danger of adopting the style and language of the textual sources, rather than wrestling with the ambiguities and implications of those sources. The ephemeral but extensive evidence of letters, eyewitness accounts, and theatrical criticism, as well as visual culture in the form of prints, painting, and sculpture, give a particularly rich view of Siddons's career and private life; but they also disguise or only accidentally reveal the factors that underlay her successes and setbacks. It is essential to probe this written and visual evidence in the light of contemporary notions of gender, aesthetics, and class to understand how Siddons's stage performances and private life were represented and understood in the Georgian era.[10]

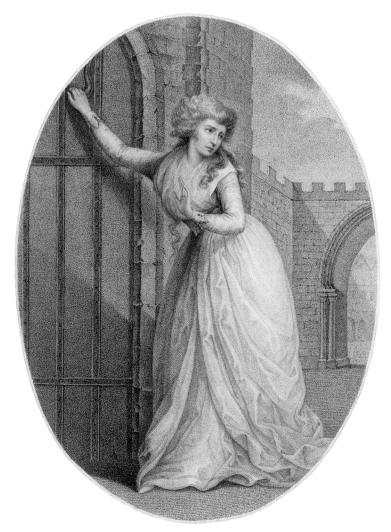

Figure 1.

GENDER AND PERFORMANCE

Although Siddons's versatility as an actress led her to perform a large variety of both tragic and comic roles during the course of her career, several key roles were associated with her. Characters such as Calista in Nicholas Rowe's *Fair Penitent*, Mrs. Beverley in Edward Moore's *The Gamester*, Zara in William Congreve's *Mourning Bride*, Euphrasia in Arthur Murphy's *Grecian Daughter*, Mrs. Haller in Friedrich von Kotzebue's *The Stranger*, and Jane Shore in Nicholas Rowe's eponymous play were products of what is generally considered a low period in the history of English drama. With the exception of Shakespearean heroines and the character of Belvidera in Thomas Otway's *Venice Preserv'd*, Siddons's major roles are only rarely performed by actresses in the late twentieth century. However, it is important to distinguish the quality of the play as text from the social and historical importance of the actress's performance.[11] Siddons's choice of parts and her method

of performing them reinforced and promoted popular ideas of virtue, piety, and women's role in society, even while her interpretations pushed against a passive acceptance of these stereotypes.

When writing of Siddons's strengths and weaknesses, her friends and biographers reinforced the idea that there were certain modes in which the actress excelled: the pious daughter, the affectionate wife, the tender mother, and the embodiment of suffering virtue.[12] Paintings and engravings of Siddons reinforced and perpetuated these stereotypes by focusing on famous scenes and evocative poses and expressions. Thus, as Jane Shore (fig. 1) in an engraving of 1790, Siddons was depicted as the impoverished and starving former mistress of King Edward IV at the nadir of her distress, knocking desperately on the door of a former companion's house to beg alleviation from her suffering. By contrast, as the Amazonian Euphrasia in Arthur Murphy's *Grecian Daughter* (see fig. 10, p. 57), she was represented by William Hamilton with more open and towering gestures as a shorthand for the filial energy that leads Euphrasia to avenge her father. Such visual contrasts echo and reinforce the dramatic distinctions Siddons gave to these roles, but in each case the "Siddonian" modes were those of ideal womanhood.

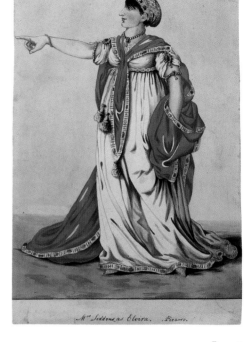

Figure 2.

There were also weaknesses and gaps identified in Siddons's repertoire. Many of her most avid admirers insisted that her natural dignity prevented her from projecting sensuality. As the critic Leigh Hunt rather delicately put it, Siddons lacked an ability to evoke the "amatory pathetic."[13] But although Siddons allegedly refused to pronounce the word "lover" on the stage, her principal characters included fallen women (Jane Shore, Calista), an adulteress (Mrs. Haller), and a prostitute (Elvira in Kotzebue's *Pizarro*). Siddons's brother, the actor-manager John Philip Kemble, substantially rewrote passages in some of the plays in order to temper any frankness or indelicacy in the characters' lines, and Siddons reportedly invested a dignity in each of these characters that transcended their sexual indiscretions.[14] Artists, too, avoided hints of sensuality in their representations of Siddons in her various "fallen woman" roles. Robert Dighton, for example, in his drawing of Siddons as Elvira in *Pizarro* (fig. 2), stresses through simplicity of gesture Elvira's integrity and sense of purpose rather than the seductiveness of the camp follower.

Even so, it was difficult for her star-struck audiences to ignore the dissonance between the actress's chaste dignity in performance

Figure 1.
Thomas Ryder
(British, 1746–1810) after
MISS LANGHAM (British,
fl. late eighteenth century).
Sarah Siddons in "Jane Shore,"
1790. Sepia color print,
20.3 × 15.2 cm (8 × 6 in.).
The Huntington.

Figure 2.
ROBERT DIGHTON
(British, 1752–1814).
*Sarah Siddons as Elvira in
Sheridan's "Pizarro": "Hold!
Pizarro—Hear me!,"* 1799.
Watercolor, 20.3 × 18.7 cm
(8 × 7 3/8 in.). Private collection,
England. Photo: A. C. Cooper
Photography.

and the intrinsic sensuality of many of her characters. Her biographer, James Boaden, isolated the problem with Siddons's portrayal of the adulterous Mrs. Haller: "Her countenance, her noble figure, her chaste and dignified manners, were so utterly at variance with the wretched disclosure she had to make, that no knowledge that it was pure, or rather impure, fiction, could reconcile me to this."[15] More palatable to her biographers were roles such as the beleaguered Queen Katharine of Aragon in Shakespeare's *Henry VIII*, who reportedly had a "strong moral resemblance" to Siddons, as "they were both benevolent, great, simple, and straightforward in their integrity; strong and sure, but not prompt in intellect; both religiously humble, yet punctiliously proud."[16] Passages such as these indicate typical slippages between Siddons's stage role and her private character—slippages that were revealingly accidental but were also cultivated by Siddons herself.

Analogous slippages also crept into the reception of portraits of the actress. Thomas Lawrence's portrait of Siddons gazing sadly and distractedly out at the observer (fig. 3) was frequently identified with the character of Mrs. Haller in *The Stranger*.[17] The artist here managed to evoke something of the guilt and grief associated with Mrs. Haller's adultery, but he may have intended to allude to the personal trials of Siddons herself. Her frequent family difficulties, including the death of her beloved daughters, were well known to Lawrence, who was her intimate acquaintance.

Notwithstanding the reality of her situation, Siddons was particularly conscious of the importance of projecting an image of content domesticity, and she performed a number of roles in which maternal affection and duty dominated her interpretation of the character. She cleverly exploited the fact that she was a mother herself from an early point in her career. Before her second, successful debut in London in 1782, she bade farewell to the Bath and Bristol theaters by bringing her children Henry, Sally, and Maria onto the stage during a speech about her "three reasons" for deserting her faithful provincial audiences.[18] The appeal to audience sentiment was as clear in this unashamed use of her own family as it was in the gloss she gave to some of her principal roles. In her performance of Isabella in Thomas Southerne's *Isabella, or the Fatal Marriage*, she was acknowledged more in criticism and visual culture for her maternal anxiety about the possible loss of her child than for her distress as a widow—which formed the most prominent theme of the play. In her first performance of this role in London in 1782, she dragged her son Henry about the stage, allowing audiences the double vision of the real and fictional mother.[19] William Hamilton's painting of Siddons with her son in this play (fig. 9, p. 54) reminded her audiences of Isabella's intense maternal grief, as Hamilton represented Siddons with an expression of pathos, feverishly clutching her son's hand. The use of such a pro-

Figure 3.
THOMAS LAWRENCE
(British, 1769–1830).
Mrs. Siddons, Formerly Said To Be as Mrs. Haller in "The Stranger," ca. 1797. Oil on canvas, 76.2 × 63.5 cm (30 × 25 in.). ©Tate Gallery, London 1998.

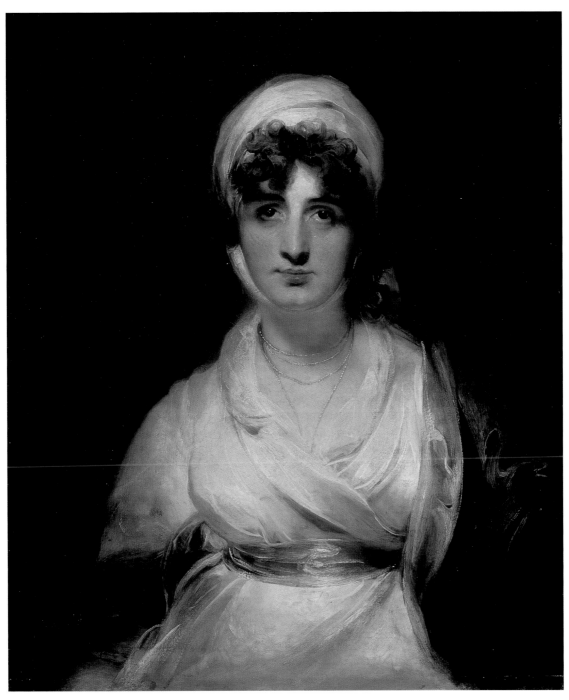

Figure 3.

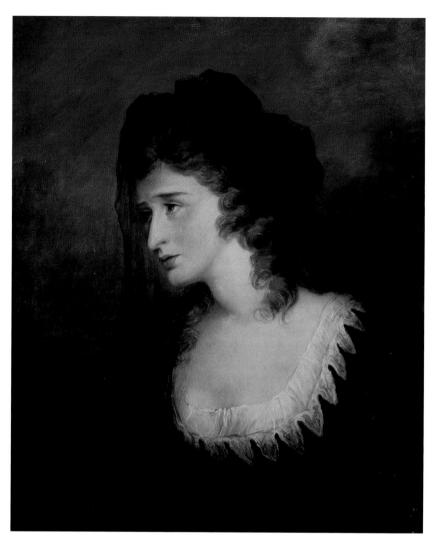

Figure 4.

Figure 4.
WILLIAM HAMILTON.
Sarah Siddons as Isabella,
ca. 1785. Oil on canvas,
76.2 × 63.5 cm
(30 × 25 in.). Private
collection, England. Photo:
A. C. Cooper Photography.

nounced facial expression was unusual even in portraits of actors in performance, but here it served to enhance the maternal emphasis that became the hallmark of Siddons's Isabella (fig. 4). A different maternal role, that of the "overjoyed mother," dominated her portrayal of Lady Randolph in John Home's *The Tragedy of Douglas*, in contrast to the aristocratic dignity maintained by her rival, Mrs. Crawford, on discovering that her long-lost son was still alive.[20]

However, while Siddons fed audiences with fashionable sentimental views about motherhood, her own dual role as mother and actress caused continual distress and problems throughout her career.[21] Although at times she would present her children to the public and play the devoted mother, she was forced to send them away to school or lodge them with friends during particularly busy working periods, and she was unable to make the journey back from Ireland to be at the deathbed of her daughter Sally in 1804.[22] Moreover, while motherhood may have been a boon to her public persona, pregnancy

was not. In order to maintain the family income, she performed while in the late phase of pregnancy, in one case going into labor on stage, and in another instance miscarrying during a performance.[23] Even before she first performed in London in 1775, Garrick exchanged a series of letters with his agent Henry Bate and Siddons's husband William, in which her "big belly" was discussed as an irritating hindrance to Garrick's plans for bringing her to London at the start of the Drury Lane season.[24] Her friend Hester Piozzi worried that Siddons's decision to act Lady Macbeth in 1794 while "big with Child" would reinforce the assertion of her enemies that she would do anything for money.[25] Only days after the birth of her last child, Cecilia, in 1794, the actress met with Sheridan to negotiate her unpaid salary.[26] It is not surprising that Siddons wistfully wrote to a friend, when recovering from another birth: "I wish they could . . . leave me the comfort and pleasure of remaining in my own convenient house, and taking care of my baby."[27]

The difficulties with which Siddons had to grapple in order to juggle her career, her concerns about money, and her family responsibilities erupted in private correspondence such as this one, which characteristically veers from gushing descriptions of her adorable children to anxious asides about her latest performance and the size of her pay packet. However, looking back on her career in later life, Siddons recollected a more controlled and deliberate state of mind: "that I had the strength and courage to get through all this labour of mind and body, interrupted too, by the cares and childish sports of my poor children who were . . . hush[e]d to silence for interrupting my studies, I look back with wonder." She makes a point of stressing her assiduity in studying for and perfecting her roles. It is clear that she could draw on tremendous physical and mental energy: not only did she lose sleep after a long working day to fine-tune a forthcoming part, but at many points in her career she led a commuting life, moving between provincial theaters, with journeys as long as ninety miles undertaken on her "rest" day.[28] This indefatigable energy aroused some contemporary comment, as did other aspects of Siddons's character and performance style that rested uneasily with the common view of her dignified domesticity. Thus while her public could view her as femininity personified, what actually made her unique were those qualities in her personality and mode of acting that fit more easily within contemporary views of masculinity.

It was common in writing about Siddons for authors to use adjectives and descriptions of her performance that evoked masculine stereotypes. They extolled her "unexpected powers of almost masculine declamation" the "vigour" or "masculine firmness" of her performance, and her tendency to portray "strong heroic virtues."[29] This image of Siddons came to the fore after her first London performances

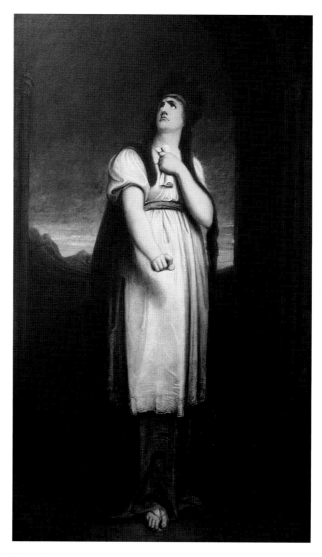

Figure 5.

Figure 5.
RICHARD WESTALL
(British, 1765–1836).
Lady Macbeth (Letter Scene),
ca. 1800. Oil on canvas,
229.9 × 138.5 cm
(90½ × 54½ in.).
London, Garrick Club/
e.t. archive.

as Lady Macbeth during the 1784–85 season. Rebutting critics who complained that she never selected Shakespearean roles and was therefore incapable of the depth that they required, Siddons created a Lady Macbeth that challenged accepted notions of the character. Her own cogent and extensive interpretation of Lady Macbeth—published in her official biography by Thomas Campbell—showed how she overturned the tendency to demonize the character. Siddons conceived of Lady Macbeth as charming, delicate, and devoted to her husband, but ultimately too fragile to withstand the moral consequences of murder.[30] It is interesting to note, however, that Siddons's own view of Lady Macbeth's behavior and motivation did not prevent observers from constructing her portrayal of the character as masculine. As Boaden put it, "the distinction of sex was only external,"[31] and many contemporary images of Siddons represent her Lady Macbeth as formidable rather than fragile.

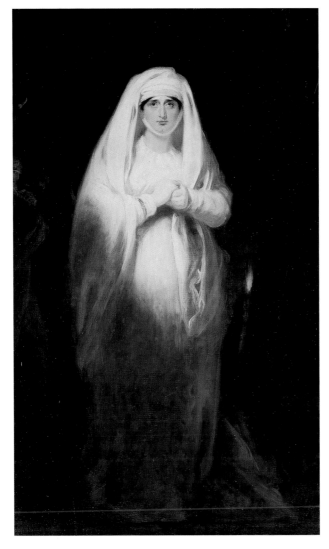

Figure 6.

As with other representations of Siddons, artists chose moments in *Macbeth* that were the most popular among the actress's audiences. Act I scene 5, in which Lady Macbeth reads her husband's letter and is fired with ambition for him, was the scene chosen by Richard Westall (fig. 5) and George Henry Harlow (see fig. 38, p. 87), both of whom exaggerated the actress's statuesque qualities and represented her in formidable, even aggressive, poses. But Harlow also painted Siddons's Lady Macbeth as the fragile beauty in the sleepwalking scene (fig. 6), where the gesture of washing her hands of crime appears self-protective and her expression signifies bewilderment rather than purpose. Thomas Beach's portrait of Siddons as a fearful Lady Macbeth in the dagger scene (fig. 7) further hints at the crumbling facade of the character's strength and thus echoes more clearly Siddons's own interpretation of Lady Macbeth's essential vulnerability.

Figure 6.
George Henry Harlow (British, 1787–1819). *Sarah Siddons as Lady Macbeth (Sleepwalking Scene)*, n.d. Oil on canvas, 61.6 × 37.5 cm (24½ × 14¾ in.). London, Garrick Club/e.t. archive.

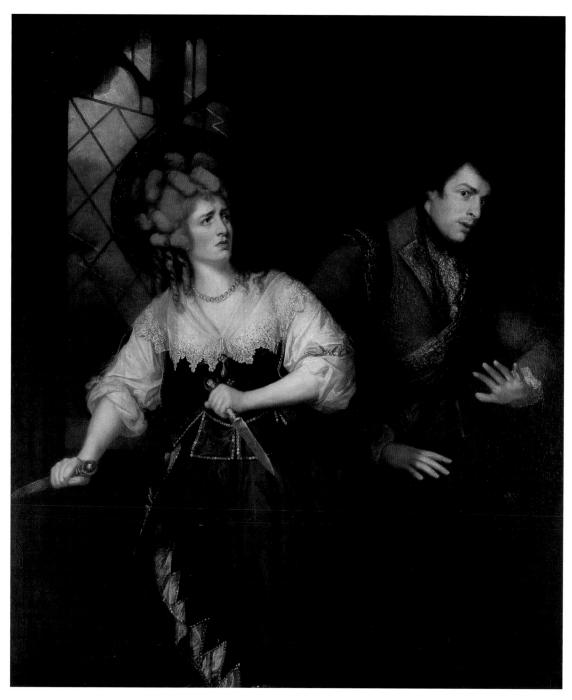

Figure 7.

Even when representing Siddons in her more characteristically "feminine" roles, artists could mingle masculine features or poses with more stereotypically feminine attributes. For example, in his study of Siddons as Lady Constance in Shakespeare's *King John* (ca. 1815), Henry Fuseli portrayed the actress as large-boned and thick-featured, but she languishes in a sensuous and inviting pose. Such vacillation in the perception of masculinity and femininity in Siddons's characters spread into other aspects of her performance and representational life. When

she adopted an unusual, hybrid costume for the "breeches" part of Rosalind in Shakespeare's *As You Like It*, her audiences derided the effect of androgyny. In this case, Siddons clung a bit prudishly to a recognizably feminine apron in scenes where Rosalind was meant to be dressed as a boy.[32] Even in such a clear instance of "acceptable" stage masculinity, Siddons chose to emphasize her womanliness.

Such ambiguities arose not least because it was easier to attribute masculine qualities to public performance than to recognize the aspects of Siddons's private character that sat uneasily with contemporary views of femininity. Not only did some representations of Siddons hint at stereotypically masculine posture or musculature but contemporaries occasionally wrote about the superiority of her mind and her subtle judgment about the meaning and nuances of her lines.[33] Despite assertions of women's intellectual abilities during the late eighteenth century, judgment, learning, and mental agility continued to be associated with men.[34] Siddons's biographer, Boaden, discerned "a male dignity in the understanding of Mrs. Siddons, that raised her above the helpless timidity of other women," and he also noted the "mental firmness" she showed in being able to put family problems aside when she performed on stage.[35] Her interest in literary criticism is attested to not only by her letters—which are littered with quotations from Shakespeare—but also by the selection of extracts from Milton's *Paradise Lost* that she published after her retirement.

These qualities and activities were certainly recognized, but they were not always emphasized. Despite the evidence of her mental abilities, Siddons's biographer Thomas Campbell encapsulated her as an "endearing domestic character"; the artist Benjamin Robert Haydon provided a diary obituary that summed her up as a "good, & pious, and an affectionate Mother"; and Boaden provided the most astonishing epitaph of all when he wrote of her as "indefatigable in her domestic concerns . . . [she] passed many a day washing and ironing for her family."[36] Siddons meanwhile was cultivated by a circle of second-generation bluestockings, including Hester Piozzi and Fanny Burney, and like them, her belief in duty and Christian virtue was connected with her desire for cultivation of the mind.[37] Siddons's close and continual study of her parts, through which she thoroughly analyzed characters' motivations, was fully consonant with late-eighteenth-century debates about women's education that saw learning as a way of improving women's virtue as well as exercising their minds.[38] An actress rather than a writer, Siddons has never been labeled a bluestocking, although the depth of her interpretations and their effect on her public drew strength from the intellectual manner in which she went about studying and developing her roles.

Figure 7.
THOMAS BEACH
(British, 1738–1806).
Sarah Siddons and John Philip Kemble in "Macbeth," 1786. Oil on canvas, 194.3 × 152.4 cm (76½ × 60 in.). London, Garrick Club/e.t. archive.

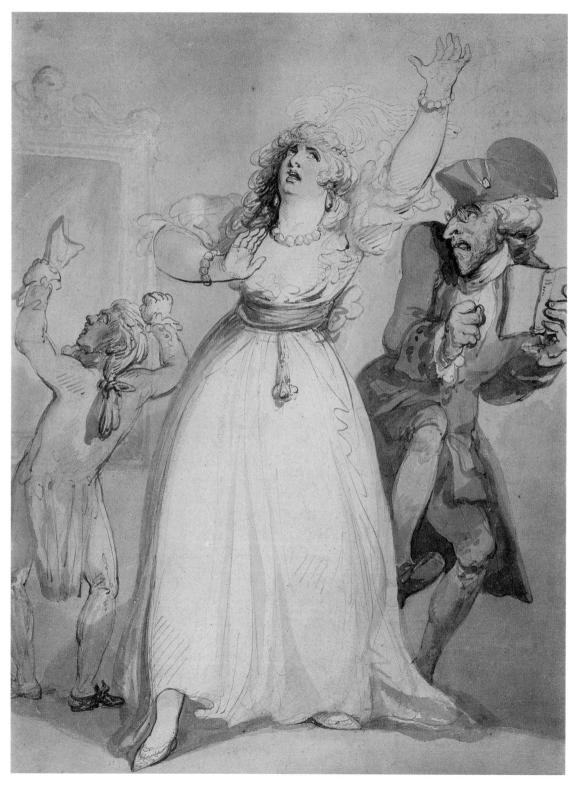

Figure 8.

"How to Harrow up the Soul": Siddons and Sensibility

To counterbalance these intellectual aspects of her acting, Siddons was known—particularly in the early part of her career—for her ability to arouse the emotions of her audiences to the point of hysteria. Popular prints highlighted the extremes of emotion on the part of both the actress and the audience. In an engraving by Thomas Rowlandson of Siddons rehearsing in the Green Room (fig. 8), she is shown in an exaggerated posture of tragic mania, while a print of only a few months earlier, *For the Benefit of Mrs. Siddons*, encapsulates the reaction to her performance by a group of weeping spectators (fig. 9). What these prints seem to indicate is that she expressed herself in extreme ways, and her audiences empathized to a degree that—while it challenged the limitations of Enlightenment rationality—permitted a safe public enactment of unacceptably violent emotions.[39] The audience response to her acting clearly distinguished her from her famous predecessor Garrick,

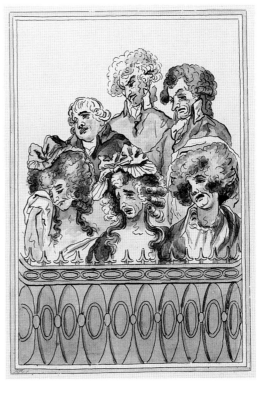

Figure 9.

whose occasionally hysterical audiences usually confined themselves to rioting and catcalling rather than crying, moaning, and fainting. The waves of emotions that swept through the theater when Siddons performed need to be carefully investigated within the context of contemporary ideas about sensibility and emotional expression.

Throughout the middle decades of the eighteenth century, sensibility in literature and theater was associated with intuition and the communication of strong feeling.[40] The "cult" of sensibility allowed men to cry, for public expressions of emotion were considered evidence of sympathetic character. Although the cult phase was falling out of fashion by the 1780s, Siddons's performances in London during the 1782–83 and 1783–84 seasons seemed to unleash the last violent surge of the sensibility phenomenon.

As sensibility involved a communication of emotion from the sufferer to the watcher, it must first be asked how Siddons suffered and conveyed her emotions. One of Garrick's principal contributions to the theater had been to fuel the expectation that actors should feel the parts and, ideally, should "become" the characters portrayed. During Garrick's time this was achieved through a contrived study of facial expression and gesture. Many acting manuals published between 1730 and 1780 itemized the passions of love, hate, sorrow, jealousy, and

Figure 8.
Thomas Rowlandson
(British, 1756–1827).
*Mrs. Siddons, Old Kemble,
and Henderson, Rehearsing in
the Green Room*, 1789.
Watercolor on paper,
22.9 × 31.1 cm (9 × 12 1/4 in.).
The Huntington.

Figure 9.
John Boyne
(British, 1750–1810).
For the Benefit of Mrs. Siddons, 1789.
Engraving, 20.6 × 14.3 cm
(8 1/8 × 5 5/8 in.). London, The
British Museum.

scorn and detailed the particular configuration of facial muscles and bodily posture that were deemed to convey these emotions.[41] Often such descriptions of the passions were based on famous works of art; the Hellenistic sculpture *Laocoön*, for instance, was considered an appropriate example of horror. Such manuals, written in the service of realism, encouraged a contrived disposition of the face and body at key moments in the action of the play. These so-called "points" were eagerly awaited by audiences and were frequently held by the actor for several seconds to allow for applause.

Reviews of Siddons's early acting style show that she drew upon the "points" of her predecessors, but she furthered the emotional effect of the action by moving rapidly between passions or endeavoring to convey several passions simultaneously. Her "versatility of countenance" caused comment,[42] and the effect of this malleability was stimulating to audiences. A description of her portrayal of the incipient madness of Belvidera in Thomas Otway's *Venice Preserv'd* referred to "Her wan countenance, her fine eyes fixed in a vacant stare!—her shrieks of horror . . . her smile at the imaginary embrace."[43] As Zara in Congreve's *Mourning Bride*, she exhibited "the combining passions of love, rage and jealousy" as well as "the contention . . . between pride and love!" as she became enamored of a fellow captive who was married to another woman.[44] While artists in Garrick's time could take advantage of the stasis of the "points" that he and his disciples favored, artists attempting to capture Siddons's early style had the greater difficulty of evoking her attention to detail and her rapid changes of expression. Artists endeavored to address this problem by hinting at temporality through suggestions of movement, contrasting gestures, or ambiguous expressions. Samuel de Wilde's portrait of *Sarah Siddons as Isabella* (fig. 10) shows the actress delicately extending the ring of her beloved husband in one hand, while raising the other as if to ward off the troubling medley of emotions that the ring inspires. Thomas Stothard's print *Sarah Siddons as Isabella: "Il Penseroso"* (fig. 11) alludes to the mobility and fluidity of Siddons's performance style by representing the actress simultaneously looking back and gesturing forward. A satirical print entitled *How to harrow up the Soul—Oh-h-h!* (fig. 12) indicates the confusion of signals that such a mixed style could elicit, as well as the limitations of attempting to represent it.

Thus Siddons went a step further than Garrick in attempting to exemplify real emotion, and her private correspondence reveals that she at times entered the emotional life of her characters—especially when their situations had parallels with her own. In the late 1790s, for instance, while she was battling with the problems of her dying daughter, Maria, and the artist Thomas Lawrence's unacceptably extreme passion for her other daughter, Sally, she wrote to her friend Penelope Pennington: "I must go dress for Mrs. Beverley—my soul is well tun'd

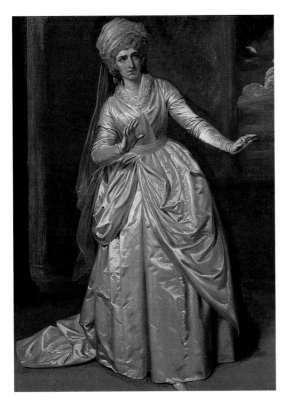

Figure 10.

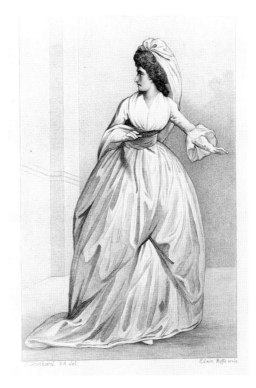

Figure 11.

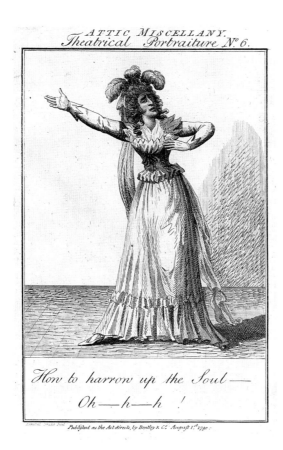

Figure 12.

Figure 10.
SAMUEL DE WILDE
(British, 1748–1832).
Sarah Siddons as Isabella,
ca. 1791. Oil on canvas, 35.6 ×
27.9 cm (14 × 11 in.). Private
collection, England. Photo:
A. C. Cooper Photography.

Figure 11.
Edwin Roffe
(British, fl. mid-nineteenth
century) after THOMAS
STOTHARD (British, 1755–
1834). *Sarah Siddons as Isabella—
"Il Penseroso,"* n.d. Engraving,
27 × 21.4 cm (10⅝ × 8⅜ in.).
The Huntington.

Figure 12.
"ANNABAL SCRATCH."
*How to harrow up the Soul—
Oh–h–h!,* 1790. Engraving,
12.4 × 9.8 cm (4¹³⁄₁₆ × 3⅞ in.)
Cambridge, Mass., The Harvard
Theatre Collection, The
Houghton Library.

for scenes of woe, and it is sometimes a great relief from the struggles I am continually making to wear a face of cheerfulness at home, that I can at least upon the stage give a full vent to the heart which . . . swells with its weight almost to bursting."[45]

After the death of Maria, Siddons carefully avoided playing any roles involving maternal grief because she feared the effect it would have on her.[46] Such a mingling of private feeling and public display of emotion was probably not what acting theorists were advocating when they urged actors to "feel the part," but this empathic understanding of the situations of her characters undoubtedly gave Siddons some motivation in her parts and may also have communicated itself to an audience well informed about her private woes and eager to cry with her.

The behavior of her audiences is one of the most notable and distinctive aspects of Siddons's history, particularly in the first two decades of her London career. Contemporary accounts give us a picture of audiences not only suffering to the point of illness also but taking a masochistic pleasure in that suffering. The metaphor of illness permeates writing about Siddons's audiences. Members of the audience sobbed, fainted, hyperventilated, developed headaches—and loved every minute of it.[47] The pleasure her audiences took in their emotional pain was expressed most clearly in a paean to Siddons, written after her successful second London debut in 1782:

> O Siddons, cease to strain
> The nerve of Pleasure on the rack of Pain:
> It thrills already in divine excess!
> Yet fondly we the fair Tormentor bless,
> And woo her to prolong our exquisite distress.[48]

Although both men and women evinced these responses, much of this empathic emotional attention came from women.[49] For them, the phenomenon of Siddons's performance offered an opportunity to experience both real and vicarious danger. The real danger lay in the crush to get into the theater. This was emphasized in a satirical image of 1784 by Robert Dighton showing the pit door of Drury Lane Theatre besieged by a crowd of shouting, fainting, even vomiting admirers (fig. 13). As the bluestocking Anna Seward reflected, "I saw her for the first time at the hazard of my life, by struggling through the terrible, fierce maddening crowd into the pit."[50] The vicarious danger lay in the emotional extremes that Siddons unleashed. The importance of women as consumers of culture in the last decades of the eighteenth century meant that their patronage of the theater and favoritism of Siddons had a powerful impact on her fame and reception. While women were at least partly responsible for the refinements that led to sentimental comedy,[51] they also enjoyed the frisson of emotional self-

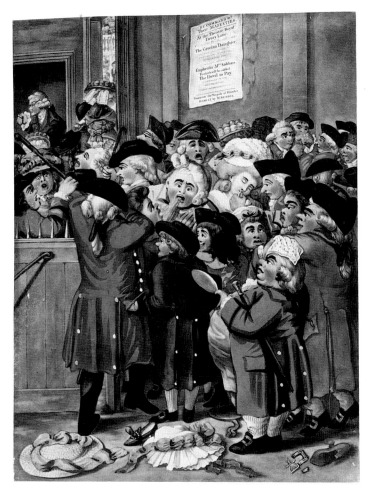

Figure 13.

indulgence that replaced vulgar language and innuendo as the danger zone of contemporary theater.

Women's responses to Siddons's performances reveal a sense of longing that goes beyond this masochistic wallowing in extreme emotion. In many instances, women writing about Siddons used the language of lovers: "I am as devoted to her as yourself," wrote Anna Seward to the Rev. Whalley, "and my affection keeps pace with my astonishment and delight; for I have conversed with her, hung upon every word which fell from that charming lip." Years later, Seward wrote again in a similar strain, "The dejecting nature of my bodily sensations counteracted the longings of my spirit . . . O, Mr. Whalley, what an enchanting Beatrice she is!" [52] A description of Siddons's acting by "A Lady of Distinction" reads like the opening lines of a love sonnet: "How can I delineate her perfections, when those very perfections, I sometimes thought, would have nearly deprived me of sensation?" [53] The popularity of miniatures of Siddons attest further to this deflected desire to possess or become the woman. The miniaturist

Figure 13.
Anonymous after
ROBERT DIGHTON.
The Pit Door, 1784.
Mezzotint, 32 × 24.9 cm
(12 5/8 × 9 3/4 in.). London,
The British Museum.

Horace Hone, for instance, took advantage of Siddons's popularity in Dublin in 1784 and executed numerous watercolor and enamel portraits of the actress in different poses and costumes (figs. 14–15). These were frequently reproduced for admiring fans who wanted a keepsake of the great tragedienne. Siddons aroused a sort of fetishistic admiration that made her the object of obsession. Even shortly after her death, her niece Fanny Kemble, when aboard ship to America in 1832, was asked to pass around

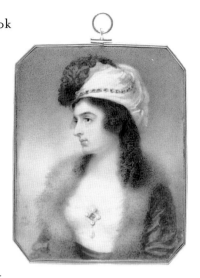

Figure 14.

clippings of Siddons's hair to relieve her fellow passengers from the boredom of the journey.[54] The expression of desire that emerged in the writing of many women complemented their tendency to empathize with Siddons through the parts she played. To an extent, Siddons enabled women to express extreme emotions denied them in everyday life and to do so in the relative safety of the theatrical environment.

The problem with this emotional self-indulgence was that it rested very uneasily with Siddons's embodiment of the chaste and dignified woman, and in some ways it was incommensurate with the attempts to purify and morally improve the theater that had been an important impetus behind the sensibility movement itself.[55] As emotion became paramount in the theater, didacticism receded. Emotion had therefore to be given a moral purpose. Boaden attempted to reconcile these competing problems in his justification of Siddons's performance: "As we are so constituted as to be purified by terror and by pity, a great moral object was gained by stealing through even their [the audience's] amusements . . . and there where affluence had rendered many of the cares of life no subjects of either burden or thought, to banish the apathy engendered by pride, and bring the best fruits of the virtues from the sympathy with fictitious sorrow."[56] The idea that the catharsis of expressing emotion could lead to moral improvement, especially of people who did not usually experience the cares of the world, was reinforced by Romantic drama critics long after sensibility had fallen out of fashion.[57] Although audiences became more restrained in their expression of emotion after the turn of the century, cathartic passions—without clear moral associations—continued to be valued in themselves and were said to be experienced by Siddons's audiences.

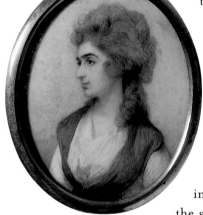

Figure 15.

Figure 14.
HORACE HONE
(British, ca. 1754–1825).
Sarah Siddons, 1786. Enamel,
H: 8.2 cm (3¼ in.).
Sotheby's (Geneva),
"Portrait Miniatures Sale,"
25 and 27 May 1993.
© Sotheby's.

Figure 15.
HORACE HONE.
Sarah Siddons, 1784.
Watercolor on ivory,
H: 8.9 cm (3½ in.).
Dublin, National Gallery
of Ireland.

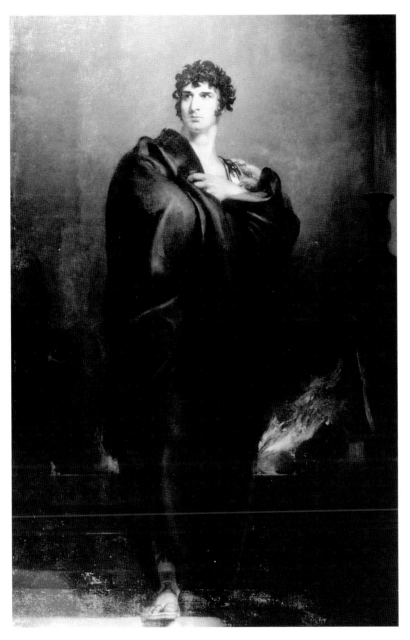

Figure 16.

THE AESTHETICS OF TRAGEDY

The moral neutrality of Siddons's emotionalism was equally charac-
teristic of the visual aspects of her performance. During the 1790s
both the Drury Lane and Covent Garden theaters were redesigned,
and one of the consequences of this was a much greater audience capac-
ity in both. The expanded space of the theater provides one explana-
tion for a perceived change in Siddons's acting style, from a very specific
and detailed study of facial expression, posture, and tone of voice, to
a broader, more operatic use of gesture and picturesque posing to

Figure 16.
THOMAS LAWRENCE.
John Philip Kemble as Coriolanus,
1798. Oil on canvas,
261.6 × 177.8 cm
(103 × 70 in.).
Guildhall Art Gallery,
Corporation of London.

convey meaning.[58] However, it is not clear exactly when these changes in her acting style came about; it is likely that they were gradual and evolved with alterations in audience expectation and response. Once the theaters were larger, it was impossible to see the detail of actors' facial expressions, and therefore discussion of theatrical performance was no longer reliant on a close analysis of the "passions" and their facial manifestation. Audiences were not so intimate with actors, and the actors may have tailored their mode of performance accordingly. When mapping the effect of Siddons's acting, it becomes clear that by the early years of the nineteenth century, her performance was more frequently viewed as if it were a work of art rather than an exhibition of nature. The ways in which her performance style and its reception interacted with contemporary aesthetics and her own self-conscious appropriation of art as a model for performance help explain her particular success with tragedy.

The term "Neoclassical" has been used as a convenient label for Siddons's later performance style, but it is perhaps too simplistic to see the aesthetics of her performance in this way.[59] The term has been used to convey the ways in which Siddons and her brother, John Philip Kemble, mirrored developments in the visual arts that promoted a greater sense of compositional order, generalization, and seriousness of purpose.[60] In acting, Kemble's tendency to adopt affected habits of speech, to declaim rather than evince genuine emotion, and to organize stage supernumeraries in balanced compositions was considered analogous to Sir Joshua Reynolds's exhortation that artists should "raise and improve," or generalize their compositions, avoiding specificities of dress, expression, and other aspects of "vulgar" realism. Thomas Lawrence's various portraits of Kemble in roles such as Coriolanus and Hamlet contribute to the monumental classical image the actor intended to promote; they are stripped of detail, devoid of extravagant pose, and empty of facial expression (fig. 16).

Despite great differences in her acting technique, Siddons was frequently associated with this "Neoclassicism" of her brother. These associations were made implicitly, rather than explicitly, and were frequently retrospective. Reynolds's aesthetic theories helped perpetuate such ideas. When arguing for the importance of history painting, Reynolds insisted that the artist should stress the general over the particular or "ornamental." In one of his *Discourses on Art* delivered to the Royal Academy of Arts, he used a theatrical analogy to explain why generality was preferable to naturalism in both art and acting, alluding to the change in acting style resulting from the larger theaters of Covent Garden and Drury Lane.[61] Reynolds was not only a friend of Siddons but he also gave her advice about costumes and hairstyle. Reynolds's loathing of contemporary dress and his distrust of too much facial

expression in history painting were both taken up by Siddons, who abandoned the specificities of fashionable dress and worked to temper her expressive countenance.[62] Influence between artist and actress worked both ways, and it is no surprise that Siddons's biographers interpreted her acting in terms drawn from Reynolds's *Discourses*.[63]

 This interchange was promoted by many paintings and engravings that elevated Siddons to an abstraction rather than represent her as a private character or an actress performing a role. Reynolds's portraits of Siddons as the Tragic Muse (see fig. 10, p. 114) was the most effective and influential of these representations. Other portraits, such as Thomas Beach's depiction of Siddons as Melancholy in Milton's "Il Penseroso" (see fig. 5, p. 50) associate the actress with abstract passions, conveyed through a similar stasis of pose and expression. William Beechey's portrait of Siddons (see fig. 30, p. 76) goes a step further and displaces performance entirely with the emblematic mask and dagger of tragedy. These representations convey the idea of a highly artificial performance mode analogous to Reynolds's advocacy of generalization and elevation in art. The transference of such conventions from writing to art and acting was consolidated by Henry Fuseli's sketchy and suggestive depiction of Siddons in the dagger scene of *Macbeth* (fig. 17), possibly painted in 1812, the year of her official retirement. Here Fuseli deliberately overturned the fussy literalism of Johann Zoffany's view of Garrick and Hannah Pritchard performing the same role nearly fifty years before (fig. 18), as well as his own previous representation of those performers in the dagger scene (fig. 19).

 However, a range of ideas were invoked in discussions of Siddons's acting, and the statuesque and poised Siddons was often praised for her naturalness.[64] In fact, in the very early years of her career, she was as well known for comedy as for tragedy, and it was in the former capacity that Garrick first introduced her to the London stage. Her critics came to deny her talent for comedy, but throughout her life, she was recognized for a vivacious sense of fun in private life. As one friend claimed, "Mrs. Siddons . . . could be infinitely comic when she pleased,"[65] although her public never accepted an image of their heroine so opposed to their conception of her as the Tragic Muse. As discussed above, early descriptions of her tragic style stress the detail with which she observed and conveyed the emotions of her characters and effected a transition between contrasting passions. The emphasis on transitions and nuance—rather than "points" and poses—echoes similar rhetoric used to describe the power of contemporary comic actresses such as Dorothy Jordan.[66] While Siddons's audiences may not have seen her as a comic performer, part of her power lay in her ability to translate the character study of a comic actor into the interpretation of tragic roles.

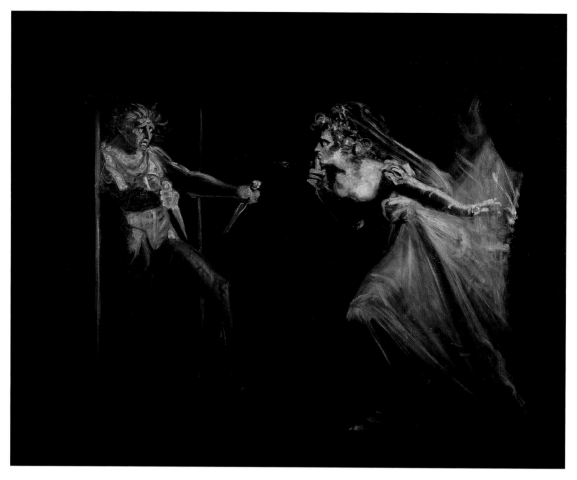

Figure 17.

Figure 17.
HENRY FUSELI
(British, 1741–1825).
Lady Macbeth Seizing the Daggers,
ca. 1812. Oil on canvas, 91.4
× 114.3 cm (36 × 45 in.).
©Tate Gallery, London 1998.

However, despite the evidence that Siddons's style was complex and subtle, she gradually became associated in criticism and visual culture with the more artificial classicism of her brother. This notion of her as a classical tragedienne was fed by portraits, which often stressed her austere, statuesque qualities, rather than the details of her physiognomy and expression. There are some minor but significant distinctions between the iconography of Siddons and that of her famous predecessor, Garrick. Both actors were the subject of portraits in and out of role, but Garrick was the brunt of much more visual satire, while Siddons inspired more sculpture. As a result of the emphasis on sculpture in the influential Neoclassical aesthetics of J. J. Winckelmann, as well as the many commissions for monumental statuary in the wake of conflicts with France from the 1790s onward, sculpture became associated with both the seriousness of the classical world and the jingoism of national feeling.[67] Siddons was seen as a fit object for sculpture not least because of her skill with tragedy and her position as a sort of national heroine. In her public role, she eschewed the playfulness of Garrick's persona and allowed her aura of supreme seriousness to deflect the humorous barbs of satirists. It is significant that sculptural

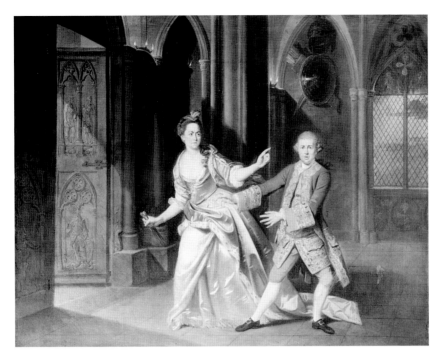

Figure 18.

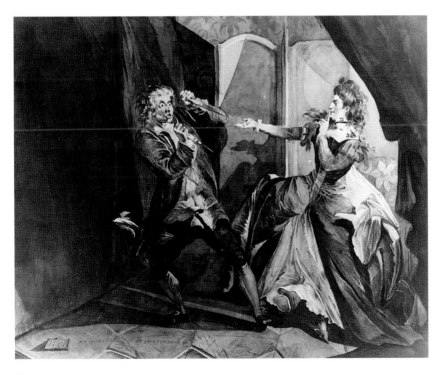

Figure 19.

Figure 18.
Johann Zoffany
(German, 1733–1810).
*David Garrick as Macbeth and
Hannah Pritchard as Lady
Macbeth*, n.d. Oil on
canvas, 102 × 127.5 cm
(40⅛ × 50¼ in.).
London, Garrick Club/
e.t. archive.

Figure 19.
Henry Fuseli.
*David Garrick and Hannah
Pritchard as Macbeth and Lady
Macbeth after the Murder of
Duncan*, ca. 1760–66.
Watercolor heightened
with white on paper,
32.4 × 39.4 cm
(12¾ × 15½ in.).
Zurich, Kunsthaus. © 1999
Kunsthaus Zurich.

representations of Siddons, such as the relief by Thomas Campbell (fig. 20) and the bust attributed to Joachim Smith (fig. 21), depict Siddons in the dress of a Roman matron, reinforcing her image as a classical heroine and ideal feminine type.

Siddons also became more clearly associated with the genre of history painting, which was gaining cautious popularity among artists in the 1780s and 1790s thanks to the advocacy of Reynolds in his position as president of the Royal Academy of Arts. Siddons's hegemony on the stage coincided with this greater public attention to history painting. Artists found her features a convenient shorthand for tragedy, melancholy, and even more lugubrious passions. George Romney employed her features as Sorrow in *The Infant Shakespeare Attended by Nature and the Passions* that he contributed to John Boydell's Shakespeare Gallery;[68] Lawrence allegedly used her face and body in his one major attempt at history painting, *Satan Summoning His Legions* (exhibited at the Royal Academy in 1797); George Henry Harlow transformed his "portrait"

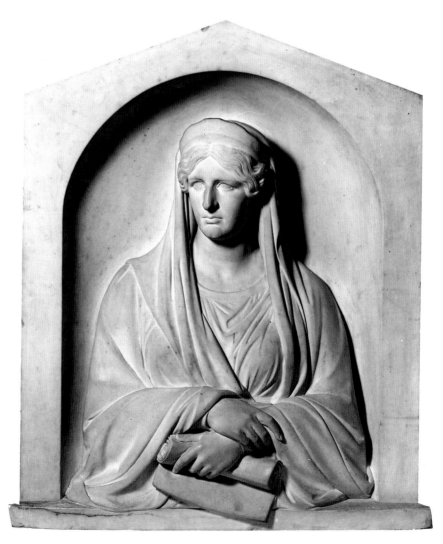

Figure 20.

of Siddons as Queen Katharine in *Henry VIII* (see fig. 40, p. 88) into a physically imposing and compositionally complex history painting.

History painters in this period were frequently decried for the "theatricality" of their compositions, but, conversely, Siddons received praise for the artistic quality of her performances. She was spoken of frequently as if she were a work of art: a "cast from the antique," "a cartoon of Raphael," "a model from Praxiteles," a "living picture."[69] Reynolds's portrait of her as the Tragic Muse became such an indelible icon that viewers began to see it as some sort of reality. Even Kemble claimed that his sister resembled the portrait when she gave public readings of Shakespeare's plays after her retirement in 1812.[70]

Siddons's tragic style was also fed by and contributed to contemporary aesthetic debates about the sublime and the picturesque. Edmund Burke most famously referred to the effect of Siddons's acting in his *Reflections on the Revolution in France*, in which the Revolution is depicted as a theatrical spectacle.[71] The term "sublime," popularized by Burke in his earlier aesthetic essay *An Enquiry into the Origins of Our Ideas of the Sublime and the Beautiful* (1759), was frequently applied to the effect of Siddons's acting on her audiences.[72] A contemporary engraving called *The Orators Journey,* published by S. W. Fores (fig. 22), shows Siddons as Lady Macbeth, sharing a horse with Burke and Charles James Fox and riding freely toward perdition. The juxtaposition of these three figures indicates the extent to which Siddons was associated with the aesthetics and politics of her own time. While Siddons's performance could be seen as sublime, it was even more frequently viewed as picturesque, literally "like a picture." In late-eighteenth-century theatrical criticism, "picturesque" was used synonymously with the opprobrious word "pantomime" to suggest that the visual effect of the acting took precedence over the content of the play.[73] Certainly Kemble was known for exploiting visual effect on the stage, but Siddons's picturesque qualities were more often related to the disposition of her body and her individual use of gesture than they were to ensemble and procession.[74]

In all of these instances, Siddons became an object of aesthetic debate, used as an example of whatever prevailing concern a particular critic or artist might wish to address. But this imaging of Siddons was more than just the effect of fashionable aesthetic trends. The fact that her acting could serve such diverse aesthetic functions is itself a testament to her versatility. Furthermore, Siddons was not simply a passive object of aesthetic criticism but an active participant in creating her

Figure 21.

Figure 20.
THOMAS CAMPBELL
(British, 1790–1858).
Sarah Siddons, 1856.
Marble, 116.8 × 95.3 cm
(46 × 37½ in.)
By courtesy of the National
Portrait Gallery, London.

Figure 21.
JOACHIM SMITH
(British, fl. 1760–1814).
Sarah Siddons, 1812. Plaster
cast, H: 72 cm (28⅜ in.).
London, The Conway
Library, The Courtald Insti-
tute of Art. With the permis-
sion of the Governors of the
Royal Shakespeare Theatre.

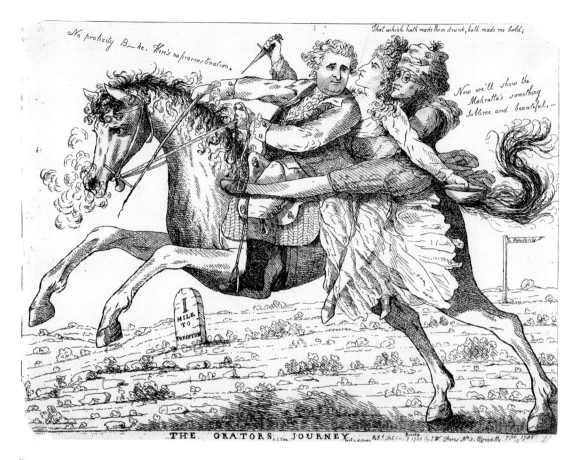

Figure 22.

own image. She was clearly aware of the way her performances functioned within contemporary aesthetic debates, and she negotiated a role for herself through her own practice of art. She began modeling in clay in 1789, and although she never gained an easy skill with sculpture, she worked hard at it, and her artistic development was assisted by her friendship with the sculptor Anne Seymour Damer.[75] She also took an active interest in visual art, and, particularly after her retirement, cultivated the role of an amateur art critic. Benjamin Robert Haydon was so thrilled with her praise of his painting *Christ Entering Jerusalem* that he completely altered his hitherto dismissive appraisal of her to one of unquestioning admiration.[76] Siddons no doubt encouraged the various anecdotes of her biographers that blur the distinction between her ability as an art critic and her role as a living work of art. Thus, when she traveled to Paris after the peace of 1815, she was examining fine art in the Louvre while other visitors to the gallery were watching her.[77] She may have modeled some of her own theatrical attitudes on contemporary sculpture, but this self-objectification was deliberate and conscious.[78] She was never a purely passive object of aesthetic debate but an active contributor, and the image she and others created was surprisingly enduring long after she had left the stage and the real impact of her performances was only a memory.

Figure 22.
ANONYMOUS.
The Orators Journey, 1785.
Engraving, 27 × 36.5 cm
(10⅝ × 14⅜ in.). London,
The British Museum.

THE QUEEN ON HER GILDED THRONE:
ARISTOCRATIC FANTASIES AND BOURGEOIS AUDIENCES

The transformation of Siddons from an awkward provincial actress to a self-possessed star, compared with queens and goddesses, was a particularly important part of her success, but one glossed over in her own memoirs and by her biographers Boaden and Campbell. Looking back on her life and career, these authors present Siddons as a fine lady from the beginning, at ease in the company of aristocracy and gentry.[79] The dissonance between this image of Siddons as queenly and the reality of a life characterized by provincial origins, unhappiness, scandalous rumors, and obsession with money was overcome in her subsequent historiography. Nevertheless, it is important to investigate these contrasts as a way of understanding why a particular kind of mixed audience adopted Siddons as its heroine.

Anecdotes of Siddons's origins attest to the fact that despite their humble status as strolling players, her mother and father "might have graced a court."[80] Siddons, when only a teenager, acted as a companion in the aristocratic household of Lady Mary Greatheed. Her earliest admirers in the fashionable spa towns of Bath and Cheltenham included the family of the Earl of Aylesbury and the Duchess of Devonshire, and very soon after her 1782 debut in London, she was invited to give readings to the royal family. In many ways, this was not surprising, as actresses for decades had developed relationships with members of the aristocracy, and two of Siddons's actress contemporaries, Elizabeth Farren and Dorothy Jordan, had well-publicized relationships with noblemen.[81] What was different about Siddons was not the patronage of the aristocracy but the way in which she was seen almost to be one of them. Indeed, in private life, the role she cultivated was not that of a duchess or lady but of a queen. She not only played queens on stage but she assumed a queenly demeanor in her private life. This was frequently the cause of comment, both admiring and snide. The adjectives "regal" and "majestic" were regularly applied to her stage performances and private mannerisms.[82] And while friends and critics could question the extent to which this regal behavior in private life was merely an extension of her performance, they more frequently conceded that she had the natural air of someone of superior breeding.[83] A comparison of Gilbert Stuart's (fig. 23) and Thomas Gainsborough's (fig. 24) portraits of Siddons reveals the latter's particular emphasis on Siddons's persona as a fine lady. Although both were painted in 1785, Stuart portrays the girlish darling of the sensibility craze with a soft and flexible expression, while Gainsborough's use of bold profile and fashionable attire captures more fully the "woman of quality" that many felt Siddons to embody, even at this early stage in her career.

Figure 23.

Siddons self-consciously cultivated this queenly role. Her memoirs—so different in tone from the unbridled earnestness of her private correspondence—adopt an air of cool superiority and demonstrate a tendency to name-drop. In them Siddons claims that when she first went to read for Queen Charlotte, she was praised for conducting herself "as if I had been used to a court," and she represents herself as a superior being surrounded by an entourage of aristocratic admirers.[84] She encouraged fashionable artists such as Reynolds, Lawrence, Romney, and Gainsborough to produce portraits of her in street dress, as well as in character, and by doing so she aligned herself with women of high birth who used the same artists for portraits that slipped in and out of role-playing.[85]

Queenly superiority, however, sat uneasily with a series of scandals that touched Siddons's career but miraculously left her private character untarnished. Even as early as 1785, she could write to her

Figure 24.

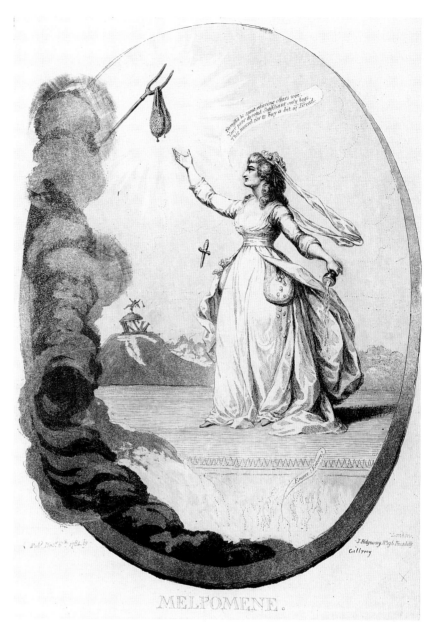

Figure 25.

Figure 25.
JAMES GILLRAY
(British, 1757–1815).
Melpomene [Mrs. Siddons], 1784.
Engraving, 33 × 24.5 cm
(13 × 9⅝ in.). London,
The British Museum.

friends the Whalleys, "I have been charged with almost everything bad,
except incontinence; and it is attributed to me as thinking a woman
may be guilty of every crime in the catalogue of crimes, provided she
retain her chastity." [86] As her comment suggests, the scandals involving
Siddons were not predominantly sexual ones, although it cannot be
said that her life was free from the usual associations of actresses with
sexual license. For a start, there was much speculation about her rela-
tionship with her husband, William, exacerbated after 1804 when the
two decided to live apart. The contradictory evidence indicates an ambi-
guity in her attitude toward her husband, who acted as her manager but
was allegedly jealous of her and unable to supply much in the way of

moral support.[87] Meanwhile, there were rumors that she had adulterous longings, first for Thomas Lawrence, then for a fencing master who went by the name of Galindo. As she was middle-aged by the time of her separation and these alleged romantic liaisons, it is possible that the titillating activities of younger actresses held more interest for a scandal-hungry public than the sexual indiscretions of a more mature woman with an established reputation.

Whatever the reason, such sexual scandals did not stick. More damaging were many years of accusations that Siddons was parsimonious to the detriment of her fellow performers. These scandals first arose in 1784 when she was performing in Dublin and allegedly refused to volunteer her services for the benefit of two fellow actors in need, West Digges and William Brereton. As benefit performances were a means for actors to gain additional income, her lack of cooperation was mistakenly construed as selfishness.[88] She was condemned in the press, and James Gillray represented her as a money-grubbing Melpomene striking a characteristic tragic pose while reaching for a bag of money (fig. 25). Certainly she was paid more than any other performer in London at the height of her fame, but for many years she was forced to fight Sheridan, manager of Drury Lane, for her salary, and insecurity about money crops up frequently in her letters.

Concern about money was one characteristic of her modest background that Siddons was unable to transcend,

Figure 26.

despite her regal performances in private and public life. Another less than elevated aspect of her heritage was her provincial origin and continued associations with regional theaters—also not easily reconcilable with her pretense of majesty. A prevailing metropolitan prejudice assumed provincial theaters and strolling players to be brutal, vulgar, and uncultivated. Thomas Rowlandson's pair of engravings, *Tragedy in London/Comedy in the Country* (fig. 26), produced around 1810, demonstrate the persistence of this stereotype well after the 1760s, when provincial theaters began to gain royal patents, and fashionable towns such as Bath and Bristol, and racing towns such as York began to draw more elite audiences during certain times of the year.[89] Indeed, accusations of vulgarity were leveled against Siddons herself when she first performed in London in 1775.[90] Although she managed to train her

Figure 26.
THOMAS ROWLANDSON. *Tragedy in London/Comedy in the Country*, ca. 1810. Etching, 35.6 × 25.4 cm (14 × 10 in.). Washington, D.C.; Special Collections Department, The Gelman Library, The George Washington University.

voice and deportment to shake off these early associations, she retained strong connections with provincial theaters and turned to them whenever she felt disillusioned with London or wanted to supplement her income. It is notable that her biographers deal only very lightly with her provincial experience. Boaden ignores it almost entirely, reshaping his biography of Siddons into a history of London theaters during the years between 1775 and 1782, when she was consolidating her reputation in Bath, Bristol, York, Manchester, Liverpool, Birmingham, and other regional centers.

But her provincialism, like her piety and virtue, was not a negligible part of Siddons's developing reputation. At the turn of the eighteenth century, the emergence of a distinct provincial middle-class identity rested in many ways on gendered notions of piety and domesticity that Siddons cultivated in her public and private performances.[91] Outside London, Siddons's perceived virtues as well as her fondness for regional theaters helped build her reputation early in her career and sustain it as she grew older. To an extent, this was also true in London, where Siddons became an object of middle-class admiration. As one satirist jibed, "even petty attornies, and gentlemen of alehouse clubs" were "civilized" by her influence.[92] Her early cultivation of the cult of sensibility also had a democratizing effect, as sensibility was concerned with a meritocracy of emotion rather than of class.[93]

But the leveling impact of Siddons's style of acting must be balanced against the problematic diversity and instability of audiences at the close of the eighteenth century and the beginning of the nineteenth.[94] The theater increasingly became a forum that not only attracted mixed audiences but also had to maintain the interest of both aristocrats and working people. The potential difficulties of a mixed theater audience came to a head in September 1809, when Kemble and Thomas Harris, then managers of Covent Garden, opened their recently rebuilt theater. In order to pay for the vast costs of rebuilding the burned theater, they altered the design to add more private boxes, thus pushing the less than affluent members of the public right to the top of the house.[95] The "Old Price" riots that resulted from this change of policy lasted until December, during which time Siddons kept away from her brother's theater and did not perform. The riots themselves were spearheaded largely by a group of radical middle-class professionals who construed the change in theater policy as elitism. Although Kemble eventually capitulated to the rioters, he, Siddons, and their circle aligned themselves with the conservative and largely aristocratic faction that saw the whole event as revolutionary rabble-rousing.

This riot unleashed political tensions present in the mixed theater audience, but it also put the public image of Siddons in a certain amount of peril. Perhaps surprisingly, her queenly demeanor on stage and off was reinforced, rather than minimized, after this period, even though the very notions of aristocracy and its privileges were abjured by the victorious rioters. What Siddons managed to adopt was not an air of genuine aristocracy but a fairy-tale regality, one that allowed her audiences to retain a fantasy of the ancien régime during a period in which its denizens no longer had the authority or the respect they had once commanded. There was something nationalistic in this response to Siddons, which allowed her audiences to translate her aristocratic demeanor into an ideal of British womanhood.[96] Harlow's historical portrait of Siddons as Queen Katharine in many ways epitomizes the queenly persona that became her stamp late in life. It is significant that Romantic writers acknowledge her as a queen, then further elevate her to a deity: while Haydon wrote that visiting her was "something of the feeling of visiting Maria Theresa," on seeing her perform Lady Macbeth, Hazlitt claimed, "It seemed almost as if a being of a superior order had dropped from a higher sphere."[97]

Siddons's diverse manifestations as goddess, queen, mother, work of art, bluestocking, businesswoman, strolling player, and chaste beauty were roles constructed by her friends, admirers, and critics and developed by the actress herself. Posterity has only these glimpses of her multifaceted individuality, presented to us in the problematic genres of theater criticism, private correspondence, biography, and portraiture. It is impossible for us to understand fully the effect of her acting or to describe or even imagine it successfully. What we can gain through a painstaking study of the sources is a rich set of clues about how the personality and performance of an unusual woman could impinge upon many different aesthetic, social, and political, as well as theatrical concerns in a complex period of history.

NOTES

1. Sarah Siddons writing to Samuel Rogers in Samuel Rogers, *Recollections of the Table-Talk of Samuel Rogers*, 2d ed. (London: Edward Moxon, 1856), 188.

2. James Boaden, *Memoirs of Mrs. Siddons*, 2 vols. (London: Henry Colburn, 1827), 2: 62.

3. Sandra Richards, *The Rise of the English Actress* (Basingstoke: Macmillan, 1993), 45.

4. See John Brewer's assertion "A successful player could only have a public private life," in John Brewer, *The Pleasures of the Imagination: English Culture in the Eighteenth Century* (London: HarperCollins, 1997), 340.

5. On the potential subversiveness of the female performer and performance, see especially Elaine Aston, *An Introduction to Feminism and the Theatre* (London: Routledge, 1995), 32.

6. For a fascinating view of women's attempts to negotiate their subjecthood, see Felicity Nussbaum, *The Autobiographical Subject: Gender and Ideology in Eighteenth-Century England* (Baltimore: Johns Hopkins University Press, 1989).

7. For arguments about the diversity of women's history, see Amanda Vickery, "Golden Age to Separate Spheres?: A Review of the Categories and Chronologies of English Women's History," *Historical Journal* 36, no. 2 (1993): 383–414; Merry E. Wiesner, *Women and Gender in Early Modern Europe* (Cambridge: Cambridge University Press, 1993); and especially Hannah Barker and Elaine Chalus, eds., *Gender in Eighteenth-Century England: Roles, Representations, and Responsibilities* (London: Longman, 1997).

8. For the problems of writing about actresses, see Jacky Bratton, "Women on Stage: Historiography and Feminist Revisionism," *Theatre Notebook* 50, no. 2 (1996): 62.

9. For an exemplary attempt to redress this, see Tracy Davis, *Actresses as Working Women: Their Social Identity in Victorian Culture* (London: Routledge, 1991).

10. Substantial and useful biographical material is available on Siddons. See especially Philip Highfill Jr., Kalman Burnim, and Edward Langhans, *A Biographical Dictionary of Actors, Actresses, Musicians, Dancers, Managers, and Other Stage Personnel in London, 1660–1800* (Carbondale: Southern Illinois University Press, 1991), s.v.; Roger Manvell, *Sarah Siddons: Portrait of an Actress* (New York: G. P. Putnam's, 1970); and Michael R. Booth's thought-provoking essay in Michael R. Booth, John Stokes, and Susan Bassnett, *Three Tragic Actresses: Siddons, Rachel, Ristori* (Cambridge: Cambridge University Press, 1996).

11. For arguments about this, see Aston, *Feminism and the Theatre*; and Michael S. Wilson, "Ut Pictura Tragoedia: An Extrinsic Approach to British Neoclassic and Romantic Theatre," *Theatre Research International* 12, no. 3 (1987): 201–20.

12. See, for example, Boaden, *Memoirs of Mrs. Siddons*, 1: 309, 316 and 2: 54. For the idea that Siddons played primarily women suffering at the hands of men, see also Booth, Stokes, and Bassnett, *Three Tragic Actresses*, 28–29; and Manvell, *Siddons*, 123.

13. Leigh Hunt, *Critical Essays* (London: John Hunt, 1807), 19. See also Mrs. Thrale's assessment in Katharine C. Balderston, ed., *Thraliana: The Diary of Mrs. Hester Lynch Thrale (Later Mrs. Piozzi), 1776–1809*, 2 vols. (Oxford: Clarendon Press, 1942), 2: 726 (entry of 26 December 1788); and Yvonne Ffrench, *Mrs. Siddons: Tragic Actress*, 2d ed. (London: Derek Verschoyle, 1954), 137.

14. Charles H. Shattuck, ed., *John Philip Kemble Promptbooks*, 11 vols. (Charlottesville: University of Virginia Press, 1974), especially volumes 10 and 11.

15. Boaden, *Memoirs of Siddons*, 2: 324–25.

16. Thomas Campbell, *The Life of Mrs. Siddons*, 2 vols. (London: Effingham Wilson, 1834), 2: 35–36.

17. The identification has been questioned on the grounds that Siddons first played the role in 1798 and the painting is presumed to date from 1797. The latter date, however, is purely speculative (William T. Whitley, *Artists and Their Friends in England, 1700–1799*, 2 vols. [London: Medici Society, 1928], 2: 214).

18. For the full text, see Campbell, *Siddons*, 1: 90–91.

19. Boaden, *Memoirs of Siddons*, 1: 292.

20. Anonymous, *The Beauties of Mrs. Siddons* (London: John Strahan, 1786), 60.

21. See her comments in William van Lennep, ed., *The Reminiscences of Sarah Kemble Siddons, 1773–1785* (Cambridge, Mass.: Widener Library, 1942), 1.

22. Siddons was reproached for her callous lack of concern for children by her enemy Mrs. Galindo (Catherine Gough Galindo, *Letter to Mrs. Siddons* [London: privately printed, 1809], 31). Siddons, however, showed a continual anxiety about the health of her daughters and her own inability to spend time with them because of her busy working life. See Oswald G. Knapp, ed., *An Artist's Love Story* (London: George Allen, 1905), 50; and Siddons's letter to Hester Piozzi of 5 January 1794 in which she refers to the "tender reproaches" of her children when she returned from a trip to Dublin (Kalman A. Burnim, "The Letters of Sarah and William Siddons to Hester Lynch Piozzi in the John Rylands Library," *Bulletin of the John Rylands Library* 52 [1969–70]: 55).

23. Entry of 4 April 1788 in Balderston, ed., *Thraliana*, 2: 713.

24. For David Garrick's letters to Henry Bate and William Siddons, see David M. Little and George Kahrl, eds., *The Letters of David Garrick*, 3 vols. (London: Oxford University Press, 1963), 2: 1038, 1047. For Bate's replies, see Manvell, *Siddons*, 22–27.

25. Entry of 3 April 1794 in Balderston, ed., *Thraliana*, 2: 876–77.

26. Siddons to Hester Piozzi, 27 August 1794, in Burnim, "Letters of Siddons," 62.

27. Siddons to an unnamed friend, July 1794, in Campbell, *Siddons*, 2: 187–88.

28. See van Lennep, ed., *Reminiscences of Siddons*, 8, 16–17; and Tate Wilkinson, *The Wandering Patentee; or, a History of the Yorkshire Theatres, from 1770 to the Present Time*, 4 vols. (York: Wilson, Spence, and Mawman, 1795), 2: 8.

29. Boaden, *Memoirs of Siddons*, 1: 32; P. P. Howe, ed., *The Complete Works of William Hazlitt*, 21 vols. (London: Dent, 1930–34), 18: 407; William Hazlitt, *The Round Table: Characters of Shakespear's Plays* (1817) (London: Dent, 1969), 188; and Balderston, ed., *Thraliana*, 2: 715.

30. Campbell, *Siddons*, 2: 10–34. For Siddons's commentary on the character of Constance in Shakespeare's *King John*, see also ibid., 1: 214–26.

31. Boaden, *Memoirs of Siddons*, 2: 133.

32. Fuseli's study of Siddons as Lady Constance was sold at Sotheby's on 3 April 1996, lot 20. On Siddons's androgynous dress as Rosalind, see Boaden, *Memoirs of Siddons*, 2: 166. Early in her career, Siddons was well known for her portrayal of Hamlet on the provincial circuit, and she performed male Shakespearean characters again in public readings after her retirement. Indeed, one of Garrick's main concerns on employing her initially at Drury Lane was her skill in breeches roles (see Henry Bate to David Garrick, 12 August 1775, Add. Mss. 25, 383, British Library, London, quoted in Manvell, *Siddons*, 23–24). During the height of her career, however, she tended to avoid the more popular breeches parts—many of which were associated with comic actresses like Dorothy Jordan.

33. See, for example, Anon., *Beauties of Siddons*, 12–13; Boaden, *Memoirs of Siddons*, 1: 315; and Campbell, *Siddons*, 1: 208. On the way she marked passages in plays with underlines for emphasis, see Ffrench, *Siddons*, 66–67.

34. See Anthony Fletcher, *Gender, Sex, and Subordination in England, 1500–1800* (New Haven: Yale University Press, 1995).

35. Boaden, *Memoirs of Siddons*, 2: 116, 290.

36. Campbell, *Siddons*, 2: 392; Benjamin Robert Haydon, *Diary*, 5 vols., ed. Willard Bissell Pope (Cambridge, Mass.: Harvard University Press, 1960), 2: 520 (entry of 9 June 1831); and James Boaden, *Memoirs of Mrs. Inchbald*, 2 vols. (London: Richard Bentley, 1833), 1: 71.

37. See Sylvia Harcstarck Myers, *The Bluestocking Circle: Women, Friendship, and the Life of the Mind in Eighteenth–Century England* (Oxford: Clarendon Press, 1990). Interestingly, Myers does not mention Siddons in her study.

38. For women's education, see Alice Browne, *The Eighteenth–Century Feminist Mind* (Brighton: Harvester, 1987); and Vivien Jones, ed., *Women in the Eighteenth Century: Constructions of Femininity* (London: Routledge, 1990).

39. For the coexistence of Enlightenment classicism and irrationality in an aesthetic context, see Alex Potts, *Flesh and the Ideal: Winckelmann and the Origins of Art History* (New Haven: Yale University Press, 1994).

40. See Janet Todd, *Sensibility: An Introduction* (London: Methuen, 1986), 4. See also G. J. Barker-Benfield, *The Culture of Sensibility: Sex and Society in Eighteenth–Century Britain* (Chicago: University of Chicago Press, 1992); and Earl R. Wasserman, "The Sympathetic Imagination in Eighteenth–Century Theories of Acting," *Journal of English and Germanic Philology* 46 (1947): 264–72.

41. See Joseph R. Roach, *The Player's Passion: Studies in the Science of Acting* (London: Associated University Presses, 1985).

42. Anon., *Beauties of Siddons*, 4.

43. Ibid., 9–10.

44. Ibid., 17, 13.

45. Siddons to Penelope Pennington, August 1798, in Knapp, *Artist's Love Story*, 59. See also Maria Siddons to Sally Bird, 6 May 1798: "My Mother crys so much at it [the play, *The Stranger*] that she is always ill" (ibid., 43–44).

46. Siddons to Penelope Pennington, 21 October 1798, ibid., 158.

47. For examples, see Linda Kelly, *The Kemble Era: John Philip Kemble, Sarah Siddons, and the London Stage* (London: Bodley Head, 1980), 42; Knapp, *Artist's Love Story*, 33 (Maria Siddons to Sally Bird, 8 April 1798); Campbell, *Siddons*, 1: 18n; Boaden, *Memoirs of Siddons*, 1: 327; and van Lennep, ed., *Reminiscences of Siddons*, 3.

48. [William Russell], *The Tragic Muse: A Poem Addressed to Mrs. Siddons* (London: G. Kearsley, 1783), 15.

49. See, for example, Anon., *Beauties of Siddons*, 25: "We feel her emotion and involuntarily shudder with her." For her effect on men, see, for instance, the letter from Maria Siddons to Sally Bird, 8 April 1798, referring to Siddons's performance of Mrs. Haller in *The Stranger*: "even men *sob* aloud" (Knapp, *Artist's Love Story*, 33).

50. Anna Seward to the Rev. Dr. Whalley, 10 April 1783, in Hesketh Pearson, ed., *The Swan of Lichfield: A Selection*

from the Correspondence of Anna Seward (London: Hamish Hamilton, 1936), 68–69.

51. For details of the importance of women as consumers in the theater, see Brewer, *Pleasures of the Imagination*; Shearer West, "Women and the Arts in the Eighteenth Century," in *La ville et la transmission des valeurs culturelles au bas moyen âge et aux temps modernes* (Brussels: Crédit communal, 1996), 193–205; Leo Hughes, *The Drama's Patrons: A Study of the Eighteenth-Century London Audience* (Austin: University of Texas Press, 1971). For a contemporary example, see *An Address to the Ladies on the Indecency of Appearing at Immodest Plays* (London: R. Griffiths, 1756).

52. Seward to Whalley, 10 April 1783 and 6 August 1795, in Pearson, *Swan of Lichfield*, 68–69, 168–69.

53. Anon., *Beauties of Siddons*, 22.

54. Entry of 15 August 1832 in Monica Gough, ed., *Fanny Kemble: Journal of a Young Actress* (New York: Columbia University Press, 1990), 4. Such feelings of desire and longing on the part of female admirers do not necessarily mean that Siddons was the subject of lesbian admiration. Women's friendships were, however, in a process of evolution during the 1790s. For instance, Siddons was friendly with the reportedly lesbian sculptor Mrs. Damer, and Siddons's sister was once pursued by another woman. See entry of 9 December 1795 in Balderston, ed., *Thraliana*, 2: 949.

55. See Leigh Woods, *Garrick Claims the Stage: Acting as Social Emblem in Eighteenth-Century England* (Westport, Conn.: Greenwood Press, 1984). For the debate about stage morality, see Shearer West, "The Justification of Leisure and Representations of the Eighteenth-Century English Stage," in Tom Winnifrith and Cyril Barrett, eds., *Leisure in Art and Literature* (London: Macmillan, 1992), 81–98.

56. Boaden, *Memoirs of Siddons*, 1: 300–301.

57. See Hazlitt, *Round Table*, 153.

58. For reactions to this and subsequent changes in the size and design of the theaters, see Manvell, Siddons, 84–85. For a criticism of large theaters by a contemporary, see Dramaticus, *An Impartial View of the Stage* (London: C. Chapple, 1816).

59. An example of this is a series of essays by Alan Hughes, "Art and Eighteenth-Century Acting Style. Part I: Aesthetics," "Part II: Attitudes," "Part III: Passions," *Theatre Notebook* 41 (1987): 24–31, 79–88, 128–38.

60. For a history of representations of Siddons and the aesthetic implications of these, see Robyn Asleson in this volume. For some background, see Ines Aliverti, *Il ritratto d'attore nel settecento francese e inglese* (Pisa: ETS Editrice, 1986); and Shearer West, *The Image of the Actor: Verbal and Visual Representation in the Age of Garrick and Kemble* (London: Pinter Publishers, 1991). Heather McPherson is preparing a monograph on representations of Siddons. I am grateful to her for giving me the opportunity to read her essay on Reynolds's *Mrs. Siddons as the Tragic Muse*. More general problems of interpreting performance in the light of aesthetic issues have been raised by a series of engaging essays in a special issue of *Theatre Research International* 22 (1997) devoted to theatrical iconography.

61. Joshua Reynolds, *Discourses on Art* (1797), ed. Robert R. Wark (New Haven: Yale University Press, 1975), 238–40. For a fascinating discussion of the aesthetics of the general and the particular, see Elizabeth A. Bohls, "Disinterestedness and Denial of the Particular: Locke, Adam Smith, and the Subject of Aesthetics," in Paul Mattick Jr., *Eighteenth-Century Aesthetics and the Reconstruction of Art* (Cambridge: Cambridge University Press, 1993), 16–51.

62. For her costume, see Boaden, *Memoirs of Siddons*, 2: 146; for her facial expression, see ibid., 1: 317. For her sculptural hairstyle and dress, see Booth, Stokes, and Bassnett, *Three Tragic Actresses*, 37; and Boaden, *Memoirs of Siddons*, 2: 290–91, who relates her interest in sculpture to her change in dress style from recent fashions to generalized garments.

63. See Boaden, *Kemble*, 2: 289 and 1: 170–71, where he mentions Reynolds's seventh discourse referring to "academic and vulgar styles of acting"; and *An Authentic Narrative of Mr. Kemble's Retirement from the Stage* (London: John Miller, 1817), xxvi, argues for "the best part of nature only." See also Shearer West, "Thomas Lawrence's 'Half-History' Portraits and the Politics of Theatre," *Art History* 14 (June 1991): 225–49. Although Boaden applied his theory more directly to Kemble, he wrote of Kemble and Siddons as part of the same "school" of acting.

64. For the idea that the actor, like the painter, needs to study real life, see, for instance, Campbell, *Siddons*, 1: 18n; and Boaden, *Memoirs of Siddons*, 2: 179–80. Criticisms of her artificiality were leveled by her rivals and enemies. See, for instance, *Funereal Stanzas Inscribed to the Revered Memory of Mrs. Anne Crawford* (Dublin: R. Milliken, 1803).

65. Edward Mangin, ed., *Piozziana; or, Recollections of the Late Mrs. Piozzi* (London: E. Moxon, 1833), 85–86. For Siddons's sense of humor, see Campbell, *Siddons*, 2: 107; and Manvell, *Siddons*, 133. For criticisms of her comic acting, see Boaden, *Memoirs of Siddons*, 2: 168; and entry of 29 July 1789 in Fanny Burney, *Diary and Letters of Madame d'Arblay, 1778–1840*, 6 vols. (London: Macmillan and Co., Ltd.), 4: 303.

66. Compare, for example, the remarks about Siddons's tragic acting made in Anon., *Beauties of Siddons* to those on Mrs. Jordan's comic acting in *An Essay on the Pre-eminence of Comic Genius with Observations on the Several Characters Mrs. Jordan Has Appeared In* (London: T. Becket, 1786).

67. See Alison Yarrington, *The Commemoration of the Hero, 1800–1864: Monuments to British Victors of the Napoleonic Wars* (New York: Garland, 1988).

68. For the Shakespeare Gallery, see especially Walter Pape and Frederick Burwick, eds., *The Boydell Shakespeare Gallery* (Essen: Verlag Peter Pomp, 1996); and Winifred Friedman, *Boydell's Shakespeare Gallery* (New York: Garland, 1976).

69. Howe, ed., *Hazlitt*, 18: 407; Ffrench, *Siddons*, 147; Campbell, *Siddons*, 2: 268; and Boaden, *Memoirs of Siddons*, 1: 298. See also James Boaden, *Memoirs of the Life of John Philip Kemble*, 2 vols. (London: Longman, 1825), 1: 131; and Hunt, *Critical Essays*, 21: "If an artist would study the expression of the passions, let him

lay by the pictures of LE BRUN, and copy the looks of
MRS Siddons."

70. See his penciled comments in "Annotated Copy
of Mrs. Inchbald's British Theatre (annotated by
Kemble)," ca. 1806, W.a.70–72, Folger Shakespeare
Library, Washington, D.C.

71. Edmund Burke, *Reflections on the Revolution in France*
(1790), ed. Conor Cruise O'Brien (Harmonds-
worth: Penguin, 1968), 175–76.

72. See, for example, Campbell, *Siddons*, 1: 209–10; and
Hunt, *Critical Essays*, 18–20, 21.

73. See *The Green-Room Mirror* (London, 1786), especially
25–26.

74. See Shattuck, ed., *Kemble Promptbooks*, with its many
examples of Kemble's attention to disposition of
groups. For picturesque aspects of Siddons's acting,
see also the illustrations and discussion in Henry
Siddons, *Practical Illustrations of Rhetorical Gesture and Action*
(London: Richard Phillips, 1807).

75. For the anecdote about her decision to begin sculpt-
ing, see Campbell, *Siddons*, 2: 166–67. For techni-
cal problems she encountered, see Sally Siddons to
Hester Piozzi, 10 October 1793, in Burnim, "Letters
of Siddons to Piozzi," 54. For Siddons's relationship
with Anna Seymour Damer, see Campbell, *Siddons*,
2: 301; and entry of 27 May 1795 in Balderston, ed.,
Thraliana, 2: 929. Siddons mostly sculpted her own
family, and little of her work survives.

76. Entry of 31 March 1820 in Haydon, *Diaries*, 2: 265.

77. Campbell, *Siddons*, 2: 357.

78. See Booth, Stokes, and Bassnett, *Three Tragic Actresses*,
37; and Ffrench, *Siddons*, 106–7.

79. See, for example, Campbell, *Siddons*, 1: 140.

80. Ibid., 1: 4.

81. See the excellent essay by Kimberley Crouch, "The
Public Life of Actresses: Prostitutes or Ladies?" in
Barker and Chalus, *Gender in Eighteenth-Century England*,
58–78; see also Richards, *Rise of the Actress*, 60, 84.

82. See, for example, Boaden, *Memoirs of Siddons*, 1: 312;
and Campbell, *Siddons*, 2: 59.

83. "At times, in private company, she gave one the
notion of a wicked, unhappy Queen, rather than
of a purely well-bred gentlewoman" (Mangin, ed.,
Piozziana, 85–86). On Siddons's "High Breeding,"
see also entry of 17 May 1790 in Balderston, ed.,
Thraliana, 2: 769; for Haydon's snide remarks about
her affectation, see entry of 11 June 1816 in Haydon,
Diaries. For Hazlitt's more reverential assessment, see
Howe, ed., *Hazlitt*, 18: 273–74, 408.

84. Van Lennep, ed., *Reminiscences of Siddons*, 22.

85. See Crouch, "Public Life of Actresses"; Gill Perry,
"Women in Disguise: Likeness, the Grand Style,
and the Conventions of 'Feminine' Portraiture in
the Work of Joshua Reynolds," in Gill Perry and
Michael Rossington, eds., *Femininity and Masculinity in
Eighteenth-Century Art and Culture* (Manchester: Manches-
ter University Press, 1994), 18–40.

86. Letter of 13 March 1785 in Percy Fitzgerald, *The
Kembles*, 2 vols. (London: Tinsley, 1871), 1: 215–16.

87. See Boaden, *Memoirs of Mrs. Siddons*, 2: 336; Knapp,
Artist's Love Story, 175–76 (quoting a letter from Sid-
dons to Mrs. Pennington of 4 December 1798 in
which she refers to William Siddons's "coldness and
reserve"). Mrs. Thrale thought her family did not
appreciate her and was appalled to discover that Sid-
dons gave his wife a venereal disease (Balderston, ed.,
Thraliana, 2: 808, 850). Campbell (*Siddons*, 2: 311–12)
denies that the Siddons couple were ever estranged,
and William Siddons's family letters reveal that the
couple visited each other frequently during the period
of estrangement. I am grateful to Dr. Robyn Aseson
for this information.

88. For a full and clear explanation of the cause and
effect of the scandal, which resulted from Siddons's
overcommitment and a series of unfortunate mis-
understandings, see Campbell, *Siddons*, 1: 276; and
Manvell, *Siddons*, 107–9.

89. For the importance of provincial theaters, see, for
instance, Wilkinson, *Wandering Patentee*; and Kathleen
Barker, *The Theatre Royal, Bristol: The First Seventy Years*
(Bristol: Bristol Historical Association, 1969).

90. *Middlesex Journal* (30 December 1775), 3.

91. Innovative work on the provincial middle class that
stresses these aspects has been carried out by Leonore
Davidoff and Catherine Hall, *Family Fortunes: Men and
Women of the English Middle Class, 1780–1850* (London:
Routledge, 1992); Peter Borsay, *The English Urban Re-
naissance: Culture and Society in the Provincial Town* (Oxford:
Clarendon Press, 1989); and Jonathan Barry and
Christopher Brooks, eds., *The Middling Sort of People:
Culture, Society, and Politics in England, 1550–1800* (Basing-
stoke: Macmillan, 1994).

92. *Green Room Mirror*, 61.

93. See Todd, *Sensibility*, 12–13.

94. Hughes, *Drama's Patrons*, 154–55.

95. For the interplay between politics and theater in the
"Old Price" riots, see Marc Baer, *Theatre and Disorder in
Late Georgian London* (Oxford: Clarendon Press, 1992);
and West, "Lawrence's 'Half-History' Portraits."

96. See Boaden, *Memoirs of Mrs. Siddons*, 1: 277–78, who
refers to Siddons dressed up as Britannia in cele-
bration of George III's recovery from illness in
1789; and Brewer, *Pleasures of the Imagination*, 346–47,
who mentions Siddons as a "popular ideal of English
womanhood." For the nationalist context of this, see
Linda Colley, *Britons: Forging the Nation, 1707–1837* (New
Haven: Yale University Press, 1992).

97. Entry of 3 April 1820 in Haydon, *Diaries*, 2: 268; and
Hazlitt, *Roundtable*, 189–90.

"She was Tragedy Personified": Crafting the Siddons Legend in Art and Life

ROBYN ASLESON

"THE TOWN HAS GOT A NEW *IDOL*—M^{RS}. SIDDONS THE Actress: a *leaden* one She seems, but we shall make her a *Golden* one before 'tis long."[1] So wrote the acerbic bluestocking Hester Thrale, on the first of December 1782, six weeks after Sarah Siddons's triumphant return to the London stage. Within months Thrale's alchemical prediction had come to pass, and the once leaden starlet found herself transformed into the golden Muse of Tragedy. Artists played a crucial role in this gilding process. Their reiterated exaltation of Siddons's tragic genius accelerated her rapid eclipse of all rivals. Later, as Siddons struggled to sustain her preeminence in a fiercely competitive profession, artists reinforced her sensational turns on the stage with impressive renderings in paintings and prints. Continual collaboration with artists over the course of a long career enabled Siddons to harness the power of art more effectively than any actress of her time.

The eighteenth century was a period of voracious people-watching, and Londoners habitually amused themselves by besieging the private homes of contemporary "stars" and scanning the crowds for them at public venues.[2] "To have seen Mrs. Siddons was an event in everyone's life,"[3] the essayist William Hazlitt wrote following her retirement, and during the actress's heyday it was an event that many

Opposite: Attributed to George Romney. *Sidonian* [*sic*] *Recollections* (detail), ca. 1785–90. (See fig. 3, p. 45.)

Figure 1.

were keen to experience. Letters of the period reveal a particular interest in comparing Siddons's appearance on the stage with that in normal life. In her reminiscences, she attested to her indignation at finding her private home transformed into a public theater by those who felt they had as much a right to see her off the stage as on: "My door was soon beset by various persons quite unknown to me, whose curiosity was on the alert to see the new Actress, some [of] whom actually forced thier [sic] way into my Drawing-room in spite of remonstrance or opposition." One such intruder used ill health as an excuse for violating the actress's privacy, stating, "My Physician won't let me go to the Theatre to see you, so I am come to look at you here."[4] Such intrusions persisted for much of Siddons's life, but in later years she appears to have accepted their inevitability. When a child was brought to her home solely in order to be able to boast of having once seen the actress, Siddons reportedly "took the child's hand, and, in a slow and solemn tone, said: 'Ah, my dear, you may well look at me, for you will never see my like again.'"[5]

Siddons's appearance was indeed remarkable, and the fascination she exerted in performance owed much to her exceptional beauty.[6] Contemporary descriptions often emphasize her deviation from the standard feminine ideal, "her height was above the middle size," and "neither nose nor chin according to the Greek standard, beyond which both advance a good deal."[7] These peculiar features played effectively from the stage and charged her portraits with dramatic power. Commentators invariably remarked on the piercing brilliance of Siddons's deep brown eyes, and artists faithfully endeavored to record their every nuance. In a painting of ca. 1785–90, John Opie captured the dazzling sparkle that seemed "to burn with a fire beyond the human" (fig. 1),[8] while Thomas Lawrence, in his depiction of Sarah Siddons as Zara (1783), suggests the sudden blaze of her eye to an unendurable intensity that "made the person on whom it was levelled, almost blink and drop their own eyes" (fig. 2). At other times, Siddons's gaze was reportedly "so full of information, that the passion is told from her look before she speaks."[9] The expressiveness of her eyes gained emphasis from the famed mobility of the actress's forehead and dark eyebrows, raised plaintively one moment and furrowed furiously the next. Siddons's powers of wordless communication were of obvious value to painters. An oil sketch attributed to George Romney and inscribed *Sidonian* [sic] *Recollections* (fig. 3) documents a range of emotion—pain, fear, and horror—conveyed by facial expression alone, and hints at the startling appearance of Siddons's eyes when "she seemed in a manner to turn them in her head—the effect was exquisite, but almost painful."[10]

Figure 1.
JOHN OPIE
(British, 1761–1807).
Sarah Siddons, ca. 1785–90.
Oil on canvas, 38.1 × 29.2 cm
(15 × 11½ in.).
Courtesy of Alan Arnott,
Scotland.

Figure 2.

Siddons's idiosyncratic facial features—the fiery eyes, mobile brows, prominent nose, and deeply undercut, dimpled chin—surpassed the imitative abilities of many of her portraitists. The famed elusiveness of her likeness lends credence to the report that even Gainsborough struggled with her intractible features, "and at last threw down the pencil, saying 'Damn the nose—there's no end to it.'"[11] Reviewing another painting of the period, one critic remarked, "Poor Lady, what a series of caricatures hast thou furnished the world with!" Seven years later, another lamented: "It seems a circumstance of peculiar remark, that our Painters should have uniformly, failed in their attempts after the Likeness of our great Tragic Actress. If ever there was a countenance expressly calculated for the strong effects of Picture, Mrs. SIDDONS possesses that countenance; and yet more barbarous travestied abominations never were seen."[12] Siddons herself often expressed dissatisfaction with the "horrid daubs" produced by many of her portraitists, complaining to her son George that she had "not any taste for publishing libels against my own person."[13] To a great extent, her face was her fortune, and professional necessity as much as personal vanity underlies the actress's concern with her appearance. She kept up a constant inventory of her looks, which altered drastically with the chronic waxing and waning of her health.

Striking appearance and tremendous fame made Siddons the object of curiosity wherever she went. She complained of feeling exposed and vulnerable on the stage, and it is no wonder that in private life she shunned the parties, concerts, and dinners to which she was constantly invited and where she would have been equally the target of all eyes. She often referred to her celebrity as a painful ordeal and remarked late in life, "It has pleased God to place me in a situation of great publicity but my natural disposition inclines me to privacy and retirement."[14] Nevertheless, Siddons was adept at orchestrating her own public image. She skillfully withheld and divulged

Figure 3.

information, believing that "Theatric politics" entailed "the necessity of being a little mysterious sometimes."[15] Keen to protect the seclusion of her hours off the stage, she carefully selected the occasions on which she would appear, when her presence would carry maximum visual impact. In 1790 she wrote asking to see her friend, Bridget Wynn, "some Evening when you are quite alone for I must be in Cog[nito] for fear of too many engagements."[16] But a year earlier Siddons had begged the same friend for invitations to "two great Balls," confessing herself eager to attend "As every body will be there and as it is necessary to be sometimes visible."[17]

PORTRAITURE AS PUBLICITY

Art provided Siddons with an alternative means of being "visible," one over which she could exercise a degree of control. During the early years of her career, she devoted herself as assiduously to posing for pictures as she did to performing, later recalling:

> *I was, as I have confess'd, an ambitious candidate for fame, and my professional avocations alone, independently of domestic arrangements, were of course incompatible with habitual observances of Parties and Concerts, & c. I therefore often declined the honour of such invitations. As much of my time as could now be "stoln from imperious affairs," was employ'd in sitting for various Pictures.*[18]

Recognizing that it was to her benefit to cooperate with those in a position to fashion her public image, Siddons went to extraordinary lengths to accommodate the artists who applied to her. Her letters reveal considerable determination to make time for their appointments, no matter how inconvenient. "I fear you will depart without my seeing you," she wrote to a good friend in 1786, "for I am unfortunately engaged the whole day tomorrow, the morning is to be spent at Hamilton's the Painters." A few years later, when her own travels threatened to remove her from town for several months, she urged Thomas Lawrence to come "finish the drawing as soon as possible," adding her hope that "he will not run away so soon as before."[19]

The benefits of such artistic collaboration were by no means Siddons's alone. Lacking commercial galleries as we know them today, artists relied heavily on the exposure provided by the exhibitions of contemporary art held annually at the Royal Academy and the Society of Artists, where a famous subject could enable even an obscure artist's work to stand out from the throng and dramatically improve opportunities for selling.[20] Highlights of the social calendar, the exhibitions drew multitudes of art lovers and people-watchers to inspect galleries crowded with well-known faces. Portraits of celebrities also lured

potential patrons to artists' private studios. During the competitive middle years of Thomas Lawrence's career, he reportedly believed that "it was of importance that his gallery in Greek Street should exhibit the beginning of portraits, to which the eye might be attracted as the mirrors of either rank, beauty or genius."[21]

The aura of glamor surrounding theatrical stars made them the most effective lure of all, and Siddons in particular excited phenomenal interest amid a burgeoning flock of admirers. The diary of Mary Hamilton, a young woman of independent means, records a day devoted almost entirely to "Siddonimania," in which visits to artists' studios functioned in tandem with visits to the theater: "Saw a picture of Mrs. Siddons in the character of Isabella in "The Fatal Marriage," very finely executed, we also went to see Mrs. Siddons' picture by Hamilton . . . My cousin and self went to the Play, saw Mrs. Siddons in the character of 'Calister' [*sic*] in the 'Fair Penitent.'"[22] So great was the interest in Sir Joshua Reynolds's portrait of Siddons that an eager public transformed William Smith's London house into a quasi-public gallery following his acquisition of the painting. Similarly, while Gainsborough's portrait of Siddons hung in a private house in Edinburgh, visitors were constantly at the door, letters of introduction in hand, requesting a glimpse of the picture.[23] The magnetic attraction exercised by these works casts new light on the notorious fact that so many of Siddons's portraits remained in painters' studios without being sold. Perhaps it was not lack of opportunity but lack of desire that prevented their creators from parting with them.

The great mutual advantage to be gained by artist and sitter alike meant that paintings and prints of Siddons swiftly flooded the marketplace. In anticipation of the Royal Academy exhibition of 1783, a critic remarked: "Mrs. Siddons will be so numerously exhibited in her tragic characters, that the very daggers she is to be in the act of drawing, will be sufficient to hang every second picture in the Academy upon, in case the President should think it expedient to convert them into pegs!" The flow of images continued unabated two years later, when another critic observed, "Perhaps she has given greater exertions to the pencils of the artists than any lady in the dramatic world."[24] Prints circulated Siddons's image even more widely, and she took an active interest in their production. Soon after Reynolds began his portrait of her, Siddons set in motion the plans for its engraving, suggesting the currently fashionable stipple process rather than Reynolds's customary mezzotint and urging the employment of an engraver other than his most frequent collaborator, Valentine Green.[25] Siddons took great delight in distributing prints to friends and admirers, treating them very much in the manner of Hollywood's proverbial 8 × 10 glossy.[26]

Melancholy and Mentality
in Siddons's Public Image

L ike all in her profession, Siddons suffered from the instability of
public opinion and the vicious rumor-mongering of those jealous
of her fame. Indeed, her first venture on the London stage during the
winter of 1775–76 had swiftly tumbled her from adulation to ridicule
and sent her scrambling to the provinces to rebuild her career. The
experience was the first of many that would leave Siddons deeply dis-
trustful of the revolving wheel of fame. Appropriately enough, the
spa town of Bath was the site of her recuperation and reinvention. In
the eighteenth century, Bath functioned as London's social and cul-
tural satellite, its population inflated periodically by a fashionable elite
drawn by the promise of improved health and amusement. From
the granting of its royal patent in 1768, Bath's theater in Orchard
Street ranked just below London's Covent Garden and Drury Lane as
England's most prestigious playhouse. As a result, the city became the
final training ground for many ambitious players who aspired to Lon-
don careers. Bath filled a similar role for painters eager to parlay
provincial success into metropolitan triumph. Within the fishbowl of
Bath, many achieved the recognition and patronage that might have
eluded them in the more competitive London market.

Early in her career, Siddons reported, she suffered "the mor-
tification of being obliged to Personate many subordinate characters
in comedy." [27] Intent on transforming herself from a failed comic
actress into a successful tragedienne, Siddons accepted the assistance
of several Bath painters whose professional ambitions melded amicably
with her own. Foremost among them was Thomas Beach, a convivial
and prolific portraitist who began his career in London as a student
of the future Royal Academy president, Sir Joshua Reynolds, before
going on to gain public notice for his paintings of Bath's literary, the-
atrical, and musical personalities. Rather than portray the up-and-
coming actress as the public knew her—on stage performing a dramatic
role—Beach's earliest portrait of Siddons drew on his personal knowl-
edge of her private character. During the winter of 1781–82 he
painted her in meditative mood, seated in a leather chair with an open
book resting in her hands (fig. 4). The painting attests to the prevail-
ing expectation that a good likeness should not only capture a person's
physical appearance but also convey something of his or her mind.
Descriptions of Beach's painting interpreted Siddons not as posing for
the painter but as "ruminating on the subject she has just read." [28] A
similar portrait of Siddons by Gilbert Stuart (see fig. 23, p. 30) later
moved one critic to remark approvingly, "Stuart dives deep into mind,
and brings up with him a conspicuous draught of character and char-
acteristic thought—all as sensible to feeling and to sight as the most
palpable projections in any feature of a face." [29]

Figure 4.

The theme of reading that Beach and Stuart adopted for their portraits of Siddons was a conventional one, widely employed to flatter the intellectual pretensions and cerebral sensibilities of cultivated ladies. By projecting this stereotype onto Siddons, the painters made bold claims for the mental (and social) refinement of a mere stage performer—and an actress at that. Siddons's reputation for superior intellectual understanding was in fact crucial in distinguishing her from other performers and exempting her from the social stigmas that applied to them. Contemporary reports attest to her habitual interaction with some of the greatest thinkers of her day, and by her own admission, she craved "intelligent society to circulate my mind." Indeed, Siddons's advanced intellect—anomalous in a woman of her class—proved problematic during the secluded years of her retirement, for as she observed, "the elevation of mind which my profession naturally induces, induces also the necessity of a higher tone of conversation, and a greater variety of intellectual resource, than can be

Figure 4.
THOMAS BEACH
(British, 1738–1806).
Sarah Siddons, 1782. Oil
on canvas, 76.2 × 66 cm
(30 × 26 in.). Auckland,
New Zealand, Auckland
Art Gallery Toi o Tomaki.

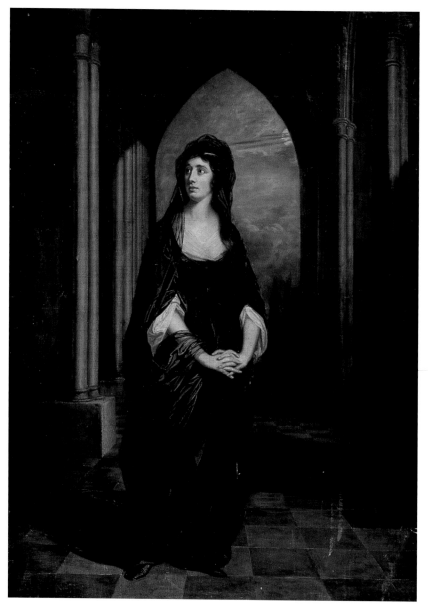

Figure 5.

expected."[30] Throughout her career, the actress sought to compensate for her deficient childhood education through minute preparatory study of the plays in which she performed.[31] Skeptics who questioned her actual comprehension of these works were misled by the apparent "naturalness" of her painstakingly crafted performances.

Beach reinforced Siddons's cerebral image with a second, more fanciful painting executed in 1782 (fig. 5). In the view of the critics, the actress's "intelligent soul seems transfused into this imitation of it," for the picture had "all the grandeur of the imagined character about it," as well as "all that grandeur, elegance, and simplicity that we admire in Mrs. Siddons."[32] Appearing in neither her own private capacity nor one of the stage roles for which she was famous, Siddons

here personifies the goddess Melancholy from John Milton's poem "Il Penseroso" (1632). Extremely popular in the late eighteenth century, Milton's celebration of the pleasures of gloom anticipated ideas fashionable in Siddons's day, when somber contemplation and emotional sensitivity were esteemed as marks of refinement. As the previous essay has shown, Siddons's phenomenal rise to fame owed much to her ability to induce these states of mind and feeling. Beach sought to ensure that his painting elicited similar sentiments by deliberately conjuring the atmosphere of a Siddons performance, placing "Melancholy" on a kind of stage, with the exaggerated perspectival recession of his architecture suggesting the illusionistic side wings and landscape backdrop of a theater set.

Beach was not the first artist to associate an actress with the theme of "Il Penseroso." In 1770 George Romney gained great acclaim for a painting of that title (fig. 6), which many considered a veiled portrait of the actress Mary Ann Yates, the great "Tragic Muse" of the pre-Siddonian era. Beach's painting was thus doubly ambitious,

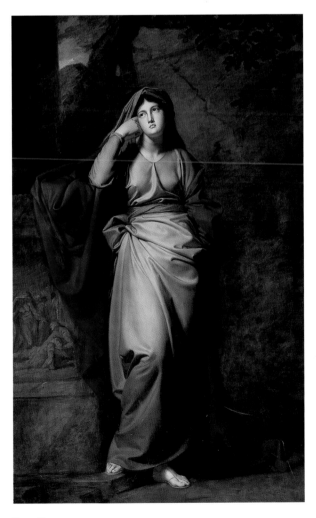

Figure 6.

Figure 5.
THOMAS BEACH.
Sarah Siddons as Melancholy—
"Il Penseroso," 1782. Oil on canvas, 123.2 × 88.3 cm (48½ × 34¾ in.). Sold at Sotheby's (London), 11 October 1993. Photograph courtesy of the Davidson Family Trust.

Figure 6.
GEORGE ROMNEY.
Melancholy—"Il Penseroso,"
1770. Oil on canvas, 236.2 × 143.5 cm (93 × 56½ in.). Sold at Christie's (London), 15 April 1988. Courtesy Christie's Images.

reinterpreting a theme associated with one of his most important competitors and casting Siddons herself in a role claimed by her most celebrated theatrical rival. The painting also marks Beach's aspiration to the mode of Grand Manner portraiture associated with his former mentor, Reynolds. In theory and practice, Reynolds had advanced the view that the merely imitative art of "face painting" attained lasting value when wedded to the universal ideas and imaginative compositions that characterized history painting.[33] Like the dramatic genre of tragedy, the artistic genre of history painting was intended to instruct and improve its audience. The theme of Melancholy supplied Beach with this elevated subject matter, but his point-by-point approach to illustrating Milton's poem betrays the habitual specificity decried by Reynolds in portraitists.[34]

Nevertheless, it was an exceptionally ambitious painting for Beach, and its heightened pretensions no doubt reflect the portentous moment at which artist and sitter collaborated. Beach was commencing his swift rise to the presidency of the Society of Artists, while Siddons was on the eve of her fateful return to Drury Lane Theatre. The latter event occurred on October 10, 1782, and the following day the first mezzotints after Beach's portrait were published, providing an impeccably timed advertisement of the artistic abilities and intellectual mettle of the two rising stars. The following spring, Beach stole a march on his London colleagues by exhibiting the oil painting of Siddons as Melancholy at the Society of Artists, where it cast honor on artist and sitter alike, providing "as strong a Testimony of the Painter's Excellence as of the Lady's wonderful Expression."[35]

ISABELLA AND THE CULT OF SENSIBILITY

Siddons reintroduced herself to London audiences in the role of Isabella in Thomas Southerne's play of the same name. Her sensational impersonation of this devoted mother and faithful widow who remarries only to discover that her husband is still alive, gained impact from the shrewd decision to cast Siddons's own eight-year-old son, Henry, in the role of Isabella's child, thus encouraging audiences to confuse the sentiments that the actress feigned on the stage with her actual feelings as a mother. The experiment was a resounding success. It was reported that "there was scarce a dry eye in the whole house, and that two Ladies in the boxes actually fainted."[36] Beach's incarnation of Siddons in the character of Melancholy in Milton's "Il Penseroso" dovetailed seamlessly with her stage appearance as Isabella and apparently led to some confusion of the two, as evidenced by Thomas Stothard's print, *Sarah Siddons as Isabella—"Il Penseroso"* (see fig. 11, p. 17).

Stothard, like many artists, was an avid theater-goer, and from his place in the audience he turned a keen eye to Siddons's gestures and expressions and to the emotional impact of particular scenes.[37] Supplementing observation in the theater with private sessions with the actress herself, Stothard and his colleagues produced a plethora of drawings, paintings, miniatures, and prints to satisfy the intense craving for images of the new star. Of the numerous representations of Siddons as Isabella that appeared between 1782 and 1785, several focused on a private interview between the mourning mother and son—one of the most emotionally wrenching scenes in the play (fig. 7). Stothard and others fixated on the actress's cradling of the boy's hands in both of her own, a gesture conveying an element of psychological intimacy that is absent from the stiff, rhetorical gestures employed in earlier theatrical prints of the same scene (fig. 8).

William Hamilton completed his own painting of Siddons as Isabella in May of 1783, just as visitors were flocking to the Royal Academy to view the annual exhibition of paintings (fig. 9). Although newspapers reported that he was too late to exhibit "his very excellent Portrait of the justly admired and esteemed Mrs. Siddons," her devotees had already sought it out in Hamilton's studio. By the time the Royal Academy exhibition opened, Hamilton had sold the portrait for £150 to Siddons's early and influential friend Sir Charles Thompson.[38] Rather than part immediately with so valuable an attraction, thereby squandering a good deal of free publicity, Hamilton retained the portrait for some weeks in the hope of luring potential patrons to his studio. He placed advertisements in at least three of the leading newspapers, inviting the public to "inspect" the painting at his house in Soho and also encouraging visitors to subscribe to a mezzotint that John Caldwall was making from the painting. These advertisements met with an overwhelming response. A contemporary biographer later recalled: "Carriages thronged the artist's door; and, if every fine lady who stepped out of them did not actually weep before the painting, they had all of them, at least their white handkerchiefs ready for that demonstration of their sensibility."[39]

Public demonstrations of sensibility were, of course, essential components of the eighteenth-century experience of tragedy, and paintings such as Hamilton's gratified not only the demand for images of the beautiful actress but also the desire to relive the profound emotions experienced while watching her. Repeat visits to witness Siddons enact favorite roles attest to this desire, as does the testimony of Lord Archibald Hamilton, who after seeing Siddons perform in October 1784, wrote to Sir Charles Thompson, the purchaser of Hamilton's double portrait:

Figure 7.

Figure 8.

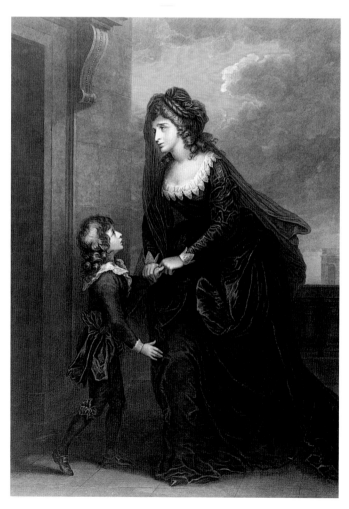

Figure 9.

Figure 7.
William Sharp
(British, 1749–1824)
after THOMAS STOTHARD
(British, 1755–1834).
*Mrs. Siddons and Her Son
in "Isabella," Act 1, scene 1*, 1783.
Engraving, 13.3 × 8.9 cm
(5¼ × 3½ in.).
The Huntington.

Figure 8.
J. Thornthwaite
(British, fl. late eighteenth
century) after JAMES ROBERTS
(British, 1725–1799). *Mrs. Yates
and Master Pullen in the Characters of
Isabella and Child*, 1776. Engraving,
13 × 18.4 cm (5⅛ × 7¼ in.)
By courtesy of the National
Portrait Gallery, London.

Figure 9.
James Caldwall
(British, b. 1739)
after WILLIAM HAMILTON
(British, 1751–1801).
Sarah Siddons as Isabella, 1785.
Engraving, 61.6 × 45.1 cm
(24¼ × 17¾ in.).
The Huntington.

> *Good God! what a blessed Society we should be could we always feel*
> *and be influenced by those generous emotions which she excites, when*
> *she makes every heart ready to burst with social, friendly & exalted*
> *Sentiments. The enthusiasm seemingly soon evaporates, yet I trust*
> *and am persuaded that even these momentary impressions have a*
> *great and good effect even in so corrupt a society as ours.*[40]

Poetic tributes to the actress frequently alluded to her capacity to stir the long-dead emotions of a jaded era. One marveled at her genius for "compelling torpid apathy to feel!" while another defined her purpose as "To teach a trifling Age to think & feel/ . . . To rouze the best Affections of the mind."[41] Contemporary letters testify to the lingering effects of her performances, which continued to play upon the emotions of the audience (as well as of the actress herself) for days thereafter.[42]

Artists like Hamilton sought to convert these tears to gold by providing second- and thirdhand experiences of Siddons-induced emotion through their paintings and prints. The strategy was by no means lost on the critics, one of whom referred to Hamilton in 1784 as the painter "who contrived to get so much vogue last year, with the portrait of Mrs. Siddons."[43] The following June, Hamilton was still milking the promotional value of his portrait of Siddons and her son in *Isabella*. He and Caldwall pulled off an effective publicity stunt by formally presenting the king with a proof print of the mezzotint. The newspaper report, undoubtedly planted by Hamilton, took care to state that the king and his daughters "expressed their approbation both of the original picture, and the print, in terms highly honourable and flattering to the two artists."[44]

Siddons's great success in sentimental roles such as Isabella generated an appetite for more of the same. A year after inciting hysterical enthusiasm in that debut role, she achieved comparable results playing another ill-fated mother of a young son in *The Tragedy of Douglas*, inducing the king and queen along with the rest of the audience to shed "plentiful tears" into their handkerchiefs.[45] Her friend Bertie Greatheed wrote the role of the sorrowful, devoted mother in his play *The Regent* (1787) with Siddons in mind—much to the actress's regret—for she viewed "this milksop lady" as "One of those monsters (I think them) of perfection, who is an angel before her time, and is so entirely resigned to the will of Heaven that (to a very mortal like myself) she appears to be the most provoking piece of still life one has ever had the misfortune to meet."[46] Nevertheless, Siddons's performance in the role only entrenched the demand for her special ability to "strike to the feelings of maternal affection, and produce a sympathy of tenderness not frequently to be felt from stage effect."[47] The actress herself was certainly wearied by the typecasting that condemned her to repeat

a limited number of sentimental roles. Complaining to a friend on November 24, 1795, about having to perform in an "odious" pantomime in which she had "a very bad part and a very fine Dress," Siddons acknowledged, "well, any thing is better than Saying Isabella & c. over and over again till one is so tir[e]d—How I do wish that Somebody wou[l]d write two or three good Tragedies Some wet afternoon!"[48]

EUPHRASIA AND THE HEROICS OF TRAGEDY

Unlike the most celebrated performers of the previous generation, David Garrick and Hannah Pritchard, who had dazzled audiences with the inexhaustible variety of their performances, Siddons was pegged early on as a specialist. Reflecting on Pritchard's great variety, Hester Thrale Piozzi was forced to admit, "Dear Siddons represents only a Lover distress'd, or a Woman of Virtue afflicted. . . . Her Powers are strong & sweet, vigorous & tasteful; but limited & confined."[49] Even within the genre of tragedy, Siddons was narrowly circumscribed. Notwithstanding her ferocious new interpretation of Lady Macbeth, which left audiences quaking with terror and riddled with goose pimples, one critic still stubbornly pronounced that "though she has not any claim to the Bravura, few can surpass her in the pathetic."[50] Siddons never did win audiences over to her comic performances— they complained that she lacked the dramatic flexibility and personal disposition to carry them off—but she did eventually seduce them to the bolder aspects of tragedy. Without ever entirely shaking her association with the tender pathos of sentimental melodramas, she ultimately took on more robust tragic roles, and made them her own.

From the beginning, artists seem to have discerned in Siddons qualities that her critics initially failed to appreciate. They recognized in particular her capacity for the heroic as well as the pathetic aspects of tragedy. The actress undoubtedly encouraged her portraitists to represent her in accordance with this most prestigious tragic mode. Yet while catering to her professional aspirations, they simultaneously advanced their own career interests by depicting the noble themes and heroic actions associated with Grand Manner history painting.

During the spring of 1780, two and a half years prior to Siddons's triumphant return to Drury Lane, London audiences had witnessed a sneak preview of one of her most swashbuckling characterizations, when William Hamilton exhibited a grandiloquent portrait of the actress as Euphrasia in Arthur Murphy's tragedy *The Grecian Daughter* (fig. 10). While playing this brave Greek princess who courageously slew the tyrant who had usurped her father's throne, Siddons reportedly hurled herself from one strong emotion to another, all the while eliciting "sobs and shrieks" from the audience. Indeed, Siddons's

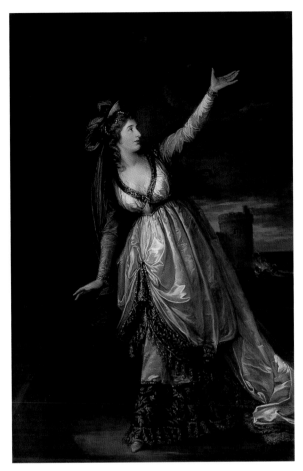

Figure 10.

Figure 11.

performances were evidently a good deal more violent than suggested by her traditional association with classical restraint. Her letters complain of "these dreadful theatrical exertions which enflame my blood and exhaust my strength," "shatter my poor crazy frame," and "[leave me] as sore in every limb as if I had been severely beaten."[51]

Hamilton suggests none of this. Rather, he distills an exuberant moment in the play through the filter of Neoclassical theory, excluding all fleeting passions and casting Siddons in an idealized, static mode that bears scant relation to her actual performance style. The only intimations of her dynamic movements on the stage are provided by the windswept hair, flowing drapery, and off-balance pose, which has her simultaneously stepping forward while looking back and gesticulating in both directions. Hamilton's studies in Italy (which were sponsored by the Neoclassical architect Robert Adam) had saturated his eye with the imagery of ancient sculpture, and it seems likely that sculptural works such as the famous *Apollo Belvedere* (fig. 11) inform the pose and demeanor adopted in his representation of Siddons. Treatises on acting advised performers to emulate the *Apollo* and other ideal works of ancient sculpture, and artists, too, were advised to make

Figure 10.
WILLIAM HAMILTON (British, 1785–1801). *Siddons as Euphrasia in "The Grecian Daughter,"* 1780. Oil on canvas, 274.3 × 182.9 cm (108 × 72 in.). Stratford-upon-Avon, England, Stratford-upon-Avon Town Hall. By kind permission of the Stratford-upon-Avon Town Council.

Figure 11.
Apollo Belvedere (prior to removal of sixteenth-century restorations). Roman copy after a ninth-century Greek original. Marble, H: 88 in. (224 cm). Rome, Vatican Museums (Museo Pio Clementino).

such esteemed works their models.[52] It is therefore impossible to say whether Hamilton projected the pose of the *Apollo* onto Siddons or whether he documented a stance she actually assumed on the stage. In any case, the allusion to classical statuary reflected favorably on sitter and artist alike.

As a performer accustomed to striking attractive stances and formulating effective gestures, Siddons would have made an ideal collaborator on such a portrait. Like Stothard, Hamilton most likely

Figure 12.

supplemented the impressions gleaned from Siddons's theatrical performances with formal portrait sittings in her home or his studio. As the actress was then performing at Bath while Hamilton was based in London, it is likely that he studied her "on the road." A life-size oil sketch attributed to Hamilton (fig. 12) suggests that he made a careful study of her head on a small and portable piece of canvas and then, once back in London, copied the study on his enormous canvas, employing a model or lay figure to stand in for the actress.

Measuring nine by six feet, Hamilton's painting is a good deal larger than the standard full-length portrait and more in keeping with the monumental scale of history painting. Representing Siddons in performance, enacting a historical role, it blurs the distinction between the two genres, generating a hybrid mode that melds the heroic actions, idealized physiques, and noble themes of history painting with the immediate appeal (and marketability) of a contemporary likeness—one linked in this case with an episode kept alive in the minds of spectators through its contemporaneous enactment in the theaters. Hamilton's painting of Siddons is in fact a key work in his transition from the history paintings that had distinguished his early career to the more remunerative if less prestigious mode of portraiture, which he began to pursue in earnest around 1780. In order to attract patronage, Hamilton had first to advertise his talents. For this reason, he adopted the risky tactic of painting major uncommissioned portraits, and he chose Sarah Siddons as his first subject.[53]

Figure 12.
Attributed to
WILLIAM HAMILTON.
Sarah Siddons, ca. 1784. Oil
on canvas, 35.6 × 30.5 cm
(14 × 12 in.). London,
Victoria and Albert Museum,
Theatre Museum.

Unfortunately, this particular experiment appears to have failed. Exhibited at the Royal Academy in 1780, Hamilton's monumental painting attracted no notice in the papers—not even from critics lamenting the paucity of inspiring historical tableaus. Following Siddons's successful transfer to London, Hamilton tried again, announcing in a newspaper of 1784 that the king and queen had seen his portrait of Siddons in the character of the Grecian Daughter and expressed "the highest satisfaction."[54] Once again, Hamilton timed this publicity stunt to coincide with the influx of visitors to the summer exhibition of the Royal Academy. Although the great size of his painting undoubtedly discouraged many purchasers, it is possible that Hamilton deliberately retained it as a constant attraction to visitors and a model for small oil copies, for which he found ready buyers. In partnership with the engraver John Caldwall, Hamilton also published two mezzotint editions of the painting in 1788 and 1789.

It is significant that Hamilton selected the character of Euphrasia for this singularly ambitious painting. The role was Siddons's personal choice for her reintroduction to Drury Lane Theatre in 1782, and in 1790 it was again the role that she chose for what she grandly termed the "second Birth to my own Empire"—actually her return to the stage following an illness of two years' duration.[55] Siddons's friend Hester Thrale Piozzi claimed that Siddons's impersonation of Euphrasia was one of the two noblest specimens of the human race she had ever seen. As the actress's first biographer noted, her physique was naturally suited to "regal attire," and in the role of Euphrasia "her beauty became more vivid from the decoration of her rank."[56]

The unusual number of paintings and prints representing Siddons as Euphrasia suggests that artists shared the actress's enthusiasm for the role. Indeed, pictorially speaking, her 1782–83 London season was devoted to eliding Siddons with this righteously vengeful, dagger-wielding Greek heroine. John Keyes Sherwin, an erstwhile pupil of the engraver Francesco Bartolozzi, painted Siddons in the role immediately following her London debut and published an engraving of the picture on December 15, 1782 (fig. 13). According to Sherwin's assistant, John Thomas Smith, Siddons sat in the front room of the artist's London house, with the curtains and shutters adjusted so as to modulate the dramatic play of light and shade over her striking features.[57]

Siddons and Sherwin shared a mutual acquaintance in the young Thomas Lawrence, destined to become president of the Royal Academy but then a thirteen-year-old prodigy adept at making rapid chalk portraits of visitors to his father's inn at Bath. Sherwin had engraved several of Lawrence's drawings in 1780, and the boy had

sketched portraits of Siddons around the same time (fig. 14). There is undoubtedly some connection between Sherwin's image of Siddons as Euphrasia and the very similar (though crudely executed) print that Thomas Trotter based on Lawrence's original drawing (fig. 15). In the wake of Siddons's London success, such drawings had acquired new value. Lawrence's father, a former actor who, like his son, cherished great enthusiasm for the stage, swiftly arranged for their reproduction by engravers such as Trotter, and it was probably he who placed the following advertisement in one of the London papers:

> *The drawing of Mrs. Siddons, from whence the small print, published in the Westminster Magazine for last month was taken, was executed at one sitting in a short space of time by Master Lawrence at Bath, which that Lady accepted as a present: and, though in her riding dress, and hastily executed, is deemed the strongest likeness of her hitherto published. But he has drawn her in the Grecian Daughter, and in another of her best characters, which is Zara in the Mourning Bride, both publishing by subscription.*[58]

Figure 13.

Figure 14.

Siddons's tacit endorsement of Lawrence's abilities added clout to his pretensions, and his youth made an effective marketing point—as evinced by the lengthy inscription on Trotter's engraving, which specified the boy's age. Such images proved instrumental in establishing Lawrence's reputation beyond Bath, paving the way for his rapid rise to fame in London a few years later.

The most ambitious depiction of Siddons as Euphrasia was painted by Robert Edge Pine (fig. 16), another painter hoping to jumpstart his career through the representation of theatrical celebrities. Like Hamilton, Pine aspired to history painting while earning his

bread and butter through portraiture, a combination that led to occasional dabbling in pictures consolidating aspects of history, portraiture, and theater. Having enjoyed modest success during an eight-year residence in Bath, Pine moved to London in 1780, where, through innovative private exhibitions, he sought to gain greater renown, chiefly for posthumous portraits of the actor David Garrick. Pine's painting of Siddons as Euphrasia is now known only through an engraving, which the artist produced as much for its publicity value as for the revenue it might generate. An advertisement published in *The Morning Chronicle* in March of 1783 provided a tantalizing description of Pine's picture and the engraving after it, inviting readers to purchase the print and see the original picture at his house in Picadilly.[59]

Siddons had first sat to Pine the previous January, and a surviving preparatory drawing sheds light on the nature of their collaboration (fig. 17).[60] The dissheveled hair, flying drapery, raised dagger, and flashing ankles of the drawing convey a vivid impression of the physically punishing performances that left Siddons aching and ill

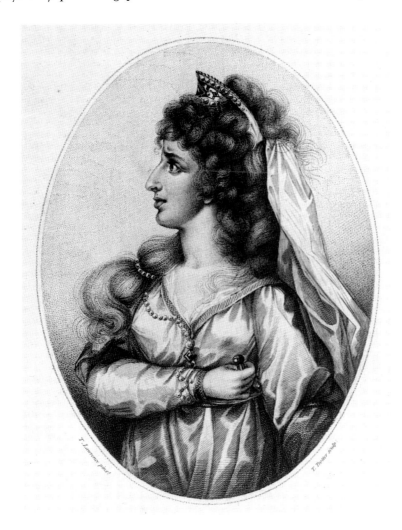

Figure 15.

Figure 13.
JOHN KEYES SHERWIN
(British, ca. 1751–1790).
Mrs. Siddons in "The Grecian Daughter," 1782. Engraving, 24.1 × 20.3 cm (9½ × 8 in.).
The Huntington.

Figure 14.
THOMAS LAWRENCE
(British, 1769–1830).
Sarah Siddons in Her Prime, n.d. Black chalk on paper, 6.4 × 8.6 cm (2½ × 3⅜ in.). New Haven, Conn., Yale University, Beinecke Rare Book and Manuscript Library.

Figure 15.
Thomas Trotter
(British, 1756–1803)
after THOMAS LAWRENCE.
Sarah Siddons in "The Grecian Daughter," 1783. Engraving, 13.7 × 10.2 cm (5⅜ × 4 in.).
The Huntington.

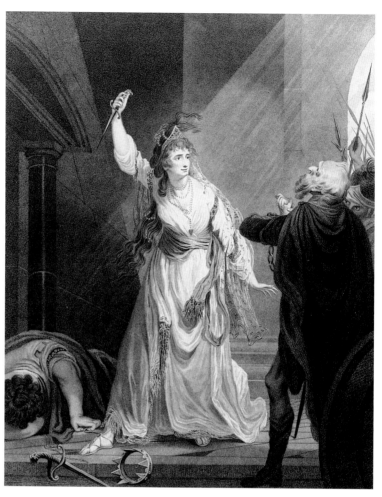

Figure 16.

for days. However, it is possible that the drawing actually documents an impromptu performance staged in Pine's studio, of the kind that Emma Hart was concurrently enacting in George Romney's studio and that she later distilled to create her famed "Attitudes" in Naples.

A private performance is further suggested by the costume Siddons wears in Pine's drawing. Modeled on the simplified drapery of Greek sculpture, which simultaneously reveals as it conceals the body, Siddons's dress hugs the contours of her breasts and thighs, leaving her arms bare. It seems far too scanty to have been worn on the British stage in 1780, especially in the role of Euphrasia. One of the principal attractions of that role was the opulent costume associated with it, suggested by the rich gold braid and tassels of Hamilton's spectacular painting. Siddons's niece Fanny Kemble later recalled her aunt performing the role "in piles of powdered curls, with a forest of feathers on top of them, high-heeled shoes, and a portentous hoop."[61] Another commentator observed that Siddons's Euphrasia "more nearly resembled an English than a Grecian matron in the costume."[62] In her personal reminiscences, Siddons noted her efforts to

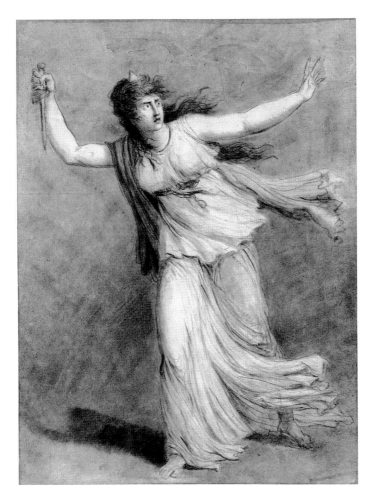

Figure 17.

correct such excesses through emulation of Greek sculpture. Reynolds is generally credited with encouraging Siddons's trend toward classical simplicity, but Pine's drawing suggests that the actress had made previous experiments with another artist.

Pine's drawing celebrates the theatrical vigor that Hamilton almost entirely refined away from his representation of Siddons as Euphrasia. In his finished painting, Pine, too, drained the life from Siddons's performance style in order to accommodate her appearance to the static model of classical sculpture. He lowered her proper right arm to the position that it assumes in the *Apollo Belvedere* and set her features into an idealized mask of calm. To compensate for the petrifying effects of idealization, Pine added other elements to the picture that restore the vitality of live performance, such as the flying hair and floating scarf, tumbling sword and crown, and diagonal rays of light. Isolated at the center of the composition, irradiated by light and elevated above the other figures, Siddons is without question ennobled by Pine's presentation, but she remains an actress playing a role on what is palpably a stage.

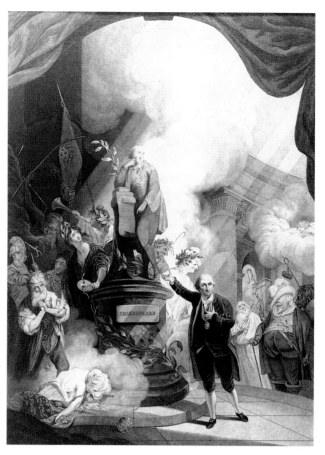

Figure 18.

Figure 18.
Caroline Watson
after ROBERT EDGE PINE.
David Garrick Reciting the
"Ode to Shakespeare," ca. 1782.
Engraving, 59.6 × 42.9 cm
(23$\frac{1}{2}$ × 16$\frac{7}{8}$ in.). The
Huntington.

Figure 19.
GEORGE ROMNEY.
Sarah Siddons, 1783. Oil
on canvas, 76.2 × 61 cm
(30 × 24 in.). Private collec-
tion, England. Photo:
A. C. Cooper Photography.

SEIZING MELPOMENE'S CROWN

In an earlier painting, Pine cast Siddons in a more magnificent guise. *David Garrick Reciting the "Ode to Shakespeare"* (ca. 1782) was a monumen-tal allegorical work measuring eight by seven feet (fig. 18). Surround-ing Garrick are various Shakespearean characters and a statue of the Bard himself at the center. To the left of this monument, crowned with a laurel wreath and holding the mask of tragedy, Pine placed the classically draped figure of Melpomene, the Tragic Muse, with facial features modeled on Siddons's own. This seems to have been the ear-liest image to assert Siddons's claim to the laurel crown of tragedy. It appeared in Pine's one-man exhibition held in Spring Gardens in 1782, just prior to Siddons's return to London, when she proved her right to the title Pine had already bestowed on her.

Within four months of Siddons's London debut, George Romney also decided to depict her as the Tragic Muse in an uncom-missioned full-length portrait (fig. 19).[63] One of the most fashionable painters of his day, Romney was among the most reticent as well. Because the reclusive artist had refrained from public exhibition since

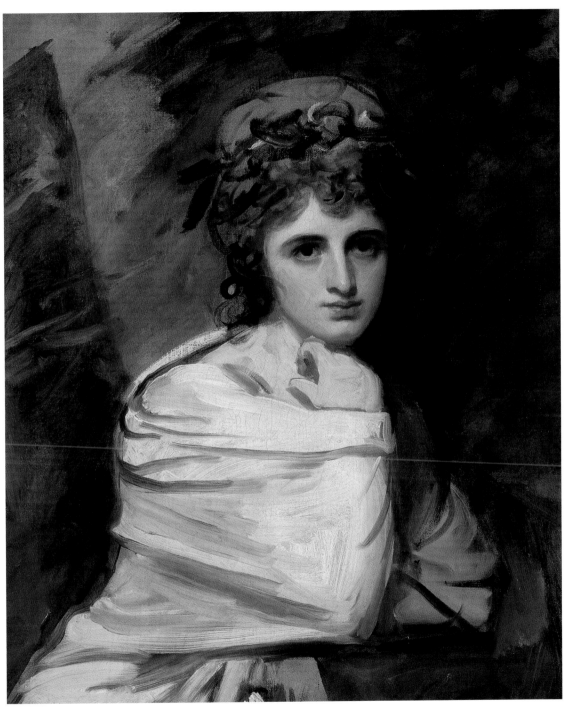

Figure 19.

Figure 20.

Figure 20.
GEORGE ROMNEY.
*Study for Portrait of Sarah
Siddons*, ca. 1783. Gray wash,
black chalk, and pencil on
paper, 49.8 × 29.6 cm
(19⅝ × 11⅝ in.).
Cambridge, Fitzwilliam
Museum.

the early 1770s, his work generally received scant notice in the papers.
The exceptional attention focused on him in 1783 betrays the tremen-
dous fascination aroused by his sitter. Concerned by Romney's noto-
rious reputation for slow and often abortive work, critics monitored
his progress all the more closely. Siddons had three early-afternoon
appointments at his studio at the beginning of 1783, but a visitor to the
studio in March reported that the portrait was still far from comple-
tion. Siddons returned for a sitting at the end of the month, and again
in early April, by which time, according to the papers, "the incredu-
lous" were speculating that the painting would never be finished, and
if finished, never seen.[64] The artist very nearly proved them right.
Romney had begun the portrait as a full-length, as reported in the
papers and revealed in a preparatory drawing (fig. 20).[65] He modeled

the pose on an ancient statue then identified as Melpomene, the Tragic Muse, which the artist had seen and sketched in Italy (fig. 21).[66] In addition to borrowing the pose, Romney explicitly emphasized Siddons's resemblance to the statue by translating its drapery, hairstyle, and marmoreal pallor to his portrait. Siddons actively encouraged this sort of identification between herself and classical statuary. In addition to her costumes, she claimed to have modeled her stage gestures and hairstyle on ancient sculptural examples. She was reputedly so overwhelmed by her perceived resemblance to a statue of Ariadne at the house of the painter William Hamilton that she sat for several minutes in rapt contemplation of it—thereby inviting further comparison with her own appearance.[67] Later in life, she took up

Figure 21.

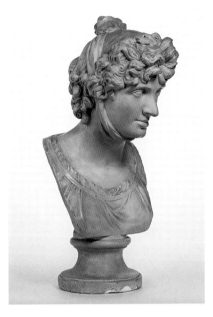

Figure 22.

sculpting for the specific reason of creating self-portraits that preserved her likeness more accurately than those produced by others. In these works she deliberately accommodated her features to the idealized conventions of Greek sculpture (fig. 22).

Romney's association of Siddons with a specific representation of Melpomene would have been clearer in the eighteenth century, when variations on the sculptural prototype were often employed in funerary monuments. Nevertheless, it was a very subtle form of identification, requiring knowledge of the antique in order to interpret the picture correctly.[68] This radically simplified and learned approach contrasts strikingly with Romney's earlier experiments in the same vein. In 1771 he had portrayed Siddons's future rival, the actress Mary Ann Yates, as the Tragic Muse in a picture whose cumbersome

Figure 21.
Muse (Once Called Melpomene). Roman copy of a Greek sculpture of the second century B.C. Marble, H: 150 cm (59 in.). © Staatliche Museen zu Berlin. Preussischer Kulturbesitz Antikensammlung.

Figure 22.
SARAH SIDDONS.
Self-Portrait, ca. 1790. Plaster, 27.6 × 27 × 63.5 cm (10⁷/₁₀ × 10³/₅ × 25 in.). London, Victoria and Albert Museum, Theatre Museum.

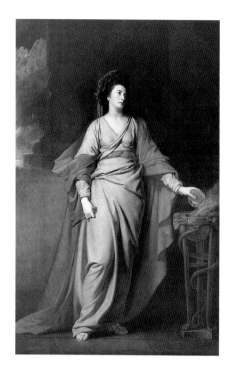

Figure 23.

apparatus included a laurel wreath, drawn dagger, and smoking tripod, into which the actress poured a libation (fig. 23). Draped in a blue robe with a crimson cloak, Yates presents a Baroque contrast to the more classical purity of Siddons—and this was probably Romney's point.[69] He emphasized it further by setting Siddons in nature while placing Yates before a manmade architectural backdrop.

By literally substituting Siddons for Yates in his new embodiment of the Tragic Muse, Romney (like Beach before him) tossed his own elegant grenade into the theatrical battlefield where the two celebrated actresses were contending for professional superiority. Comparisons of Siddons and Yates pepper contemporary reviews, and the fevered pitch of the competition within weeks of Siddons's London debut inspired at least one satirical print, entitled *The Rival Queens of Covent Garden and Drury Lane Theatres, at a Gymnastic Rehearsal!* (fig. 24). Published in the autumn of 1782, this image of fistfighting theatrical divas predicts that the decorous Yates will achieve the laurel crown of victory, while the upstart Siddons, hair askew and breasts bared like an Amazon, appears destined to receive the jester's cap and bells. Romney's proclamation of Siddons's preeminence in tragedy must therefore be recognized as a controversial, if not unprecedented, proclamation of a new theatrical order.[70]

Figure 24.

Romney's sophisticated intentions may have eluded his audience, for although the critics praised the picture elaborately—one asserting that Raphael himself would have been glad to have painted it[71]—none mentioned its association with the Tragic Muse. The painting remained on Romney's hands until late 1785, when the *Public Advertiser* announced that his full length of Mrs. Siddons had been purchased.[72] For reasons that remain obscure, Romney thereafter cut down the whole-length to the present head-and-shoulders format, thereby substituting psychological intimacy for grandeur of effect and further disguising the picture's allusion to the Tragic Muse.[73] Again, this may have been precisely the artist's intention, for while dawdling over his portrait, Romney had allowed a rival painter to produce his own version of Siddons in the guise of Melpomene in a work that Romney believed had entirely eclipsed his own.[74]

REYNOLDS'S TRAGIC MUSE

The painting in question was Sir Joshua Reynolds's portrait *Sarah Siddons as the Tragic Muse* (see fig. 10, p. 114), begun in early May of 1783, seven months after the actress's London debut.[75] According to his pupil James Northcote, the unfavorable reception of Reynolds's pictures in the Royal Academy exhibition of 1782 had bolstered the artist's determination to reassert his preeminence in conspicuous form. A portrait of the celebrated Siddons was the surest way of attracting notice, and indeed her absence among the Grand Manner portraits on the walls of the Academy had already elicited grumbling in the newspapers. On May 1, 1783, the *Public Advertiser* noted:

> *It is remarkable . . . that in the Exhibition of the Royal Academy, not a single Portrait of Mrs. Siddons, in Oil Colours, is to be found. To express all the Grace and Beauty of her Figure, is a difficult Task; but yet such faint and inadequate Resemblances of her as stand in Front of Sixpenny Plays and Magazines, should excite some of our artists to do her ampler Justice.*[76]

Such complaints, together with those lodged against Romney for refusing to exhibit his own portrait of Siddons, indicate the great hunger for images of the actress. In this context, it is scarcely surprising that Reynolds chose to paint her at this time, or that he took special pains to ensure that his portrait stood up to intense public scrutiny.

The account of Reynolds's portrait that appears in Siddons's personal reminiscences glosses over the artist's choice of subject and merely states: "When I attended him for the first sitting, after many more gratifying encomiums than I dare repeat, he took me by the hand, saying, 'Ascend your undisputed throne and graciously bestow

Figure 23.
GEORGE ROMNEY.
Mary Ann Yates as the Tragic Muse, 1771. Oil on canvas, 240 × 152.4 cm (94½ × 60 in.).
Brisbane, Queensland Art Gallery, Gift of Lady Trout, 1988.

Figure 24.
ANONYMOUS.
The Rival Queens of Covent Garden and Drury Lane Theatres, at a Gymnastic Rehearsal!, 1782.
Engraving, 22.5 × 33.7 cm (8⅞ × 13¼ in.).
London, The British Museum.

Figure 25.

Figure 25.
James Heath
(British, 1757–1834),
after THOMAS STOTHARD.
*Mrs. Yates in the Character
of the Tragic Muse, Reciting the
Monody to the Memory of
Mr. Garrick*, 1783. Engrav-
ing, 17.5 × 9.8 cm
(6⁵/₁₆ × 3¹³/₁₆ in.). By
courtesy of the National
Portrait Gallery, London.

upon me some good idea of the Tragic Muse.'"[77] In reality, just a few
months after her arrival in London, Siddons's claim to the throne of
tragedy was strong, but by no means undisputed. Indeed, several days
earlier a print after Stothard had appeared representing *Mrs. Yates in
the Character of the Tragic Muse, Reciting the Monody to the Memory of Mr. Garrick*
(fig. 25). By coincidence or design, Siddons adopted a similar pose
upon ascending the "throne" in Reynolds's studio, and her open chal-
lenge to the authority of Yates and other venerable doyennes of the
stage would have lent an enlivening air of controversy to Reynolds's
static image.[78] Nevertheless, the artist was obviously treading well-worn
ground in associating Siddons with Melpomene. In addition to the
images already discussed, the historian William Russell had published
in March of 1783 a poetic tribute entitled *The Tragic Muse. Addressed to
Mrs. Siddons*,[79] and on May 7, Thomas Cook's engraving *Mrs. Siddons in the
Character of the Tragic Muse* was published as part of John Bell's British
Theatre series (fig. 26).

Popular material of this kind established the groundwork for
Reynolds's portrait of Siddons. He may also have drawn on the work of
his friends. Prior to adopting Cook's more fashionable (if less sophis-
ticated) image of Sarah Siddons as Tragedy, Bell's series on the British
theater had featured anonymous female embodiments of Melpomene
designed by Reynolds's associate, John Hamilton Mortimer (fig. 27).[80]
Reynolds probably knew of these designs, which inspired a series

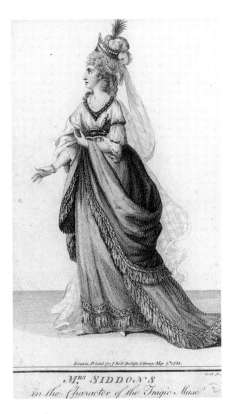

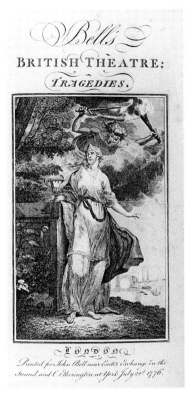

Figure 26.　　　　　　　　Figure 27.

of fourteen etchings that Mortimer published with a dedication to Reynolds in 1778. Bearing the standard props of the bloody dagger and poisoned chalice, Mortimer's heavenward-gazing Melpomene shares many elements with Reynolds's depiction of Siddons. Both figures are attended by horribly grimacing wraiths in the clouds above them: in Mortimer's image it is a havoc-wreaking fury bearing a sword and flaming torch; in Reynolds's, it is one of two "accompanying Genii, ready to administer the Dagger or the Bowl."[81]

It has been demonstrated elsewhere that the facial expressions of Reynolds's two attendant figures correspond with Compassion (on the left) and Fright (on the right) as illustrated in Charles Lebrun's *Method to Learn to Design the Passions*, published in English in 1734.[82] The figures thus allude to the influential statement in Aristotle's *Poetics* that the value of tragedy lay in the emotional catharsis it engendered through the experience of pity and fear. The enlightened expression of Siddons's upturned head and the contrasting gesture of her arms—one drooping in seeming dejection, the other raised in inspiration—suggest that she embodies the climactic moment of tragic epiphany when the combined effects of pity and fear have produced consoling illumination. Such moments were what Lord Archibald Hamilton had in mind in the previously cited letter of 1784, when he wrote of the "blessed Society we should be could we always feel and be influenced by those generous emotions which [Siddons] excites."

Figure 26.
THOMAS COOK (British, 1744–1818). *Mrs. Siddons in the Character of the Tragic Muse*, 1783. Engraving, 14.9 × 10.2 cm (5⅞ × 4 in.). By courtesy of the National Portrait Gallery, London.

Figure 27.
JOHN HAMILTON MORTIMER (British, 1740–1779). *Melpomene*, 1777. Engraving, 13 × 8.9 cm (5⅛ × 3½ in.). Chicago, University of Chicago Library, Special Collections.

Reynolds did not spontaneously invent this elegantly simple yet learned embodiment of Tragedy. Rather, he fumbled his way toward it, painting over reconsidered passages as he steadily honed the picture into its current state of logical and visual clarity. As discussed in the next essay, a recent X-ray of the *Tragic Muse* has revealed something of the evolution of Reynolds's design (see fig. II, p. II5). To the right of Siddons, head resting sadly in hand, Reynolds had originally painted an embodiment of Melancholy, the aspect of Tragedy with which, as we have seen, Siddons was most closely associated at the time and which may owe a particular debt to the painting *Sarah Siddons as Melancholy* by Reynolds's former pupil, Beach. By excising this figure, Reynolds by no means eliminated the picture's melancholic connotations.

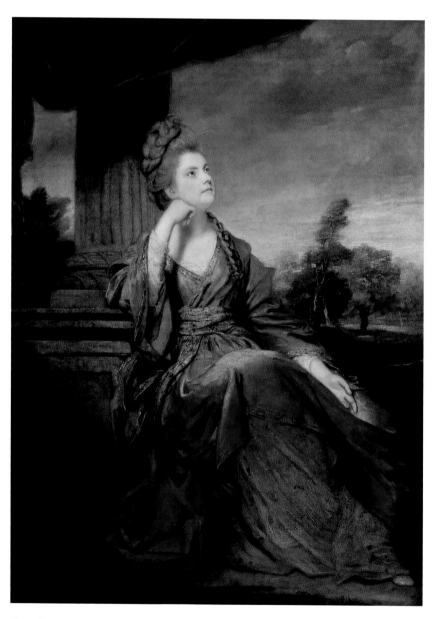

Figure 28.

Siddons's pose and heavenward gaze actually derive from a prototype that he had developed a decade earlier while adapting the traditional iconography of melancholy to contemporary representations of feminine sensibility. The most obvious precursor of the *Tragic Muse* is Reynolds's portrait of Maria, Duchess of Gloucester (1774) (fig. 28), which, in addition to anticipating Siddons's pose, may also have suggested minor details such as the tawny color and rough texture of her drapery, edged with a key pattern, and the long braid of plaited hair draped over her proper left shoulder.[83] Indeed, at least one critic noted the old-fashioned look of the *Tragic Muse*, which showed Siddons "attired in the fashionable habilments of twenty or thirty years ago."[84] On his premises Reynolds kept a portfolio of prints after his own paintings as a reference book of poses that he habitually recycled. It would not have been unusual for him to rework one here.

 It is unclear how effective Reynolds's painting was in producing the uplifting, cathartic impression that the artist probably had in mind. One critic characterized it as "an ideal representation of despair," but another likened the actress's expression to that of "Patience on a monument smiling at Grief!"[85] Siddons herself conceived of the painting in terms of Reynolds's initial emphasis on the melancholic, famously dissuading him from "heighten[ing] that tone of complexion so exquisitely accordant with the chilling and deeply concentrated musing of Pale Melancholy."[86] According to Siddons, Reynolds later thanked her for the suggestion, for "he had been inexpressibly gratifyd [*sic*] by observing many persons weep in contemplating this favourite effort of his Pencil."[87] Ironically, Reynolds himself frequently remarked that Siddons "was an Actress who never made Him feel."[88]

 On its appearance at the Royal Academy exhibition of 1784, critics immediately heralded Reynolds's *Tragic Muse* as far more than a "mere" portrait. It was a work of art possessing enduring, universal value, "a feast for the mind," that was "interesting to the stranger as well as the relation." By allowing Siddons's own nature to dictate every element of the picture—from elevated subject matter, to subdued color scheme, to dignified design—Reynolds had succeeded in capturing "the character as well as the features" of the famous actress, who was deemed to be "among the most inspiriting objects of genius."[89] In subsequent years, Reynolds's painting was perennially singled out by critics and artists alike as one of the greatest portraits of all time. The exorbitant price of one thousand guineas that the artist placed on the picture no doubt contributed to the awe in which many held it. The image was widely disseminated through engravings as well as painted copies, some produced in Reynolds's studio, others by far less expert hands. In November of 1785, Siddons herself reenacted the painting in a tableau vivant staged during the revival of Garrick's Jubilee.[90]

Figure 28.
JOSHUA REYNOLDS
(British, 1723–1792).
Maria, Duchess of Gloucester,
1774. Oil on canvas,
187.3 × 136.5 cm
(73¾ × 53¾ in.). The
Royal Collection © Her
Majesty Queen Elizabeth II.

CHALLENGES TO REYNOLDS

After 1784, any artist who depicted Siddons had to contend with the awesome prestige of Reynolds's definitive image. Those who portrayed her in the guise of Tragedy faced a particular challenge. In his drawing of ca. 1785 (fig. 29), the miniaturist Richard Cosway endeavored to sidestep Reynolds altogether by invoking the more venerable authority of ancient and medieval iconography.[91] He appears to have followed the description of Tragedy that appeared in George Richardson's 1779 redaction of Cesare Ripa's *Iconologia* (1593), where Tragedy is described in these terms:

> *The figure of a majestick woman, dressed in mourning, holding a dagger in her hand, which are expressive of the greatness, pain and terror of this subject; the murdered child at her feet, alludes to cruel and violent death, being the theme of tragedy. The figure is shod in buskins, as they were worn by princes and heroes of the ancients, and in imitation of them, were introduced by tragedians, to denote that this sort of poetry requires great and sagacious conceptions, neither common nor trivial. To the back ground of this subject, the trophies of heroes may be introduced, and a palace at a distance, on fire.*[92]

Appropriately, Cosway shrouded Siddons in a dark cloak suggestive of mourning, with a bloody dagger symbolic of "violent death" in her lowered hand. Her drapery, reminiscent of classical statuary, together with the diadem on her head and the buskins on her feet, establish the regal aura of Tragedy that, as Ripa stated, "requires great and sagacious conceptions, neither mean nor trivial." Eschewing the ponderous seated position for which Reynolds was criticized,[93] Cosway accentuated Siddons's famously majestic proportions. Striding boldly forward, the actress tramples underfoot a warrior's breastplate—one of the "trophies of heroes" specified by Ripa. Cosway also alluded to Tragedy's capacity for illumination by means of Siddons's skyward gesture, which serves the same purpose as the uplifted gaze in Reynolds's painting. The hapless putto bearing the poisoned chalice provides a whimsical contrast both to the murdered child mentioned by Ripa and to its counterpart in Reynolds's painting, the chalice-bearing figure of Horror.[94] It also serves as a charming comic foil to Siddons's own solemnity, exemplifying the kind of witty contrast and complexity that appealed to eighteenth-century tastes. Siddons would certainly have approved of the erudite character of Cosway's drawing, but she probably contributed little to it. Indeed, it is tempting to link the drawing with a letter in which Cosway inquired about the day on which he might have a sitting from Mrs. Siddons, "as he has arranged his ideas relative to the action, etc., etc., and could begin it immediately."[95]

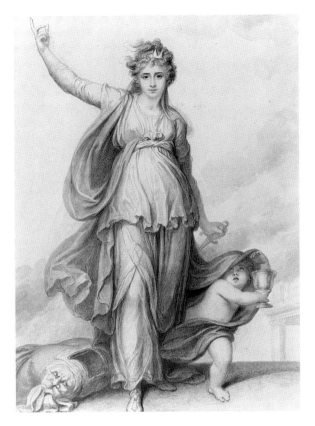

Figure 29.

A decade passed before a major representation of Siddons in generalized tragic mode challenged the authority of Reynolds's famous portrait. In 1794 William Beechey announced his new status as Associate of the Royal Academy and Portrait Painter to Queen Charlotte by exhibiting *Sarah Siddons with the Emblems of Tragedy* at the Royal Academy (fig. 30). Like Cosway, Beechey accentuated the majestic height of his subject, painting her at full-length, stalking through a wooded grove, with a bloody dagger in one hand and a tragic mask in the other. Behind her is a plinth inscribed SHAKESPEARE, surmounted by a weeping cupid and a toppled comic mask. The meaning of the imagery is unclear, but it may signify the eclipsing of the comic vein in Shakespeare (symbolized by the cupid and the fallen mask) by Siddons's resurrection of his long-neglected tragedies.

More importantly, Beechey's bold reinterpretation of the celebrated actress represents a strategic move in his competition with rival painters Thomas Lawrence and John Hoppner, who narrowly preceded him in attaining Royal and Academic honors. His painting reformulates the engaging conceits they had devised for their recently acclaimed portraits of the comic actresses Dorothy Jordan (fig. 31) and Elizabeth Farren (fig. 32).[96] By painting a tragic rather than a comic actress, Beechey may have wished to distinguish himself as a more serious sort of painter.

Figure 29.
RICHARD COSWAY
(British, 1742–1821).
Sarah Siddons as Tragedy,
ca. 1785. Pencil and
gray washes on paper,
23.2 × 17.2 cm
(9⅛ × 6⅚ in.). Private
collection, England. Photo:
A. C. Cooper Photography.

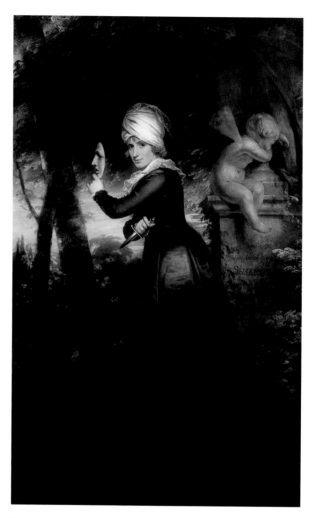

Figure 30.

Figure 30.
WILLIAM BEECHEY
(British, 1753–1839).
*Sarah Siddons with the Emblems
of Tragedy*, 1793. Oil on
canvas, 245.1 × 153.7 cm
(96¹/₂ × 60¹/₂ in.). By
courtesy of the National
Portrait Gallery, London.

Yet as an embodiment of Tragedy, his painting was deemed a failure. Like so many grand, uncommissioned portraits of Siddons, it did not sell, remaining in the artist's studio until his death in 1836.[97] The critic Anthony Pasquin claimed that Beechey had executed a painting that failed both as a likeness ("too thin for the original") and as a work of art ("not accurately designed"). Rash ambition had caused Beechey's downfall, the critic surmised, for "He has suffered Mr. Hoppner to supersede him, which is a sufferance that took place while his genius was tipsy and his enemies vigilant."[98] To Georgian eyes, the painting seemed to lack the gravity that Ripa had specified as necessary to tragedy. Theatrical masks, though a standard element in ancient Greek and Roman representations of Tragedy, were almost exclusively associated with Comedy in eighteenth-century paintings—especially when a figure was shown peeping out playfully from behind one. Pasquin dismissed Siddons's coy pose as "affectedly disgusting," for "it conveys the semblance of a gypsey in sattin, disporting at a masquerade, rather than the murder-loving Melpomene."

Figure 31.

Figure 32.

THE ACTRESS IN PRIVATE LIFE

The element of snobbery implicit in Pasquin's criticism—his dismissal of Beechey's masquerade gypsy as an imposter for the noble Tragic Muse—also cropped up in discussions of Siddons, with some commentators arguing for her intellectual genius, while others dismissed her as a mere play-actor. Fascinated by the interplay of artifice and naturalism in Siddons's "real" self, her contemporaries scrutinized her behavior in private life as carefully as they did her performances on the stage. Keenly aware of her ambivalent and anomalous position, Siddons was careful to imbue her every gesture and glance—whether on or off the stage—with a gravity appropriate to the high seriousness of the tragic mode. A friend who had noted "a great difference in Mrs. Siddons when she is in a small familiar party from what she appears in a large company where she is reserved and cautious," cited her explanation that "she has a character to support and is afraid of losing importance." In general, Siddons's constant self-monitoring

Figure 31.
JOHN HOPPNER
(British, 1758–1810).
Dorothy Jordan as the Comic Muse, 1786. Oil on canvas, 236.9 × 145.4 cm (93¼ × 57¼ in.). The Royal Collection © Her Majesty Queen Elizabeth II.

Figure 32.
THOMAS LAWRENCE.
Elizabeth Farren, Later Countess of Derby, 1790. Oil on canvas, 238.8 × 146.1 cm (94 × 57½ in.). New York, The Metropolitan Museum of Art, Bequest of Edward S. Harkness.

engendered the impression that she was perpetually staging a perfor-
mance, or as one of her associates put it, that she was "always a Tragedy
Queen: always acting a part even among Her own relations."[99] The
artist Thomas Lawrence observed more charitably that the "modest
gravity which I believe must belong to high tragic genius . . . was strictly
natural to her, though, from being peculiar in the general gaiety of
society, it was often thought assumed."[100]

Despite Siddons's vigilance in calibrating her appearance and
behavior to the dignity of Tragedy, the actress occasionally surprised
acquaintances with spontaneous displays of less severe aspects of her
personality. Several artists seized on such uncharacteristic revelations
as a means of challenging established notions of her and of displaying
their own original insights into a familiar subject. But in the same way
that critics and audiences resisted Siddons's attempts to expand the
range of her theatrical roles, so, too, they often rejected images that
contradicted prevalent assumptions about her nature.

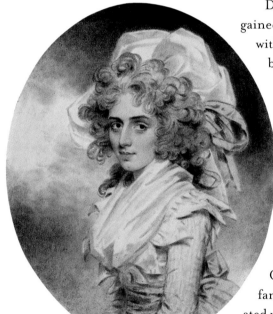

During the spring of 1787 the artist John Downman
gained a fresh perspective on Siddons while collaborating
with her on a private theatrical performance organized
by Charles Lennox, 3rd Duke of Richmond. Sid-
dons advised the genteel group of amateurs on cos-
tumes and other matters, while Downman
executed portraits of contemporary beauties for
the stage scenery. Among Downman's portraits
was a pastel of Siddons in which the winsome,
smiling face is scarcely recognizable as her own
(fig. 33). In explanation of his uncharacteristic
conception of the actress, Downman later
inscribed the drawing with the remark, "Off the
Stage I thought her face more inclined to the
Comic."[101] Appropriately, he altered Siddons's
famously pallid complexion—which she herself associ-
ated with the "the chilling and deeply concentrated mus-
ing of Pale Melancholy"—by means of cheerfully rouged
cheeks and lips. In contrast to the simplified style of dress that she
increasingly adopted, the artist dressed her in the latest extravagances,
her hair powdered and frizzed and topped with an oversized mobcap.

Downman's iconoclasm annoyed at least one critic, who com-
plained that the portrait bore hardly any resemblance to the original,
for "Mrs. Siddons whose Frown is tragick, and whose Countenance is
masculine, is drawn like a pastoral Coquette."[102] Ironically, by striving
to show an unaccustomed aspect of Siddons, Downman seems merely
to have accommodated her to the standard sugar-coated type that he
employed for all his female sitters. A critic observed in 1789, "He has
but two passable faces, one face for ladies and another for gentlemen,

Figure 33.

Figure 33.
JOHN DOWNMAN
(British, 1750–1824).
Portrait of Mrs. Siddons,
1787. Pastel on paper,
20.3 × 17.2 cm
(8 × 6³/₄ in.). By courtesy
of the National Portrait
Gallery, London.

& one or other of these prototypes all his likenesses are brought to ressemble."[103]

Nevertheless, by enhancing Siddons's physical similarity to the other portraits executed for the Richmond House theatricals, Downman succeeded in papering over the social gulf that separated the actress from the aristocratic women whose portraits were displayed alongside hers: the Duchess of Richmond, the Duchess of Devonshire, Lady Duncannon, and Lady Elizabeth Foster. In real life, these women had met Siddons halfway, each having embraced public celebrity to a degree considered unseemly in a lady of gentility. Apart from Siddons, the only other professional actress in the Richmond House series was her Drury Lane colleague Elizabeth Farren, who would shortly over-leap the social gulf by marrying the Earl of Derby. The Richmond House theatricals and Downman's eclectic portrait series thus exem-plify the promiscuous cross-fertilization between lower-class per-former and upper-class amateur that worried many commentators of the period. The playwright Richard Cumberland wrote in 1788:

> *I revolt with indignation from the idea of a lady of fashion being trammelled in the trickery of the stage, and taught her airs and graces, till she is made the facsimile of a mannerist. . . . Let none such be con-sulted in dressing or drilling an honorary novitiate in the forms and fashions of the public stage . . . the fine lady will be disqualified by copying the actress, and the actress will become ridiculous by apeing the fine lady.*[104]

Siddons's stellar reputation may have made her an exception to Cumberland's rule, and indeed, contemporary commentators always took pains to trace the evidence of social elevation in her behavior and appearance, noting approvingly that "she looks, walks, and moves like a woman of a superior rank."[105]

As noted earlier, Downman's stock female portrait type was judged particularly inappropriate for Siddons as a result of the actress's perceived "masculinity" of appearance and manner. Other artists who attempted to show her in a milder light met with similar criticism. When in 1785 William Hamilton exhibited a painting of the actress in private character, dressed in a riding hat and black silk cloak, critics acknowledged the accuracy of the likeness but condemned the softening effects of Hamilton's technique. One writer glossed over the "impropriety" of the masculine dress in order to dwell on the polished paint handling, which demonstrated "too much effeminacy—too much of the delicate pencil, for a proper likeness of the strong and expres-sive lines of that great Actress—too much of Romeo's bride—too little of Macbeth's Queen."[106] The eighteenth-century notion of "likeness" thus extended beyond the accurate mapping of features to the mode of execution, which had to be appropriate to the subject. Beyond that, the

painting also had to please as a work of art. Having expressed reservations about the "delicacy" of Hamilton's treatment of Siddons, another writer concluded, "So much for the portrait—considered as a picture, it is cold and hard."[107]

By portraying Siddons as a coquettish beauty whose fashionable dress anchored her solidly in the here-and-now, Downman playfully pierced the mystique of the Tragic Muse. At the same time, his charming picture deflated the somber imagery and rarefied theory embodied by Reynolds's painting. In this respect Downman merely emulated Reynolds's great rival, Thomas Gainsborough, who had painted Siddons in the winter of 1785 (see fig. 24, p. 31), a few months after the *Tragic Muse* made its sensational debut at the Royal Academy. Ironically, that exhibition also marked a watershed for Gainsborough, but a distinctly negative one, constituting his final, bitter estrangement from the institution that his chief competitor dominated. Irritated by the unfavorable position in which his painting *The Three Eldest Princesses* (fig. 34) was to be hung, Gainsborough demanded the immediate return of all his submissions and made good on a prior threat never to exhibit at the Academy again.[108] The painting obviously continued to weigh on Gainsborough's mind when he undertook the portrait of Siddons, for he lifted her pose—complete with the red curtain and chair—directly from the right-hand figure in *The Three Eldest Princesses*.

Gainsborough's adversarial relationship with the Royal Academy and its president following the summer of 1784 sheds light on his decision to paint Siddons in a manner diametrically opposed to Reynolds's own. Acutely attuned to the factual realities of contemporary life and notoriously impatient with pretense, Gainsborough transformed the president's spiritual muse into a distinctly material girl. Whereas Reynolds elevated Siddons to an ambiguous, supernatural realm—floating on clouds, attended by phantoms, gazing heavenward in sublime rapture—Gainsborough deposited her solidly on earth. Rather than a mystic throne, she occupies a modern chair, with a simple swag of curtain standing in for the nebulous clouds and phantoms of Reynolds's painting. In his Royal Academy addresses Reynolds cautioned against the trivializing appearance of contemporary fashions in portraiture, asserting that in the best painting, "cloathing is neither woollen, nor linen, nor silk, sattin, or velvet: it is drapery; it is nothing more."[109] With gleeful contrariness, Gainsborough decked Siddons out in cutting-edge apparel, lovingly differentiating the various materials of satin, lace, feathers, and fur, and presenting a persuasive counterargument to Reynolds's endorsement of vague, formless drapery.

Gainsborough's female portraits of the 1780s (such as *The Three Eldest Princesses*) are remarkable for shimmering, illusionistic effects of

Figure 34.
THOMAS GAINSBOROUGH
(British, 1727–1788).
The Three Eldest Princesses,
1784. Oil on canvas,
129.5 × 179.7 cm
(51 × 70¾ in.). The Royal
Collection © Her Majesty
Queen Elizabeth II.

rapid brushwork, which lend an immaterial quality to his sitters. The uncharacteristic clarity of his portrait of Siddons no doubt reflects the artist's desire to distinguish this work from Reynolds's, but his idiosyncratic treatment may also have had something to do with the actress herself. Contrasting Gainsborough's handling of male and female subjects, a contemporary critic noted, "His portraits of the Angels of the Court frequently gave us as much the idea of Angels as they could do, from having no particle of a gross, earthy, or substantial form about them. But in his portraits of men imitation assumes the energy of life."[110] Gainsborough's adoption of vital "masculine" substantiality in his portrait of Siddons accords with the prevalent view of her inverted gender qualities and of the consequent inappropriateness of "feminine" delicacy in depictions of her. As Siddons's first biographer noted, "the commanding height and powerful action of her figure, though always feminine, seemed to tower beyond her sex."[111]

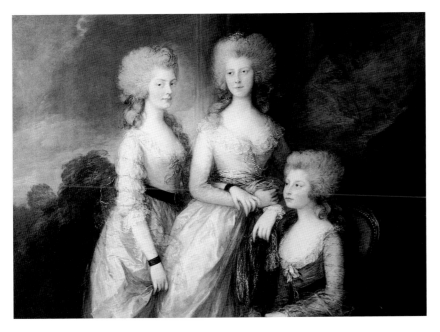

Figure 34.

LAWRENCE AND THE KEMBLE FAMILY

Of all the artists who represented Siddons, Thomas Lawrence knew her most intimately and portrayed her most variously. As noted earlier, he was a teenage prodigy when Siddons first sat to him in Bath prior to embarking on her triumphant London career. On Lawrence's own successful transfer to London in 1787, he became a constant companion and observer of the actress and her family. He executed so many drawings and paintings of them during the 1790s that one critic was moved to remark, "this Artist appears to be perpetually employed

in tracing and retracing the features of the KEMBLE family."[112] Lawrence seems to have idolized Siddons to an unhealthy degree and to have elevated her brother, John Philip Kemble, to a similarly lofty plane. Summarizing the chief influences on his portraiture in a letter written shortly before his death, he divided his subjects into the categories of Men, Women, and Children, with a fourth category reserved for Siddons and her brother.[113]

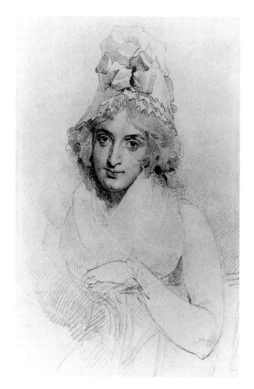

Whereas Kemble inspired Lawrence to paint exceptionally grandiloquent and heroic imagery— "half-History pictures," as he called them[114]—Siddons had the reverse effect, eliciting tender images whose directness and familiarity present a refreshing contrast to her many more formidable portraits. The candid gaze she focuses on the viewer in a drawing of about 1790 mingles shrewd intelligence with frank vulnerability (fig. 35). The exact circumstances behind this drawing (like those surrounding many of Siddons's surviving portraits) are unknown. The artist may have made the drawing for personal pleasure or commercial speculation, or it may have originated with a commission from one of Siddons's admirers. In any case, the intimate quality of the drawing was apparently no bar to public circulation, for Lawrence initially planned to reproduce it as an etching.[115]

Numerous engravings and painted copies resulted from another seemingly intimate portrait of Siddons from the late 1790s (see fig. 3, p. 7), in which Lawrence softened the actress's image still more, subsuming the intelligent gaze of his earlier drawing beneath a dewy sweetness and replacing the jaunty mobcap with a pale scarf that rings her head like a halo. Such images attest to Lawrence's eagerness to bring Siddons's true "private" self to public notice, thereby correcting what he considered to be fallacious notions of her. Defending Siddons against the charge of histrionic artificiality both on and off the stage, he once described her as "naturally a very grave character, but among Her family she is easy, yielding and unaffected."[116] Lawrence's preconceptions about his sitters' characters had a profound impact on his treatment of their features. As he paradoxically informed one of his colleagues, Siddons's face contained "parts and forms which did not appear to belong to Mrs. Siddons, and should therefore be omitted in her portraiture."[117]

Lawrence's unorthodox characterizations evidently found favor with Siddons and her family,[118] but critics disagreed about their accuracy. One considered the portrait Lawrence exhibited at the Royal

Figure 35.

Figure 35.
THOMAS LAWRENCE.
Sarah Siddons, 1790. Pencil
on paper, 19.1 × 12.4 cm
(7¹/₂ × 4¹³/₁₆ in.). San
Francisco, Fine Arts
Museums of San Francisco,
Achenbach Foundation.

Academy in 1797 to be "unquestionably the most exact in point of similitude that has ever appeared of that admirable actress. It seems to represent her mind as well as her features."[119] But Anthony Pasquin disagreed strenuously, remarking of the picture:

> *It is no more like her than Hebe is similar to Bellona. We have here youth, flexibility of features, and an attempt at the formation of beauty, to denote a lady who is so proverbially stern in her countenance that it approaches to savageness, —so determined in the outline of her visage, that it requires the delusion of the scene to render it soft and agreeable, and who is so far from being young, that her climacteric [menopause] will be no more.*[120]

Evidently intent on offending artist and sitter alike, the cantankerous critic overlooked the possibility that in private life Siddons might possess physical and personal attributes quite different from those "proverbially" associated with her more ferocious stage appearances. His remarks exemplify the sort of typecasting that Siddons and her portraitists struggled to overturn. They also unintentionally underscore the chamelionlike abilities of the forty-year-old actress, for during the period that Lawrence was painting her, she was successfully carrying off the illusion of winsome, youthful beauty while impersonating such stage ingenues as Isabella, Portia, and Euphrasia, and delighting to reports that she was "more beautifull than ever."[121]

Lawrence's intense preoccupation with Siddons and her family proved disastrous on a personal level, resulting in the premature deaths of two invalid daughters whom the artist had courted and jilted in rapid succession. His persistent attention also occasioned rumors of romantic involvement with Siddons herself—one of the few scandals to blot her zealously guarded reputation. In March of 1804, while Lawrence was struggling to complete a portrait commissioned by the actress's "inestimable and beloved friend," Caroline Fitzhugh (fig. 36), it was reported that "Mrs Siddons sat to Lawrence for a whole length last night by Lamplight, till 2 o'clock this morning."[122] Undaunted by the raised eyebrows, Siddons was behaving true to well-established form by squeezing in a painter's request for a sitting, no matter how inconvenient.

Reynolds's iconic *Tragic Muse* inevitably weighed heavily on Lawrence's mind as he carried out Siddons's full-length portrait for Caroline Fitzhugh, the most grandiose of all his paintings of the actress. It was probably around this time that he executed a chalk drawing of Siddons in the guise of the Tragic Muse that might have yielded a sensational and impassioned work to rival his portraits of her brother, Kemble, had Lawrence pursued it (fig. 37). Instead, he embarked on an entirely novel treatment, representing her onstage but in private character, performing not a theatrical role but a dramatic

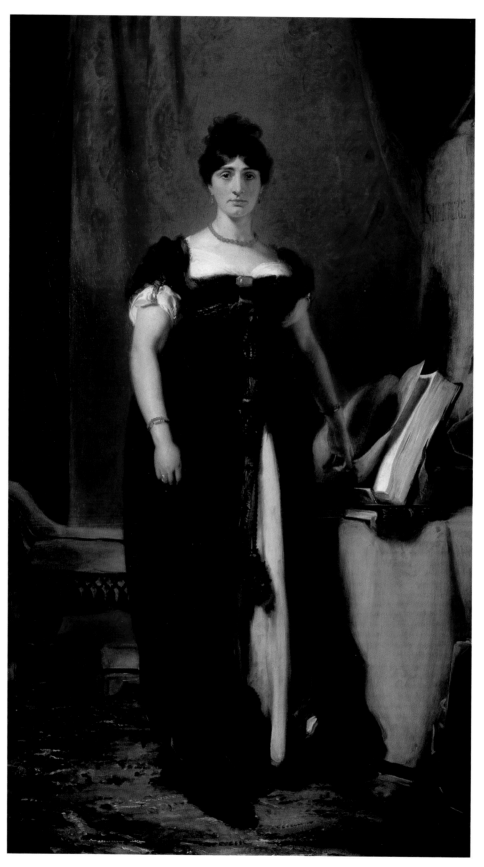

Figure 36.

reading. Siddons would later present many such readings to the general public, usually adapting passages from Shakespeare and Milton. Prior to her retirement in 1812, however, she generally read only at the command of the king and queen, who in 1783 had appointed her preceptress in English reading to the royal princesses.[123]

Representing Siddons as she had appeared before royalty, Lawrence endows the actress herself with a distinctly regal air. Exhibiting a dispassionate dignity, she makes no attempt to beguile her audience, but meets our eyes with a direct gaze that is self-possessed without being imperious. The artist's low vantage point exaggerates her apparent height, causing the dark figure to tower majesterially over the viewer. Lawrence's insistence on Siddons's regal stateliness matches reports of her actual demeanor at court. Indeed, at her very first reading, the king and queen had expressed surprise at her uncommon equanimity in so intimidating a position. Decades later, Siddons took the trouble to mention the comment in her reminiscences, but she shrugged it off with the casual remark, "At any rate, I had frequently personated Queens."[124]

Cold and daunting in its formality, Lawrence's portrait is hardly the sort of personal memento that one would expect to have emanated from a private commission marking a long and intense friendship. Perhaps Fitzhugh and Lawrence wished to mark the close of Siddons's career with a commemorative image worthy of her legend. The actress had by then ceased to perform (temporarily, as it happened) and thought that she "had bade an eternal adieu" to the stage.[125] Fitzhugh ultimately presented the painting to the British nation and may have considered it all along as a public monument, albeit one erected to a friend. In any case, neither Siddons nor Lawrence lost time in circulating the image publicly. Following its exhibition at the Royal Academy, where it was deemed "very far from being a pleasing performance,"[126] Lawrence actually confiscated the canvas from the framemaker who was packing it off to Fitzhugh in order to have a copy made as an aid to engraving.[127] Siddons, for her part, eagerly distributed prints to farflung family members, declaring it "more like me than any thing that has been done."[128]

CONSOLIDATING THE LEGEND

Lawrence represented Siddons in 1804 at the age of forty-nine. By then, it was reported, she had "lost her beauty to a great degree" so that "her exertions of action, and especially of countenance, degenerate a little towards caricature."[129] Increased girth had destroyed the illusion of youth that she had extended well into middle age, and the repetitiousness of her work had dulled the former flashes of brilliance.

Figure 36.
THOMAS LAWRENCE.
Sarah Siddons, 1804. Oil on canvas, 250.2 × 143.5 cm (98½ × 56½ in.).
© Tate Gallery, London 1998.

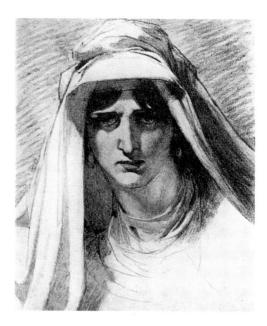

Figure 37.

One observer complained that she was "so perpetually in paroxysms of agony that she wears out their effect. She does not reserve her great guns . . . for critical situations, but fires them off as minute guns, without any discrimination."[130] Siddons had nevertheless lost none of her charismatic appeal in the eyes of George Henry Harlow, a fledgling artist who haunted the London theaters during the early years of the nineteenth century, sketching actors in performance. Harlow had become Lawrence's student in 1802 at the age of fifteen and probably witnessed his master at work on the grand, full-length portrait of Siddons. The experience apparently made a deep impression on Harlow, who devoted his brief career to theatrical paintings, specializing in images of Siddons and her family. In Harlow's art, Siddons gained a quality of immortality, her likeness frozen for all time in an idealized mask based on Lawrence's portraits. Harlow's painting of Siddons in the letter scene of *Macbeth*, for example, imitates the setting and dress of Lawrence's full-length portrait while also adopting its low vantage point, so that the actress again appears as a towering presence (fig. 38).

The popularity of Harlow's paintings demonstrates the persistent demand for images of Siddons even after her retirement in 1812. Drawing on Siddonian lore, Harlow reworked the on-the-spot sketches of the actress that he had made as a starstruck teenager, producing romanticized paintings that were subsequently reproduced as engravings. His painting *Sarah Siddons as Lady Macbeth (Sleepwalking Scene)* (see fig. 6, p. 11), exhibited at the British Institution in 1815, commemorates the actress's signature role—the one in which she had chosen to appear for her official farewell performance three years

Figure 37.
THOMAS LAWRENCE.
Sarah Siddons as the Tragic Muse, ca. 1804. Black and red chalks on paper, 20.3 × 16.5 cm (8 × 6½ in.). Private collection.

Figure 38.
GEORGE HENRY HARLOW (British, 1787–1819).
Sarah Siddons as Lady Macbeth (Letter Scene), ca. 1814. Oil on canvas, 238.8 × 147.3 cm (94½ × 58 in.). Greenville, S.C., Bob Jones University Collection.

earlier.[131] Harlow focused on Siddons's most famous innovation in that role: her seemingly inconsequential decision to set down the candle while sleepwalking in order to carry out a pantomime washing of her guilty hands. Her deviation from time-honored tradition generated great controversy but ultimately earned plaudits for instinctive naturalism. Harlow's depiction of Siddons as a ghostly figure in white, luminous in the darkness, conveys the eerie quality of her performance. But a related drawing concentrating on the actress's head and shoulders betrays the influence of Lawrence's sentimentalizing approach to Siddons (fig. 39). Here, the earnest, melting gaze and moist, beestung lips lose the sublimity of Lady Macbeth in the teary pathos of Isabella.

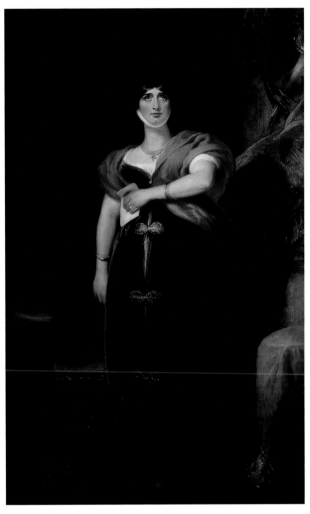

Figure 38.

Harlow emulated Lawrence's likenesses of Siddons; he also shared his former master's peculiar fixation on the actress. A long series of portraits culminated in Harlow's *Court for the Trial of Queen Katharine* of 1817 (fig. 40), originally commissioned as a small full-length portrait of Siddons, to be painted from memory as she appeared in Shakespeare's *Henry VIII*. The actress's unexpected return to the stage in 1816 for two benefit appearances as Queen Katharine furnished additional opportunities to observe her, and this may have triggered Harlow's decision to create a more ostentatious image, something more on the order of history painting. Longing for a private sitting with the actress, Harlow convinced his patron, the music teacher Thomas Welsh, to obtain her consent. Thereafter, Harlow steadily expanded his modest commission into a far more ambitious scene containing over twenty figures, to include himself (at far left) and members of Siddons's family. Harlow initially refused to accept a higher price than that originally agreed upon, saying "that he should be amply repaid by the reputation it would bring him, and that he should owe everything to Mr. Welsh for getting Mrs. Siddons to sit for him."[132]

Harlow elected to represent a minor episode in the play that Siddons—through her complex interpretation of a single line of dialogue—had transformed into a personal tour de force. According to

contemporary observers, her wordless expression of rapid and subtle emotional transitions while preparing to address her nemesis in the trial scene had to be seen to be believed: "Those who have seen it will never forget it—but to those who have not, we feel it impossible to describe . . . —no language can possibly convey a picture of her immediate reassumption of the fulness of majesty, glowing with scorn, contempt, anger and the terrific pride of innocence, when she turns round to Wolsey, and exclaims, 'to YOU I speak!' "[133] The complexities of Siddons's nuanced performance proved as intangible in paint as they were in words, but Harlow evidently succeeded in stirring powerful memories in those who had witnessed the actress in action. Declared picture of the year at the Royal Academy exhibition of 1817, *The Court for the Trial of Queen Katharine* brought Harlow the acclaim he anticipated, and the following day he doubled his portrait prices. The painting, together with myriad engravings after it, proved to be a defining image for the play as well as a crystallization of Siddons's fame. It served as a model for the staging of the Trial Scene for much of the nineteenth century and provided a model for Henry Andrews's painting of 1830 depicting Fanny Kemble performing in her aunt's former role (fig. 41).

In Fanny Kemble, Siddons's legacy appeared to live on, though decidedly in miniature. She was once described as "Mrs. Siddons seen through the diminishing end of an opera glass." The gallant Lawrence

Figure 39.

Figure 39.
GEORGE HENRY HARLOW.
*Sarah Siddons as Lady Macbeth
(Sleepwalking Scene)*, n.d.
Pencil and red chalk
on paper 22 × 17.8 cm
(8⅝ × 7 in.). The
Huntington.

Figure 40.
GEORGE HENRY HARLOW.
*The Court for the Trial of
Queen Katharine*, 1817. Oil
on panel, 160 × 218.5 cm
(63 × 86 in.). Winchcombe,
Sudeley Castle, Walter
Morrison Collection.

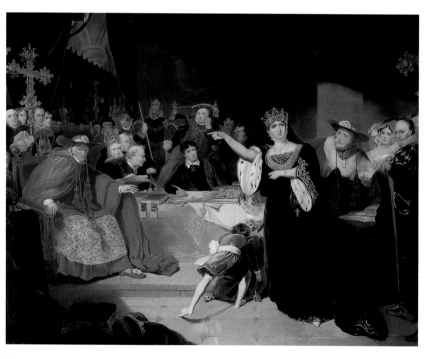

Figure 40.

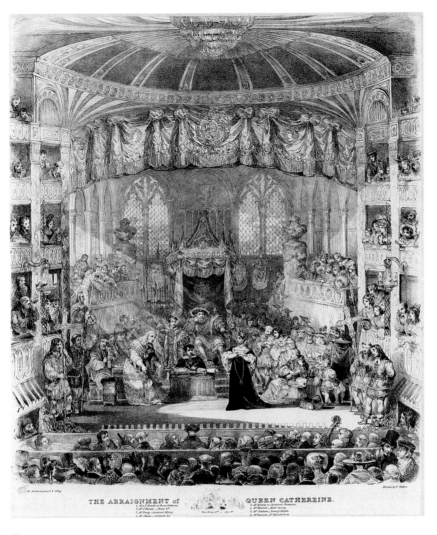

THE ARRAIGNMENT of QUEEN CATHEREINE.

Figure 41.

was more complimentary, finding her "eyes and hair like Mrs. Siddons in her finest time."[134] The dynastic transfer of dramatic genius from Sarah Siddons to Fanny Kemble is the theme of Henry Briggs's double portrait of 1830 (fig. 42). Represented shortly before her death, Siddons sits in an armchair, a position that alludes to Reynolds's and Gainsborough's celebrated portraits, which are unusual in showing the actress in a seated pose. Paging through a book, Siddons calls to mind the dramatic readings in which she had most recently performed, as well as her longstanding associations with intellectual sensibilities. The overt subject of the painting is Fanny Kemble's success in her signature role of Juliet, a character proverbially antithetical to Siddons's own nature. A star no more, the aging actress is cast here in the role of supporting player. And yet no Juliet was ever more upstaged by her Nurse. Siddons remains the focus of the artist's attention, her venerable presence lending dynastic authority and professional credibility to the pretensions of her young niece.

Figure 41.
After HENRY ANDREWS (British, fl. 1797–1828). *The Arraignment of Queen Cathereine* [*sic*], 1830. Lithograph, 54 × 44 cm (21¼ × 17⅜ in.). Cambridge, Mass., The Harvard Theatre Collection, The Houghton Library.

"She was tragedy personified," William Hazlitt once said of Sarah Siddons. "She was the stateliest ornament of the public mind."[135] For thirty years, artists reinforced Siddons's identity as a personification of tragedy and a stately public ornament. Having accelerated her ascendancy to stardom, they helped her negotiate the hazards of celebrity and ultimately endowed her with a quasi-mythical aura that protected her personal and professional reputation. Through her mutually advantageous collaboration with artists, Siddons gained the opportunity to play "roles" on canvas that she never performed onstage. Skilled in performance, fluent in the visual language of expression, and gifted with an uncanny ability to touch the emotions, she inspired the one painting that so many of her contemporaries singled out as the finest portrait ever produced. Art played a vital role in making a legend of Sarah Siddons, and it is art that sustains her fascination today.

Figure 42.
HENRY PERRONET BRIGGS
(British, ca. 1791–1844).
Sarah Siddons and Fanny Kemble, 1830. Oil on canvas, ca. 127 × 101.6 cm (50 × 40 in.). Boston Athenaeum.

Figure 42.

NOTES

1. Entry of 1 December 1782 in Katharine C. Balder-
 ston, ed., *Thraliana: The Diary of Mrs. Hester Lynch Thrale
 (Later Mrs. Piozzi), 1776—1809*, 2 vols. (Oxford: Claren-
 don Press, 1951), 1: 554.

2. For example, public curiosity about the beautiful
 Gunning sisters reached such a pitch that it was re-
 ported in 1752, "there are mobs at their doors to
 see them get into their chairs; and people go early
 to get places at the theatre when it is known they will
 be there" (Horace Walpole to Horace Mann in W. S.
 Lewis, ed., *The Yale Edition of Horace Walpole's Correspon-
 dence*, 48 vols. [London: Oxford University Press,
 1965], 20: 311—20). Most women became celebrities
 through great physical beauty enhanced by scandal.
 Siddons was unusual in gaining attention for talent
 as well as beauty.

3. William Hazlitt, "Mrs. Siddons," *The Examiner*, 15 June
 1816, in P. P. Howe, ed., *The Complete Works of William
 Hazlitt*, 21 vols. (London and Toronto: J. M. Dent
 and Sons, Ltd., 1930), 5: 312; similarly, echoing
 Hazlitt, James Boaden opined, "She must be seen
 to be known" (James Boaden, *Memoirs of Mrs. Inchbald*,
 2 vols. [London: Richard Bentley, 1833], 1: 287);
 and the artist James Northcote observed, "if you had
 not seen Mrs. Siddons, you could have no idea of
 her. . . . She was like a preternatural being descended
 to the earth" ("Mr. Northcote's Conversations" in
 Howe, ed., *Complete Works*, 11: 307).

4. William van Lennep, ed., *Reminiscences of Sarah Kemble
 Siddons, 1773—1785* (Cambridge, Mass.: Widener
 Library, 1942), 20—21.

5. Florence Mary Parsons, *The Incomparable Siddons* (Lon-
 don: Methuen, 1909), 268.

6. Some claimed that she "owed most of her fame to her
 figure, countenance & deportment" (entry of Febru-
 ary 1796 in Kenneth Garlick and Angus Macintyre,
 eds., *The Diary of Joseph Farington*, 16 vols. [New Haven:
 Yale University Press, 1979], 2: 489).

7. Boaden, *Memoirs of Mrs. Inchbald*, 1: 2; Thomas Davies,
 *Dramatic Miscellanies: Consisting of Critical Observations on

 Several Plays of Shakespeare*, 3 vols. (Dublin: S. Price,
 1784), 3: 147; Lewis, ed., *Walpole's Correspondence*,
 33: 359—60.

8. James Ballantyne, *Characters by Mrs. Siddons* (Edinburgh:
 privately printed, 1812), 33.

9. Davies, *Dramatic Miscellanies*, 3: 147.

10. John Genest, *Some Account of the English Stage, from the Resto-
 ration in 1660 to 1830*, 10 vols. (Bath: H. E. Carrington,
 1832), 7: 306. As Alan Hughes has observed, George
 Romney shows Siddons mimicking the expressions of
 acute pain, fear, and horror as illustrated in Charles
 Le Brun's influential *Conférence sur l'expression générale*
 (1698); see Alan Hughes, "Art and Eighteenth-
 Century Acting Style. Part III: Passions," *Theatre
 Notebook* 41 (1987): 132.

11. William T. Whitley, *Thomas Gainsborough* (London:
 Smith, Elder, 1915), 370.

12. "Exhibition of the Royal Academy," *Universal Daily Reg-
 ister*, 5 May 1785, 2; "Mrs. Siddons," *Oracle*, 24 March
 1792, 3. On the failure of sculptors, painters, and
 poets to convey to posterity Siddons's awesome pres-
 ence, see Ballantyne, *Characters by Mrs. Siddons*, 40.

13. Siddons to George Siddons, Westbourne Farm, Pad-
 dington, 6 September 1808, letter 11, MS. Film 1686,
 Bodleian Library, Oxford. For additional disparage-
 ment of portraitists in the same correspondence, see
 letters 2 (30 June 1804), 20 (29 March 1812), 34
 (18 November 1816), and 46 (1 November 1821). See
 also Siddons to Elizabeth Adair, 9 December 1786,
 G7 (vol. 159; 1786—94), Barrington Papers, British
 Library, London; and Kennard, 153).

14. Siddons to John Taylor, 5 August 1793, private col-
 lection; Siddons to Lady Milbanke, 17 February 1809,
 Dep. Lovelace-Byron 14, f. 98, Bodleian Library,
 Oxford. See also Siddons to Elizabeth Adair, 16 Sep-
 tember 1796, G8 (vol. 160; 1795—1824), Barrington
 Papers, British Library, London; and William Sid-
 dons to his son, George Siddons, 2 February 1806,
 MS. Film 1686, Bodleian Library, Oxford.

15. Siddons to Sir Charles Hotham, 20 July 1787, in

A. M. W. Stirling, *The Hothams, Being the Chronicles of the Hothams of Scarborough and South Dalton*, 2 vols. (London: Herbert Jenkins, 1918), 2: 232.

16. Siddons to Bridget Wynn, 28 February 1790, TS.1272.73, Harvard Theater Collection, Cambridge, Massachusetts.

17. Siddons to Wynn, 29 March 1789, TS.1272.73, Harvard Theater Collection, Cambridge, Massachusetts.

18. Van Lennep, ed., *Reminiscences of Sarah Kemble Siddons*, 17.

19. Siddons to Elizabeth Adair, 19 October 1786, G7 (vol. 159; 1786–94), Barrington Papers, British Library, London; Siddons to Thomas Lawrence, n.d. [spring 1791], LAW/1/37, Lawrence Papers, Royal Academy, London.

20. Dramatic subjects were seen as a particular specialty of "rising artists" striving to launch their reputations ("Exhibition of the Royal Academy," *Universal Daily Register*, 2 May 1786, 3).

21. Boaden, *Memoirs of Mrs. Inchbald*, 1: 349.

22. Entry of 1 April 1783 in Elizabeth Anson and Florence Anson, eds., *Mary Hamilton, afterwards Mrs. John Dickenson, at Court and at Home, from Letters and Diaries, 1756 to 1816* (London: John Murray, 1925), 133; for "Siddonimania," see *Morning Post, and Daily Advertiser*, 23 June 1784, 2.

23. On Gainsborough, see Florence Mary Parsons, "Mrs. Siddons as a Portrait Sitter," *Nineteenth Century & After* 82 (September 1917): 620; on Reynolds, see Lady Barbara Stephens's manuscript biography of William Smith, M.P., c. 1940, 12, Add. 7621/712, Cambridge University Library.

24. *Morning Herald, and Daily Advertiser*, 23 April 1783, 3; *Morning Herald, and Daily Advertiser*, 12 March 1785 (cited in William T. Whitley, *Artists and Their Friends in England, 1700–1799*, 2 vols. [London: Medici Society, 1928], 2: 35).

25. Whitley, *Artists and Their Friends*, 2: 7–8; *Public Advertiser*, 26 April 1784, 3.

26. Siddons to the Whalleys, 15 March 1785, quoted in Nina H. Kennard, *Mrs. Siddons* (London: W. H. Allen and Co., Ltd., 1893), 153; Siddons to Dawson Turner, 13 March 1819, O.13.1739, Dawson Turner Manuscripts, Trinity College, Cambridge University; Siddons to Harriet Siddons, Y.c. 432(14), Folger Shakespeare Library, Washington, D.C.; Siddons to her son, George Siddons, 21 February, 19 June, and 21 July 1811, MS. Film 1686, Bodleian Library, Oxford.

27. Van Lennep, *Reminiscences of Sarah Kample Siddons*, 7.

28. Letter signed "Veritas," *Morning Chronicle, and London Advertiser*, 23 May 1783, 4.

29. "Stuart: The Vandyck of the Time," *World*, 18 April 1787 (cited in William T. Whitley, *Gilbert Stuart* [Cambridge, Mass.: Harvard University Press, 1932], 59–60).

30. Siddons to her son and daughter-in-law, George and Mary Siddons, 15 September 1813 and 29 August 1814, MS. Film 1686, Bodleian Library, Oxford.

31. Extracts from Siddons's detailed memoranda on various characters are published in Thomas Campbell, *Life of Sarah Siddons*, 2 vols. (London: Effingham Wilson, 1834).

32. *Morning Chronicle, and London Advertiser*, 1 May 1783, 3; *London Chronicle*, 1 May 1783, 4; and 3 May 1783, 3; *Parker's General Advertiser, and Morning Intelligencer*, 21 May 1783, 2.

33. Joshua Reynolds, *Discourses on Art* (1797), ed. Robert R. Wark (New Haven: Yale University Press, 1975), 62, see also 140.

34. Siddons imitates the "pensive Nun" of the poem, "devout and pure, / Sober, stedfast, and demure," who walks with "musing gate" and heavenward gaze, her "rapt soul" reflected in her eyes. The somber browns and blacks of Thomas Beach's palette are also dictated by John Milton's description, as is Siddons costume and the architectural setting of "studious Cloysters," "high embowed Roof," and "antique Pillars."

35. Letter signed "An Old Correspondent," *Public Advertiser*, 13 May 1783, 2.

36. *London Chronicle*, 11 October 1782, 355.

37. For Thomas Stothard's comments on Siddons on and off the stage, see Anna Eliza Bray, *Life of Thomas Stothard, R.A.* (London: John Murray, 1851), 96–97.

38. *Public Advertiser*, 24 April 1783, 3; *Gazetteer and New Daily Advertiser*, 3 May 1783, 3. The price was reported as 124 guineas in the *General Evening Post* (London), 20–22 May 1783, 4; and *Parker's General Advertiser, and Morning Intelligencer*, 23 May 1783, 2. See also Stirling, *Hothams*, 2: 225; and "Postscriptum, Exhibition of Paintings, &c. at the Royal Academy, Somerset-Place," *St. James's Chronicle; or, British Evening-Post*, 4 May 1784, 4.

39. Campbell, *Siddons*, 1: 191–92. For William Hamilton's advertisements, see "Mrs. Siddons," *Morning Herald, and Daily Advertiser*, 12 May 1783 and 1 and 31 May 1783, 1; *Morning Chronicle, and London Advertiser*, 14 May 1783, 1.

40. Lord Archibald Hamilton to Sir Charles Thompson, 10 October 1784, in Stirling, *Hothams*, 2: 221.

41. "Inscription on a Temple in the Gardens of Castletown by Mr. Napier at the request of Lady Louisa Conolly"; letter to Siddons from R. Bransby Cooper, Church Sq., Great Yarmouth, 11 December 1783; see also "Verses address'd to Mrs. Siddons" ("The Mind by pleasure harden'd, taught to moan, / O'er feigned distress & sorrows not its own"); "On Mrs. Siddons's Performance of Lady Randolph in the Tragedy of Douglas, Theatre, Plymouth Dock, Sept. 1790" ("Chill Apathy can feel when taught by thee / And Dullness, cur'd of mental blindness, see. / From thee th' obdurate Man shall learn to feel"); "To Mrs. Siddons" ("In listless indolence I pass'd my Life: / Felt neither pains, nor pleasures in excess / And thought, that Apathy was happiness: / But Siddons came, and at her magic call / The wildest passions fill'd my ravish'd Soul"), Siddons manuscript notebook, Bath Reference Library.

42. "We were there [Drury Lane] last night tho'; and I have scarcely slept since, for the strong Agitation into which Southerne and Siddons together threw me last night" (Hester Lynch Piozzi to Penelope Sophia Weston, London, 3 April 1789, in Edward A. Bloom and Lillian D. Bloom, eds., *The Piozzi Letters: Correspondence of Hester Lynch Piozzi, 1784–1821 (Formerly Mrs. Thrale)*, 4 vols. [Newark: University of Delaware Press, 1996], 1: 292).

43. "The Exhibition," *Morning Chronicle, and London Advertiser*, 17 May 1784, 3.

44. *Morning Post, and Daily Advertiser*, 11 June 1785, 2.

45. *London Chronicle*, 23 September 1783, 3.

46. Siddons to Dr. Whalley, 1 September 1787, in Percy Fitzgerald, *The Kembles*, 2 vols. (London: Tinsley Brothers, n.d.), 1: 254–55.

47. "Theatre: Drury Lane," *Times*, 19 May 1788, 3. For the vogue for theatrical representations of "distressed womanhood," see Christopher Reid, "Burke's Tragic Muse: Sarah Siddons and the Feminization of the *Reflections*" in Steven Blakemore, ed., *Burke and the French Revolution* (Athens: University of Georgia Press, 1992), 1–68.

48. Siddons to Lady Perceval, 24 November 1795, TS.1272.73, Harvard Theater Collection, Cambridge, Massachusetts.

49. Entry of 11 January 1789 in Balderston, ed., *Thraliana*, 2: 725. Sir Walter Scott drew a similar conclusion about Siddons's limitations in comparison with David Garrick (Scott to Miss Seward, ca. 1897, Add. MS. 37,425, f. 108, British Library, London).

50. *Universal Daily Register*, 15 May 1786, 3.

51. Siddons to Bridget Wynn, 3 June 1789 and 8 October 1781, TS.1272.73, Harvard Theater Collection, Cambridge, Massachusetts; Siddons to Elizabeth Adair (?), 4 April 1787, G7 (vol. 159; 1786–94), Barrington Papers, British Library, London.

52. Alan Hughes, "Art and Eighteenth-Century Acting Style. Part I: Aesthetics," *Theatre Notebook* 41 (1987): 27; and "Part II: Attitudes," 80–81; Dene Barnett, "The Performance Practice of Acting: The Eighteenth Century. V: Posture and Attitude," *Theatre Research International* 6 (October 1981): 1–32.

53. In addition to his grand tableau of the actress in character, William Hamilton also represented her in private life, sporting a feathered hat and ponderous corkscrew curls, in a drawing engraved and published by R. Blyth in 1780 (National Portrait Gallery Archives, London).

54. *Gazetteer and New Daily Advertiser*, 28 April 1784, 2.

55. Siddons to Elizabeth Adair, 19 November 1790, G7 (vol. 159; 1786–94), Barrington Papers, British Library, London.

56. James Boaden, *Memoirs of Mrs. Siddons*, 2 vols. (London: Henry Colburn, 1827), 1: 312.

57. John Thomas Smith, *A Book for a Rainy Day; or, Recollections of the Events of the Years 1766–1833*, ed. Wilfred Whitten (London: Methuen, 1905), 84.

58. *Morning Chronicle, and London Advertiser*, 7 February 1783, 3; see also "An Account of the Celebrated Mrs. Siddons [Embellished with a Striking Likeness]," *Westminster Gazette*, January 1783, 3–5. For Lawrence's connections with the Bath stage, see John Bernard, *Retrospections of the Stage*, 2 vols. (London: Henry Colburn and Richard Bentley, 1830), 2: 77–89.

59. *Morning Chronicle, and London Advertiser*, 18 March 1783, 1. For Pine, see Robert G. Stewart, *Robert Edge Pine: A British Portrait Painter in America, 1784–1788* (Washington, D.C.: National Portrait Gallery, 1979).

60. The drawing has hitherto been attributed to Hamilton on the basis of its vague resemblance to his painting *Sarah Siddons as Euphrasia*, but its closer correspondence to Pine's representation of the same subject recommends reattribution. On Siddons's sitting to Pine, see *Morning Chronicle, and London Advertiser*, 17 January 1783, 2.

61. Frances Ann Kemble, *Records of a Girlhood* (New York: Henry Holt, 1879), 190.

62. John Doran, *"Their Majesties' Servants": Annals of the English Stage from Thomas Betterton to Edmund Kean*, 2 vols. (New York: W. J. Middleton, 1865), 2: 305. Siddons favored the role in part "because the dress is so very impressive and advantageous" (Siddons to Elizabeth Adair, 19 November 1790, G7 [vol. 159; 1786–94], Barrington Papers, British Library, London).

63. The subject matter is identified in William Blake's letter to William Hayley of 23 February 1804 (Add. MS. 30,262, f. 86, British Library, London).

64. "The Man-Milliner. XI," *European Magazine* (March 1783): 192; *Public Advertiser*, 22 April 1783, 3; Whitley, *Artists and Their Friends*, 1: 392. Siddons later claimed that she was unable to keep her appointments with Romney and gave "one sitting, and one only" (Parsons, "Mrs. Siddons as a Portrait Sitter," 621). Six sessions with the actress are, however, recorded in Romney's diary for 1783 (Add. MS. 38,083, British Library, London).

65. "The Man-Milliner. XI," *European Magazine* (March 1783): 192. For the most important discussion of this painting, see Jennifer C. Watson, "Mrs. Siddons and Tryphosa Jane Wallis," *Apollo* 136 (September 1992): 147–51.

66. Watson, "Mrs. Siddons," 148.

67. Campbell, *Siddons*, 1: 192.

68. It was identified as such in a letter of 23 February 1804 from William Blake to William Hayley: "He [the owner, Mr. Braithwaite] shewed me a very fine Portrait of Mrs. Siddons (by Romney) as the Tragic Muse half length, that is the Head & hands, & in his best style" (Add. MS. 30,262, f. 86, British Library, London).

69. For a comparison of Romney's portrait of Mary Ann Yates with Reynolds's portrait *Sarah Siddons as the Tragic Muse*, as embodiments of contrasting theatrical styles, see Michael S. Wilson, "The 'Incomparable' Siddons as Reynolds's Muse: Art and Ideology on the British Stage," in Ann Hurley and Kate Greenspan, eds., *So Rich a Tapestry: The Sister Arts and Cultural Studies* (Cranbury, N.J.: Associated University Presses, 1995), 117–48.

70. Siddons, in turn, faced constant challenges from rising young actresses who sought to usurp her authority. She and her friends kept an anxious eye on the latest theatrical star to ignite public enthusiasm (see, for example, Bloom and Bloom, eds., *Piozzi Letters*, 1: 183, 4: 176). In later life, she reflected ruefully on the heady years when she was "in the plenitude of that interest which youth, beauty, and above all Novelty, could bestow upon me" (Siddons to George Siddons, Warwickshire, 18 September 1815, letter 30, MS. Film 1686, Bodleian Library, Oxford).

71. "Exhibition," *Morning Chronicle*, 8 May 1786, 4.

72. Whitley, *Artists and Their Friends*, 63.

73. Romney also appears to have executed a whole-length

portrait, *Sarah Siddons in the Character of Jael*, illustrating a violent Old Testament episode: "Then Jael (Heber's wife) took a nail of the tent, and took a hammer in her hand, and went softly unto him, and smote the nail into his temples, and fastened it into the ground, for he was fast asleep and weary, so he died" (Judges 4 : 21).When exhibited in the early nineteenth century, the catalogue entry claimed: "This was allowed twenty years ago to be a striking likeness of the above celebrated and accomplished actress" (European Museum [London], catalogues, dated May 1812– 29 August 1814, Getty Provenance Index).

74. Parsons, "Mrs. Siddons as a Portrait Sitter," 621.

75. Whitley, *Artists and Their Friends*, 2: 7–8.

76. *Public Advertiser*, 1 May 1783, 4. "It is rather a Matter of Surprize that this popular Actress should not yet have attracted the Pencil of any of the Academicians, while there are two Pictures of her in this Exhibition" (letter regarding the Society of British Artists exhibition, signed "H.," *Public Advertiser*, 10 May 1783, 2).

77. Van Lennep, ed., *Reminiscences of Sarah Kemble Siddons*, 16.

78. Siddons's pretensions to the elevated "chair" occupied by Yates formed the subject of "Theatrical Intelligence," *Morning Chronicle, and London Advertiser*, 27 January 1783, 3: "This night affords the first instance of what the publick have long wished for— an opportunity of comparing Mrs. Siddons and Mrs. Yates in Jane Shore. The latter has for these twenty years preceding the present season, been allowed to be infinitely superior to every competitor in the character; within the last three months, publick fame has lifted Mrs. Siddons into a chair of equal elevation—whether she is entitled to that situation or not, this evening will determine." For Yates's rivalry with Siddons, see Genest, *Some Account of the English Stage*, 6: 346; Edgar Wind, *Hume and the Heroic Portrait: Studies in Eighteenth-Century Imagery*, ed. Jaynie Anderson (Oxford: Clarendon Press, 1986), 44–46.

79. For a contemporary criticism of the poem, see *London Review*, March 1783, 203.

80. The advertisement for a reprint of John Bell's series noted "ten different figures of the dramatic muses, as frontispieces to each volume, designed on purpose for this work by the late Mr. Mortimer" (*London Courant, and Westminster Chronicle*, 25 May 1780, 1).

81. "Exhibition of the Royal Academy. 1784," *Public Advertiser*, 28 April 1784, 2; *London Chronicle*, 27–29 April 1784, 416.

82. Robert R. Wark, *Ten British Pictures, 1740–1840* (San Marino, Calif.: Huntington Library, 1971), 49–51.

83. For a possible connection between *Maria, Duchess of Gloucester* and Albrecht Dürer's *Melancholy*, see *Gainsborough & Reynolds: Contrasts in Royal Patronage* (London: Queen's Gallery, 1994), 54.

84. For Thomas Cooper's criticism of 1785, see Parsons, "Mrs. Siddons as a Portrait Painter," 619.

85. "Royal Academy (Continuation of Sir Joshua Reynolds's Pictures)," *St. James's Chronicle*, 29 April 1784, 4; *Morning Herald, and Daily Advertiser*, 28 April 1784, 2.

86. Van Lennep, ed., *Reminiscences of Sarah Kemble Siddons*,

17–18. "The Color of the face was kept *pale* at her *request* as more proper to the character" (entry of 2 May 1797 in Garlick and Macintyre, eds., *Diary of Joseph Farington*, 3: 832). For Siddons's similar comment on Benjamin Hayden's painting *Christ's Triumphant Entry into Jerusalem*, see William T. Whitley, *Art in England, 1800–1820* (Cambridge: Cambridge University Press, 1928), 315.

87. Van Lennep, ed., *Reminiscences of Sarah Kemble Siddons*, 18.

88. See also "Review of the Royal Academy Exhibition," *Morning Post, and Daily Advertiser*, 5 May 1784, 3. Comments made by the artist's niece, Lady Inchiquin (entry of 3 November 1799 in Garlick and Macintyre, eds., *Diary of Joseph Farington*, 4: 1297).

89. *General Evening Post*, 24–27 April 1784, 4; "The Exhibition," *Public Advertiser*, 1 May 1784, 2; "The Exhibition," *Morning Chronicle, and London Advertiser*, 17 May 1784, 3. See also "Royal Exhibition, Continued," *London Chronicle*, 1 May 1784, 421; "Poet's Corner: To Sir Joshua Reynolds, on His Portrait of Miss Kemble, in the Exhibition at the Royal Academy," *St. James's Chronicle*, 27 April 1784; "Exhibition of the Royal Academy. 1784," *Public Advertiser*, 28 April 1784, 2.

90. *London Chronicle*, 19 November 1785, 485.

91. Richard Cosway's undated drawing may bear some relation to the "delicate small whole-length" of Siddons that the *Morning Herald* described him as finishing in March 1785 (Whitley, *Artists and Their Friends*, 2: 35).

92. George Richardson, *Iconology; or, A Collection of Emblematical Figures*, 2 vols. (London: G. Scott, 1779).

93. One critic noted that "surely her [Siddons's] figure might have appeared much more dignified had she been erect ("Royal Academy [Continuation of Sir Joshua Reynolds' Pictures]," *Morning Herald, and Daily Advertiser*, 28 April 1784, 2). Reynolds's friend Mary Hamilton noted in her diary on 8 May 1784: "I wish he had not placed her in an Arm-Chair, wch resembles Stone & too ponderous to be borne up by Clouds, neither is the Lady Macbeth's figure sylph like enough to be wafted upwards by a Breeze, even without the chair" (Anson and Anson, eds., *Mary Hamilton*, 179).

94. Cosway's putto also recalls the cherub that Reynolds ultimately excised from the lower left corner of the *Tragic Muse*. William Hazlitt, no doubt thinking of Ripa, interpreted Reynolds's cherub as "a dead child" (see "A Sublime and Masterly Performance," note 60 in this volume).

95. Richard Cosway to Mr. Cumberland, Berkeley Street, n.d. (probably 1783 or 1784), in Whitley, *Artists and Their Friends*, 2: 35–36. Siddons gave a similarly free hand to Ozias Humphrey, writing prior to her first sitting that she left "it entirely to the determination of Mr Humphry, whether the Picture shall be a large miniature, or a small whole length" (undated letter, ALS Sarah Siddons, Harvard Theater Collection, Cambridge, Massachusetts).

96. The mask-holding gesture in William Beechey's portrait also recalls Romney's portrait of the actress Elizabeth Hartley of ca. 1782 (ex-Sotheby's, 3 April 1996, 71).

97. William Roberts, *Sir William Beechey, R.A.* (London: Duckworth, 1907), 45.
98. Ibid., 45–46.
99. Entries of 3 January 1797 and 3 January 1800 in Garlick and Macintyre, eds., *Diary of Joseph Farington*, 3: 737 and 4: 1341. Sir Gilbert Elliot observed in a letter of 12 April 1787 that off the stage Siddons spoke "in a slow, set, and studied sort of phrase and accent very like the most familiar passages of her acting, but still in a degree theatrical" (Nina, countess of Minto, ed., *Life and Letters of Sir Gilbert Elliot, First Earl of Minto, from 1751 to 1806*, 3 vols. [London: Longmans, Green, 1874], 1: 152).
100. Ronald Sutherland Gower, *Sir Thomas Lawrence* (London: Goupil, 1900), 32.
101. The scene painting was by Thomas Greenwood, who worked for Drury Lane Theatre. See Percy Noble, *Anne Seymour Damer* (London: Kegan, Paul, Trench, Trübner, 1908), 96–97; Sybil Rosenfeld, *Temples of Thespis: Some Private Theatres and Theatricals in England and Wales, 1700–1820* (London: Society for Theatre Research, 1978), 36.
102. *St. James's Chronicle; or, British Evening-Post*, 24 May 1788, 4.
103. Jane Munro, *John Downman, 1750–1824* (Cambridge: Fitzwilliam Museum, 1996), 16.
104. "Remarks upon the Present Taste for Acting Private Plays," *European Magazine* (August 1788), cited in Rosenfeld, *Temples of Thespis*, 14.
105. Davies, *Dramatic Miscellanies*, 3: 147.
106. "Royal Academy: Exhibition of Pictures," *General Advertiser*, 28 April 1785, 3.
107. *Morning Post, and Daily Advertiser*, 5 May 1785, 2.
108. *Gainsborough & Reynolds*, 36.
109. Reynolds, *Discourses*, 62, see also 140.
110. "Mr. Gainsborough, the Painter," *Morning Chronicle, and London Advertiser*, 8 August 1788, 3.
111. Boaden, *Memoirs of Mrs. Inchbald*, 1: 312. For another examination of Siddons's innovative cultural role in expanding the range and nature of "feminine" attributes, see Pat Rogers, "'Towering Beyond Her Sex': Stature and Sublimity in the Achievement of Sarah Siddons," in Mary Anne Schofield and Cecilia Macheski, eds., *Curtain Calls: British and American Women in the Theater, 1660–1820* (Athens: Ohio University Press, 1991), 48–67.
112. "Royal Academy," *Times*, 28 April 1804, 2. See also Boaden, *Memoirs of Mrs. Inchbald*, 1: 342.
113. Gower, *Lawrence*, 88.
114. See Shearer West, "Thomas Lawrence's 'Half-History' Portraits and the Politics of Theatre," *Art History* 14 (June 1991): 225–49.
115. Kenneth Garlick, *Sir Thomas Lawrence: Portraits of an Age, 1790–1830* (Alexandria, Va.: Art Services International, 1993), 134.
116. Entry of 7 January 1800 in Garlick and Macintyre, eds., *Diary of Joseph Farington*, 4: 1345. For confirmation of Lawrence's opinion, see William T. Whitley, *Art in England, 1821–1837* (Cambridge: Cambridge University Press, 1930), 215.
117. Whitley, *Art in England (1821–1837)*, 83.
118. Comments of Siddons and her family recorded in entries for 17 May 1796 and 2 May 1797 in Garlick and Macintyre, eds., *Diary of Joseph Farington*, 2: 550, 3: 832. This portrait and other major works owned by Siddons and her family were almost certainly bestowed as gifts rather than paid for as commissions. When the actress herself commissioned portraits as gifts for friends and family, she tended to favor inexpensive items, such as miniatures, and relied on minor artists, such as a paraplegic woman known as "Miss Bissen" (Siddons to her son and daughter-in-law, George and Mary Siddons, ca. March/April 1823, letter no. 48, MS. Film 1686, Bodleian Library, Oxford).
119. Whitley, *Artists and Their Friends*, 2:214.
120. Cited in Douglas Goldring, *Regency Portrait Painter: The Life of Sir Thomas Lawrence, P.R.A.* (London: Macdonald: 1951), 111.
121. Siddons to Hester Piozzi, 15 May 1795, HM24015, Huntington Library, San Marino, California.
122. Entry of 2 March 1804 in Garlick and Macintyre, eds., *Diary of Joseph Farington*. By November the rumor had spread that the artist and his sitter had eloped, prompting William Siddons to publish a notice in the *Times* offering one thousand pounds for information leading to the conviction of the rumor's perpetrator (Whitley, *Art in England, 1800–1820*, 219).
123. Boaden, *Memoirs of Mrs. Siddons*, 2: 283–89.
124. Van Lennep, ed., *Reminiscences of Sarah Kemble Siddons*, 22.
125. Siddons to George Siddons, 22 September 1803, letter 1, MS. Film 1686, Bodleian Library, Oxford.
126. "Royal Academy," *Times*, 28 April 1804, 2.
127. Lawrence intended to make two small copies from the painting, one for the print and another for "a most particular Friend" (Lawrence to Caroline Fitzhugh, 4 August 1804, typescript copy in National Portrait Gallery Archives, London).
128. Siddons to Harriet Siddons, October (1809?), Y.c. 432(14), Folger Shakespeare Library, Washington, D.C.; Siddons to George Siddons, 21 February, 19 June, and 21 July 1811, letters 17–19, MS. Film 1686, Bodleian Library, Oxford.
129. Minto, ed., *Elliot*, 3: 239; see also Parsons, *Incomparable Siddons*, 264.
130. Mrs. St. George (later Mrs. Trench) cited in Parsons, *Incomparable Siddons*, 263.
131. She repeated the role when recalled to the stage for benefit performances in 1813, 1816, and 1817 (Genest, *Some Account of the English Stage*, 7: 312).
132. Whitley, *Art in England (1800–1820)*, 272.
133. Ballantyne, *Characters by Mrs. Siddons*, 32–33; see also Fleeming Jenkin, *Papers Literary, Scientific, &c.*, ed. Sidney Colvin and J. A. Ewing (London: Longmans, Green, 1887), 76.
134. Kemble, *Records of a Girlhood*, 3; Lawrence to Mrs. Angerstein, 22 November 1827 (cited in Gower, *Lawrence*, 32). See also John Gibson Lockhart, *The Life of Sir Walter Scott*, 10 vols. (Edinburgh: T. A. Constable, 1902), 1: 302–3.
135. Hazlitt, *Complete Works*, 5: 312.

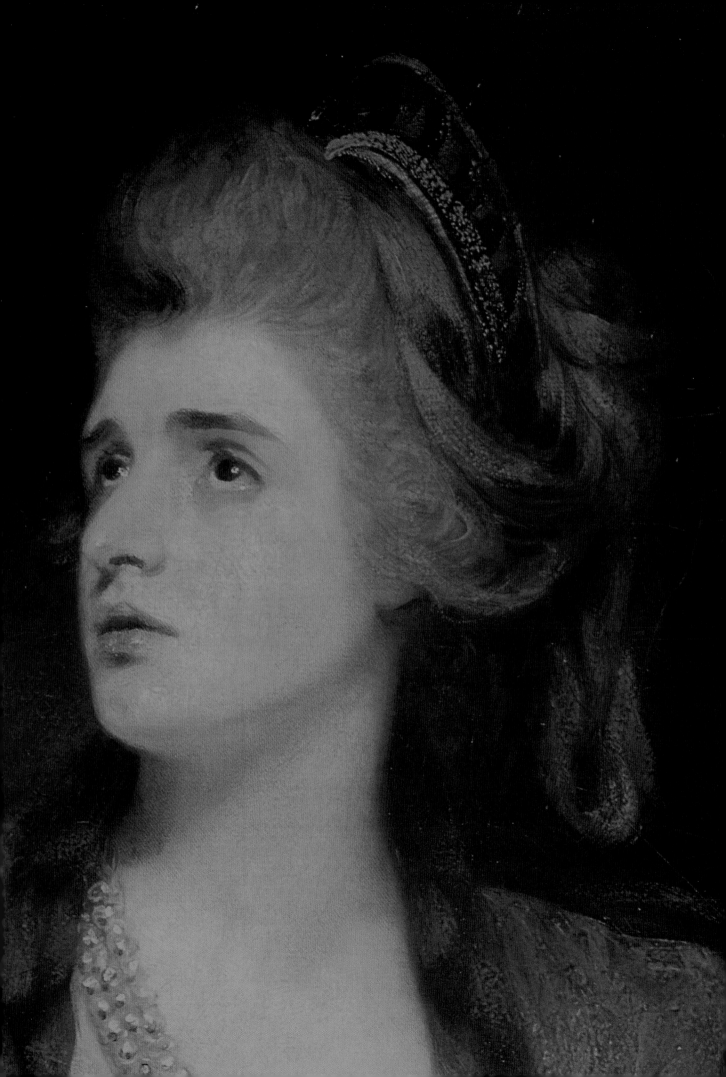

"A Sublime and Masterly Performance":

The Making of Sir Joshua Reynolds's

Sarah Siddons as the Tragic Muse

SHELLEY BENNETT
MARK LEONARD
With technical studies by NARAYAN KHANDEKAR

THIS ESSAY EXAMINES THE TWO GREAT MASTERPIECES OF Sir Joshua Reynolds's career: his painting *Sarah Siddons as the Tragic Muse* and his own carefully crafted image as an artist. Although Reynolds ultimately figured among the most prominent members of Georgian society and was arguably one of the most influential artists of the eighteenth century, he, like Sarah Siddons, had to overcome modest social origins in order to achieve success. The son of a cleric, he worked assiduously to establish his artistic preeminence during the late 1750s and early 1760s. He also forged prestigious social contacts, counting among his friends such literary luminaries as Samuel Johnson. On the founding of the Royal Academy of Arts in 1768, Reynolds was elected president and was subsequently knighted by George III—the first painter to receive such an honor since 1692. Indeed, before Reynolds's time, Britons regarded painting as a tradesman's craft rather than a creative art. Reynolds transformed this view, and his efforts on behalf of the profession did much to elevate the status of the artist in British society. The series of *Discourses* that he delivered annually to students of the Royal Academy did not deal with the mundane matters of artists' materials and techniques; instead they aimed to inspire the students' minds to loftier realms, "to that spark of divinity which we have within,"[1] to use Reynolds's own words.

Opposite:
JOSHUA REYNOLDS.
Sarah Siddons as the Tragic Muse (detail), 1784. (See fig. 10, p. 114.)

Although artistic skill made possible Reynolds's rise to fame and fortune, his success was undoubtedly accelerated by the polished public persona that he carefully cultivated. In attesting to Reynolds's superior claims to the presidency of the Royal Academy, his studio assistant and biographer James Northcote scarcely noted his master's painterly abilities, observing instead that "it is certain that, every circumstance considered, he was the most fit, if not the only person, qualified to take the chair: his professional rank, his large fortune, the circle of society in which he moved, all these contributed to establish his claim."[2] The presidency lent Reynolds tremendous authority, and "[he] received it with satisfaction, as he well knew that it would give additional splendour to his works in vulgar eyes."[3] Reynolds further enhanced his mystique as an artist through pursuit of Old Master painting techniques. His supposed access to the "secrets" of the great artists of the past added an illustrious patina to his reputation. Tempering this impressive facade was Reynolds's personal charm and instinctive insight into the vanities and aspirations of his clients. All of these factors informed the practical procedures and physical environment that Reynolds devised for his studio, which mirrored the Georgian stage as a site of social ferment, artistic experimentation, and self-fashioning for the artist and his sitters alike.[4] There, portraits evolved as the result of spontaneous performance and collaborative interchange.

The making and marketing of *Sarah Siddons as the Tragic Muse* provide dramatic glimpses of these aspects of the Georgian artist's studio. Setting the seal on Reynolds's preeminence while crystalizing the fame of Siddons herself, the portrait inspired speculation and myth making from its inception. Its legendary status bolstered the demand for engravings as well as painted copies, some of which were produced under Reynolds's eye in his own studio. By comparing the original painting of 1784 (now in the Huntington Art Collections) with a version painted in 1789 (now in the Dulwich Picture Gallery), this essay sheds light on Reynolds's arcane painting techniques while examining his strategic use of the portrait to mold public perception of his genius.

THE MUSE OF HISTORY

Reynolds was captivated with the endless variety of visual effects achieved by the "great Painters"[5] and "celebrated Masters"[6] who came before him. He spent two years in Rome while still in his early twenties (from 1750 until 1752), and his journals and sketchbooks from that time are filled with comments about the paintings he saw, as well as his observations and interpretations of the techniques that other artists may have used to achieve their various visual effects.[7] In 1781, just three years before he painted *Sarah Siddons as the Tragic Muse*,

he spent a considerable amount of time traveling through Northern Europe, again taking many notes about paintings and painters' techniques. He was particularly impressed with Rubens, Rembrandt, and a number of Rembrandt's followers. In describing a room full of eight Rembrandts in Düsseldorf, Reynolds commented that "the chief merit of [the room] consists in [Rembrandt's] peculiarity of manner, of admitting but little light, and giving to that little a wonderful brilliancy."[8] Reynolds's admiration of such a lighting scheme must have led him to the dramatic, and very Rembrandtesque, use of light in the portrait of Sarah Siddons. His emulation of Rembrandt is also reflected in both the color scheme (which is nearly monochromatic yet because of the rich warmth of the tones infuses the entire painting with a glowing brilliance) and the vigorous texture of the thick brushwork (which stands out in high relief on the surface of the canvas, particularly in the heavy fabrics of Siddons's costume).

Today, we understand that the true "secrets" of the Old Masters are to be found in the solidity and straightforward nature of their painting techniques, which were based upon strong traditions of studio training and guild practice. Much of our current understanding comes from the fact that we are able to rely upon a variety of scientific analytical techniques to discover how pictures are constructed. In the eighteenth century, however, none of these techniques was available, so artists were left to speculate on the mysteries of how their predecessors produced their pictures. Reynolds's interest in the technical "secrets" of the Old Masters could lead him to obsessive behavior with the pictures in his own collection, often with dire consequences. As Northcote relates, "I remember once, in particular, a fine picture of Parmegiano [sic], that I bought by his order at a sale, which he rubbed and scoured down to the very pannel on which it had been painted, so that at last nothing remained of the picture."[9] However, this anecdote does underscore the fact that Reynolds (like all great artists) understood quite well that the underlying structure of a painting plays an important role in creating a firm foundation for the final visual effects that are seen on the surface.

Reynolds's fascination with re-creating the visual effects of the Old Masters led him to use a range of painting materials that, even in his own lifetime, often led to disaster. In his own technical notes, Reynolds referred to the bizarre materials and mixtures that he developed for the purpose. An entry for a portrait painted in 1772, for example, claims that the picture was prepared with "gum tragacanth and whiting then waxed then egged then varnished" and that the cracks were subsequently "retouched."[10] Recent analysis of many Reynolds pictures has led to the conclusion that the only consistent thing about Reynolds's technique is its complete inconsistency.[11] The diverse and dynamic ambiance of Reynolds's studio undoubtedly encouraged him

to experiment with both the process and technique of painting, habitually breaking the rules. As Gainsborough so aptly said of him, "damn him, how various he is!"[12] We know that he was fond of using megilp,[13] a mixture of mastic and oil, that would have heightened the luminous appearance of his oil paint. Unfortunately, despite its initial translucency and seductively creamy texture, megilp-based paints develop a disturbing series of deep contraction cracks that completely disrupt the visual unity of the surface (a problem that has occurred in the 1789 version of *Sarah Siddons as the Tragic Muse*). But in addition to megilp, Reynolds used a number of other media and mixtures; some of his pictures were entirely painted with wax (a technique that had been introduced in France in the 1750s),[14] while others combined layers of oil paint sandwiched between mixtures of resins, waxes, and oils.

In addition to unorthodox media, Reynolds was seduced by pigments that often proved fugitive or problematic. One such material was bitumen, a warm black pigment, much prized by eighteenth-century artists because of its ability to produce glazes of exceptional depth and translucency. Unfortunately, bitumen (or asphaltum, as it is sometimes called) is basically a type of tar that, even when mixed with proper drying oils, never fully dries to a solid layer. As a result, bitumen-containing paint films tend to crack and shrink in alarming ways, often resulting in disfigured surfaces (as, again, appears to have been the case with the 1789 version of *Sarah Siddons as the Tragic Muse*). Reynolds was particularly fond of using a transparent red lake as a glaze in the flesh tones of his portraits;[15] the effect produced was undoubtedly one of exceptional warmth and delicacy. Unfortunately, the lake pigments that he used, particularly in his earlier works, were exceptionally fugitive, so that by the mid-1750s Reynolds's portraits were notorious for fading to the point that the skin tones took on a deathly pallor. The artist insisted on using these fugitive pigments, however. Northcote claims that he tried to convince Reynolds to use vermilion (an opaque and quite stable red pigment) instead of the fugitive lakes in 1775, but he was rebuffed by Reynolds, who "looked on his hand and said 'I can see no vermilion in flesh.'"[16]

Reynolds's patrons often paid the price for his obstinacy. A painting of *The Nativity* (exhibited at the Royal Academy in 1779) evidently fell apart during its transit to the Duke of Rutland. In a letter to the duke in 1784, Reynolds denied that his painting techniques had anything to do with the problem, claiming that "the falling off of the colour must [have been] occasioned by the shaking in the carriage."[17]

There is an element of theatrical bravado in Reynolds's self-confident pursuit of experimental methods. In the same way that Siddons disregarded her critics and colleagues in order to revise roles in accordance with her personal convictions, so Reynolds cultivated a dramatic air of self-reliance in his pursuit of unorthodox methods.

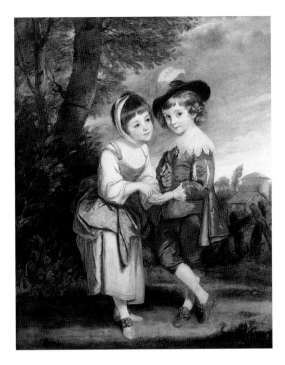

Figure 1.

THE STUDIO AS STAGE SET

Analogies between the artist's studio and the theatrical stage under-score the fact that Georgian portrait painting was in essence a performance art. The sitter posed before the painter, while the artist performed with paint before the sitter. Reynolds's contemporaries recognized and celebrated this performative aspect of his portraits. One of the numerous laudatory reviews that appeared after the exhibition of *Sarah Siddons as the Tragic Muse* at the Royal Academy in 1784 noted: "It is indeed a most sublime and masterly Performance. . . . He seems to have conceived, and executed it with ENTHUSIASM."[18] Reynolds often encouraged his sitters to play unaccustomed roles, complete with costumes and props (fig. 1).[19] Indeed, one of the most popular conventions of eighteenth-century portraiture was to be represented in a guise one would not have assumed in daily life. To cater to this fashion, Reynolds, like most of his fellow artists, seems to have kept a collection of historic, masquerade, and fantasy (or "fancy") dress costumes and fabrics in his studio. Mary Isabella, Duchess of Rutland, noted that she had to try on "eleven different dresses" for her portrait before Reynolds painted her "in that bedgown."[20] For her depiction as the immortal Tragic Muse, Siddons was presented in a timeless, generalized costume.[21]

Reynolds also decked himself out with costumery and props that deliberately recall Rembrandt's portraits of scholars and learned men. In his self-portrait *Sir Joshua Reynolds* (fig. 2), the robes, the hat,

Figure 1.
JOSHUA REYNOLDS
(British, 1723–1792).
The Young Fortune-Teller,
1775. Oil on canvas,
139.7 × 109.2 cm
(55 × 43 in.).
The Huntington.

the pose, and the bust in the background echo the appearance of such Rembrandt subjects as *Aristotle Contemplating the Bust of Homer* (fig. 3). It is significant that Reynolds chose to represent himself in a manner that deliberately recalls the Old Masters. In this way, he reinforced the connections between his own practice and that of the celebrated painters of the past.

Contemporaries noted that Reynolds did not sit when painting but was in perpetual motion.[22] He was engaged in a performance before the sitter, who was the paying audience. The size of the audience was increased by the common practice for the clients to bring with them their friends and relatives.[23] Reynolds used a paddle-shaped palette and brushes measuring about nineteen inches, so that he could easily see his sitter, who in turn could view him at work.[24] To further the sitter's ability to watch his performance, he placed beside the sitter's chair "a Chippendale mirror of dark mahogany carved with sprigs of flowers."[25] Dr. James Beattie, who sat to Reynolds in 1773, noted in his diary: "By placing a large mirror opposite to my face, Sir Joshua Reynolds put it into my power to see every stroke of his pencil [i.e., paint brush]; and I was greatly entertained to observe the progress of the work, and the easy and masterly manner of the artist."[26]

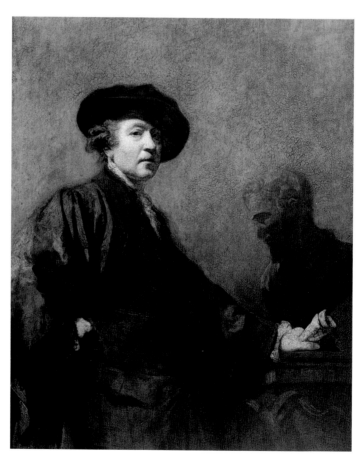

Figure 2.

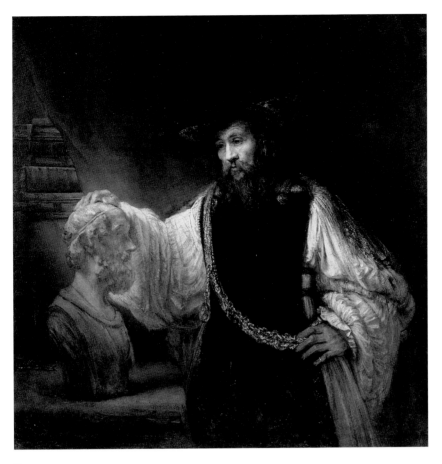

Figure 3.

Watching painters at work has often been appreciated as a source of enjoyment.[27] For Reynolds, the production of pleasure was a noble objective, a goal that further associated the performance of the artist with that of the actor. As he commented to Boswell, "I do not perceive why the profession of a player should be despised; for the great and ultimate end of all the employments of mankind is to produce amusement."[28] In his studio, the eloquent flow of polite conversation would have made genteel sitters feel at ease, thus veiling the social distinctions between artist and client and enabling the painter to capture a characteristic likeness. Indeed, the eighteenth-century artist and art commentator George Vertue noted that portrait painters needed "an affable and obliging Temper, with a share of Wit."[29] Reynolds, who was known for the lively conversation of his dinners, evidently adapted the same social skills to the environment of his studio.[30] As Mary Hamilton wrote in 1785, "Sir J.R. [Joshua Reynolds] is always cheerful & one of the pleasantest men I know in society, particularly in his own House, where he makes every one feel perfectly at ease."[31] It would seem that Reynolds's manner of charming his sitters involved a heavy dose of flattery. We know from Sarah Siddons that he began their session "with more gratifying encomiums than I dare repeat."[32] Flattery,

Figure 2.
JOSHUA REYNOLDS.
Sir Joshua Reynolds,
ca. 1773. Oil on panel,
127 × 101.6 cm
(50 × 40 in.). © Royal
Academy of Arts, London.

Figure 3.
REMBRANDT
HARMENSZ. VAN RIJN
(Dutch, 1606–1669).
*Aristotle Contemplating the
Bust of Homer*, 1653. Oil on
canvas, 143.5 × 136.5 cm
(56 1/2 × 53 3/4 in.). New
York, The Metropolitan
Museum of Art. Purchase,
special contributions and
funds given or bequeathed
by friends of the Museum,
1961.

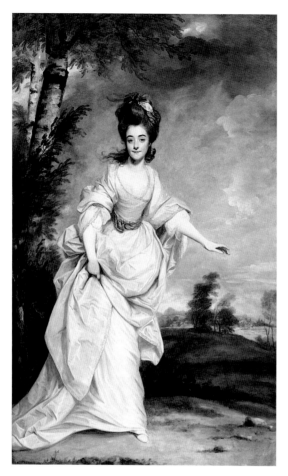

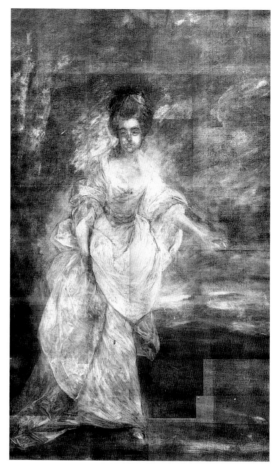

Figure 4.

Figure 5.

Figure 4.
JOSHUA REYNOLDS.
Diana, Viscountess Crosbie,
1777. Oil on canvas,
236.2 × 144.8 cm
(93 × 57 in.).
The Huntington.

Figure 5.
X-ray computer composite
of *Diana, Viscountess Crosbie*.

Figure 6.
JOSHUA REYNOLDS.
Mrs. Hale as Euphrosyne,
1766. Mezzotint engraved
by James Watson (British,
1740–1790), 61.9 × 38.1 cm
(24 3/8 × 15 in.). The
Huntington.

George Romney's son noted, was the painter's principal instrument in enticing patrons.[33] Skill in engaging the interests of clients was particularly important in relieving the tedium associated with sitting for a portrait, which involved repeated studio visits of varying lengths.

In the dynamic environment of Reynolds's studio, the creation of a portrait embodied a collaborative effort between the sitter (or patron) and the artist. A recent X-ray of Reynolds's portrait of *Diana, Viscountess Crosbie* (figs. 4–5), dated 1777, helps to reconstruct one of the many types of noncontractual negotiations that probably took place between patron and artist in the studio. The serious facial expression seen in the X-ray is what one expects to find in late-eighteenth-century portraiture. In the final image, Reynolds changed Lady Crosbie's expression to a more unusual, simpering smile. Since this expression departs from his typical Grand Manner presentation, Reynolds probably made the alteration in response to the demands of the patron, the sitter's fiancé. It is likely, however, that the expression was not changed to make it more characteristic of Lady Crosbie's personality but to match it more closely to Reynolds's well-known allegorical portrait of *Mrs. Hale as Euphrosyne*, which preceded his painting of Lady Crosbie and

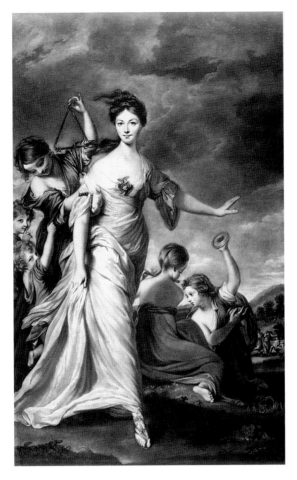

Figure 6.

probably was the prototype for the smile and the unusual pose.[34] The patron probably knew the 1766 mezzotint after *Mrs. Hale as Euphrosyne* (fig. 6). He may have seen it in the portfolio of prints after Reynolds's portraits that the artist kept in his waiting room and then requested that the painting be based on it—without the allegory and extra figures—later complaining when the serious expression Reynolds initially painted did not match the print.

Catering to a patron's wishes was common artistic practice in the eighteenth century. Indeed, the patron's contributions to the conception of a painting could be profound. In a remarkable letter of 1775 to the statesman Edmund Burke, the Duke of Richmond wrote:

> *You promised to sit for your picture to Mr. Romney. . . . I doubt not but you have now some other busines of great importance on your hands; but if I wait for your picture till you have nothing to do I am likely to go without it . . . I have thought of a method even to reconcile your business with this sitting, which is by having Mr. Romney to take your portrait while you are reading or writing, whichever you like best. . . . Romney has half finished one of me, which, for my own convenience, I chose to have reading.[35]*

Portrait painters had to accommodate their patrons in various ways. In the collaborative venture of portrait painting, not only did the artist perform for the patron, the sitter performed for the artist.

Because of the importance of the studio as a "stage set" for the entertainment and self-fashioning of his sitters as well as himself, Reynolds, like other successful portrait painters, devoted considerable attention to the creation of an appropriate atmosphere.[36] When he moved in 1760 from his house and studio in Great Newport Street to a larger house in Leicester Fields (now Leicester Square), he added "a splendid gallery for the exhibition of his works, and a commodious and elegant room for his sitters."[37] In order to make his aristocratic clients feel at home while conveying a lavish impression of his own wealth and status, Reynolds expended large sums on decorating the studio and gallery, dressing his servants in livery and maintaining an elaborate coach. He combined his professional and social aspirations by hosting a ball with refreshments to "a numerous and elegant company" in his gallery.[38] It is not surprising that visits to the galleries of Reynolds and other fashionable painters became a popular pastime of the well-to-do.[39]

But Reynolds's gallery and home were open to a broad social spectrum. At the private entertainments he hosted, his guests were drawn from an eclectic range, including leading literary figures as well as members of the aristocracy and well-known actors and actresses.[40] As Sarah Siddons recalled in her reminiscences: "I had frequently the honour of Dining with Sir Joshua Reynolds in Leicester Square. At his house were assembled all the good, the wise, the talented, and rank and fashion of the age."[41] The unceremonious, informal nature of Reynolds's dinner parties was often commented upon, as was the social muddle of these occasions.[42] A similar social amalgam was present in his studio. Young art students were permitted to study there. Journalists also seem to have been allowed free access to the "show-room" and the studio of Reynolds, as they were to the premises of other late-eighteenth-century painters.[43] Moreover, evidence suggests that Reynolds's studio was a place where respectable and disreputable people often mixed. The surviving appointment books for Reynolds's sitters indicate that well-known "courtesans" of the day, such as Nelly O'Brien (fig. 7) and Kitty Fisher (fig. 8), and actresses such as Mrs. Abington, a former flower-seller and prostitute, were in and out of his studio, sitting for their portraits at all times of the day to cater to the flourishing market for their images.[44] These women would inevitably have brushed shoulders with members of high society of both genders who came to sit for their own portraits.

Social boundaries were very subtly drawn in late-eighteenth-century London, and Reynolds's studio was essentially a microcosm of the world outside his door. Residing in houses adjoining his in Lei-

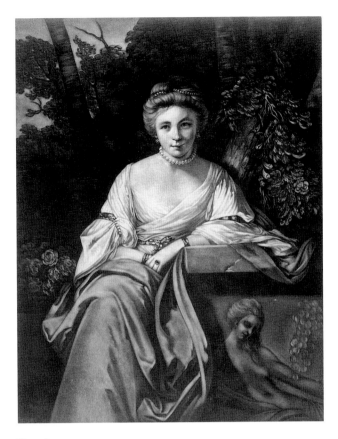

Figure 7.

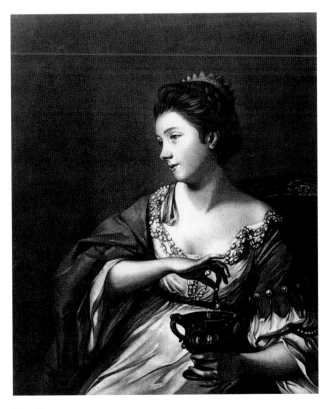

Figure 8.

Figure 7.
JOSHUA REYNOLDS.
Nelly O'Brien, 1770.
Mezzotint engraved by James
Watson, 45.7 × 35.2 cm
(18 × 13⁷⁄₈ in.).
The Huntington.

Figure 8.
JOSHUA REYNOLDS.
*Kitty Fisher as the Queen of
Egypt*, n.d. Mezzotint
engraved by Edward Fisher
(British, 1730–ca. 1785),
30.2 × 25.1 cm
(11⁷⁄₈ × 9⁷⁄₈ in.).
The Huntington.

cester Fields were artists, craftsmen, tradespeople, prostitutes, gentry, actors, and actresses—among them Sarah Siddons. Prostitutes often mingled with the upper-class women whom they strove to emulate at various popular entertainment sites. Dr. Thomas Campbell, in recounting his visit to the Pantheon on March 27, 1775, noted that Lady Archer was "painted like a Doll, but handsome, her feathers nodded like the plumes of Mambrinos helmet—yet some of the whores had longer peacock-feathers."[45] The theater provided a similar type of social interaction. Commenting on the vogue for amateur theatricals staged privately by noble families during this period,[46] the *Times* noted on May 28, 1788, "The cause of private plays, is owing to the disagreeable necessity that people of fashion found in a public Play-House, of mixing with the strumpets of the town, who made the gayest figure in the Theatre."[47] By taking part in these plays, however, the genteel participants themselves crossed established class boundaries in the opinion of the *Times* writer, engaging in "a trade somewhat below the dignity of an ancient House of Nobility." Like visits to popular public entertainments such as the Pantheon and the theater, Reynolds's studio provided an experience that was eminently respectable, yet titillating and exhilarating in its fluid mix of gender and class.

Moreover, like the amateur theatrical or masquerade ball, portraiture itself served as a potent vehicle for obscuring social class. Portraits provided a particularly effective means of narrowing the social gulf between actresses and aristocratic women, as indicated by Sarah Siddons's strategic use of her own image, discussed in the first two essays. Portraits of actresses were exhibited alongside depictions of the elite at the annual exhibitions at the Royal Academy of Art, as were portraits of infamous courtesans. This practice drew scathing commentary from one viewer, who noted, "The French, who visit our exhibition, are shocked at the indelicacy of placing the portraits of notorious prostitutes, triumphing as it were in vice, close to the pictures of women of rank and virtue. In Paris, such portraits would, on no account, be admitted."[48] Portraits of well-known prostitutes were also introduced into the private homes of the aristocracy, legitimized by hanging on their walls among the Old Master paintings and family portraits.[49]

Portraiture, because of its ability to blur social class, provided many opportunities for experimentation with identity. As noted earlier, Reynolds's sitters often assumed unaccustomed roles in posing for their portraits, and many of these inverted their actual social status. For example, the Duke of Marlborough's daughter posed as a gypsy fortune-teller (fig. 1), while conversely the famous courtesan Kitty Fisher posed as the Queen of Egypt (fig. 8). Reynolds similarly transformed street urchins into angels and cupids,[50] and a popular stage actress into a noble, immortal Tragic Muse. Reynolds also obscured

the distinctions between classes of paintings, in particular between highly valued narrative paintings by Old Masters and distinctly contemporary works, such as portraits. Idealized depictions of heroic, noble themes were ranked at the top of the hierarchy of subjects in traditional art theory, while portraiture (which was concerned with the representation of temporal likeness) was ranked close to the bottom, as a subject displaying little imagination. To elide these distinctions, Reynolds hung some of his own portraits among the famous collection of Old Master paintings that he exhibited in the gallery of his studio.[51] As noted earlier, he also emulated the composition and technique of Old Master paintings in devising his portraits.

Reynolds and his fellow portraitists developed additional public-relations ploys to further their success as fashionable artists. For example, Gainsborough's friend Philip Thicknesse proposed that the portrait Gainsborough had painted of him should be hung in his studio to serve "as a decoy duck for customers."[52] Reynolds's portrait of *Sarah Siddons as the Tragic Muse* may have functioned similarly as a "decoy duck" to advertise his skills to potential clients. Although there are arguments to suggest that Richard Brinsley Sheridan, the manager of Drury Lane, commissioned the portrait of one of his most famous actresses in the guise of the Tragic Muse, it is more likely that it was uncommissioned. Reynolds probably painted it to promote his skills as an artist both at the annual exhibition at the Royal Academy of Arts and subsequently in his gallery.[53] As noted in the previous essay, most early portraits of Siddons were uncommissioned works that artists appear to have undertaken for publicity purposes. Like Reynolds's *Tragic Muse*, most of these remained in the artists' studios for many years, functioning effectively as lures to prospective clients.

Contemporary correspondence indicates that Reynolds's portrait of Sarah Siddons was an effective advertisement both for the artist and for his sitter. Regarding her visit to Reynolds's house in January of 1785, Mary Hamilton wrote to her fiancé:

> We amused ourselves in admiring Sir Joshua's paintings [they would have seen The Tragic Muse], he happen'd to hear I was there, & came out of his painting room & kindly invited us to enter. . . . I should vastly like to have your whole length, by my friend Sir Joshua, but alas! We are not rich enough for these indulgences. Thence to Drury Lane Theatre to engage places for Mrs. Siddons's Benefit. I wish to see her in one of Shakespeare's characters, & as I find she is to perform Lady Macbeth that night I shall treat myself.[54]

Hamilton's seamless transition from artist's studio to theatrical stage attests to the close alliance of the two sites in Georgian social life and helps account for the flourishing collaborative relationships of actors and artists during the period.

To further disseminate his reputation and increase his fortune, Reynolds exploited the promotional value of prints after his portraits.[55] Portrait prints of current celebrities (including popular actresses) were published for a wide public. Reynolds's imagery—whether in the form of portraits or prints—supported a booming commercial market at the end of the century.[56] For Siddons, the prints issued after her portraits—particularly those after Reynolds's famous depiction of her as the Tragic Muse—played a crucial role in controlling her public image and building the publicity that led to fame and success.[57] Both painter and actress benefited from this public-relations strategy.

The Studio Assistants

When, as a young man, Reynolds returned to London after his trip to Italy in the early 1750s, he quickly became a success, producing as many as 150 pictures in a single year.[58] This output necessitated the employment of a number of studio assistants, including both professional artists and students. The most famous of these was the aforementioned James Northcote, whose *Memoirs of Sir Joshua Reynolds* fill two volumes and record a great deal of what we know about life in Reynolds's studio. Another important assistant was Giuseppe Marchi, an Italian painter who returned from Rome with Reynolds in 1752 and remained in the studio (with the exception of a brief hiatus in the late 1760s) for the rest of the master's life.[59] Several other assistants have been identified, including William Score, who worked with Reynolds from 1778 to 1784. Northcote identified Score as the painter of the Dulwich version of *Sarah Siddons as the Tragic Muse*,[60] although this seems unlikely, as the Dulwich version was not painted until 1789, several years after Score's tenure in Reynolds's studio.

The participation of drapery painters and landscape painters on commissioned portraits was considered part of the normal course of business for an artist's studio. Indeed, the use of assistants to paint the drapery and background had been standard studio practice in England since the seventeenth century.[61] Besides adding the finishing touches to original portraits, studio assistants often produced copies for relatives and friends of the sitter,[62] as well as for collectors who admired particular paintings. Such copies were considered to be "originals" and were fully endorsed (perhaps even promoted) by Reynolds as such. For example, the 1789 version of *Sarah Siddons as the Tragic Muse* repeats the prominent signature in the same spot on the costume as in the prime version of the subject.

It was not uncommon for Reynolds simply to work on the face and hands of a portrait (which he usually blocked in first), leaving the

rest of the composition to be completed (undoubtedly under his very watchful eye) by others in the studio. At the very least, he seems to have devoted between four and five hours to the painting of the face alone. As he explained in a letter of 1777: "It requires in general three sittings, about an hour and a half each time, but if the sitter chooses it the face could be begun and finished in day. It is divided into separate times for the convenience and ease of the person who sits. When the face is finished the rest is done without troubling the sitter."[63] Reynolds's surviving appointment books indicate, however, that full-length portraits often required clients to return for additional sittings. An unfinished portrait of *Mrs. John Spencer and Her Daughter* (fig. 9) gives us a glimpse of his working method. The stretched canvas could either be left unprimed or prepared with a thin tinted layer of gesso. The position of the figures was blocked in with quick strokes of dark paint, which tended to give only the broadest suggestions of the basic outlines of the forms. This is in keeping with contemporary descriptions of Reynolds's technique, which describe his starting portraits "without making any previous sketch or outline."[64] The basic forms of the faces were then blocked in with a cool, gray tone (known as "dead-coloring" because of the absence of a significant amount of warm, flesh-colored pigments in this preparatory layer), usually composed of a mixture of lead white, black, and a bit of red lake. As one eyewitness noted, "he began with much celerity to scumble those pigments together, till he had produced, in less than an hour, a likeness sufficiently intelligible, yet withal, as might be expected, cold and pallid to the last degree."[65]

The sitters would come back one or two more times (or as many as sixteen for a particularly complicated full-length portrait),[66] but in the interim other hands in the studio may have participated in the completion of draperies or landscape settings. For example, Reynolds's assistant James Northcote wrote to his brother in 1772: "I was employed for Sir Joshua on the most considerable job I have yet done; it is painting the drapery to the whole length picture of the Duke of Cumberland, he is dressed in his Installation robes, Knight of the Garter, which I paint from the Duke's own robes put on upon the layman."[67] This figure was a jointed mannequin, commonly used to stand in for the client in the painting of clothing and draperies. Alternatively, portrait painters subcontracted out the painting of the clothing to drapery specialists, who were entirely independent artists with their own studios. Reynolds also employed life models (including his studio assistants) to stand in for the sitter while the portrait was being completed. In addition, he relied upon his collection of plaster casts of body parts, such as a leg of the popular actress Mrs. Jordan.[68] This aspect of his studio practice underlies the amusing commentary of the *Morning Chronicle* on the sale of effects from Reynolds's studio after his death: "The plaster busts, bodies, necks, legs, arms and thighs,

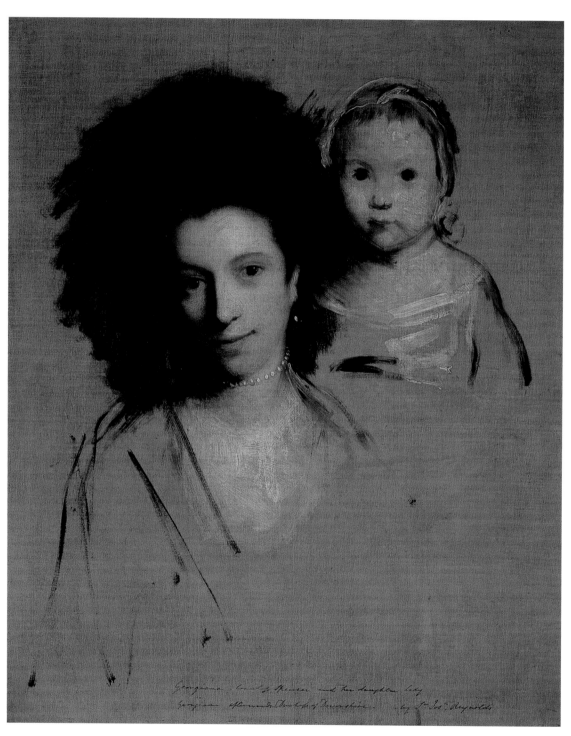

Figure 9.

which were *studies* to the late President give a fine opportunity to the Ladies and Gentlemen, who have been painted by him, of choosing out the originals of the *limbs* and *features* with which they were severally honoured."[69]

However, it is highly unlikely that Reynolds allowed his studio assistants to play a role in any stage of the development or execution of his painting of Sarah Siddons. Because of the fame and importance of the sitter, and Reynolds's own aspirations for the fame and importance of the painting itself, the picture was undoubtedly crafted entirely by his own hand. As we shall see, a close study of the complicated genesis of the picture, as well as the materials and techniques used in its creation, tends to support this theory.

THE MAKING OF
SARAH SIDDONS AS THE TRAGIC MUSE

Reynolds's willingness to accommodate the wishes of his sitters and patrons has been noted earlier and is evidenced by many surviving letters. This feature of his practice supports Siddons's assertion of the role she played in the creation of her portrait as the Tragic Muse (fig. 10). In her own account later in her life, she claimed:

> When I attended him for the first sitting, after many more gratify-ing encomiums than I dare repeat, he took me by the hand, saying, 'Ascend your undisputed throne, and graciously bestow upon me some grand Idea of The Tragick Muse.' I walked up the steps & seated myself instantly in the attitude in which She now appears. This idea satisfyd him so well that he, without one moments hesitation, deter-mined not to alter it.[70]

An eyewitness observer, however, gave an entirely different account of the events. Samuel Rogers maintained that he was in Reynolds's studio "when Mrs. Siddons came in, having walked rapidly to be in time for her appointment." Without a word from Reynolds, Rogers alleged, "She threw herself, out of breath, into an armchair; having taken off her bonnet and dropped her head upon her left hand—the other hand drooping over the arm of the chair. Suddenly lifting her head she said, 'How shall I sit?' 'Just as you are,' said Sir Joshua, and so she is painted."[71] Siddons's claim that she had been instrumental in origi-nating her own pose and curtailing subsequent alterations by Reynolds may be more indicative of her desire to control her own image—even after the fact—than an accurate record of events in the studio. Reyn-olds was probably quick to adapt her performance to a preexisting model he had developed in earlier portraits to depict the contempla-tive sensibilities of well-born women, as discussed in the previous essay.

Figure 9.
JOSHUA REYNOLDS.
Mrs. John Spencer and Her Daughter, 1759. Oil on canvas, 76.2 × 63.5 cm (30 × 25 in.). Devonshire Collection, Chatsworth. By permission of the Duke of Devonshire and the Chatsworth Settlement Trustees.

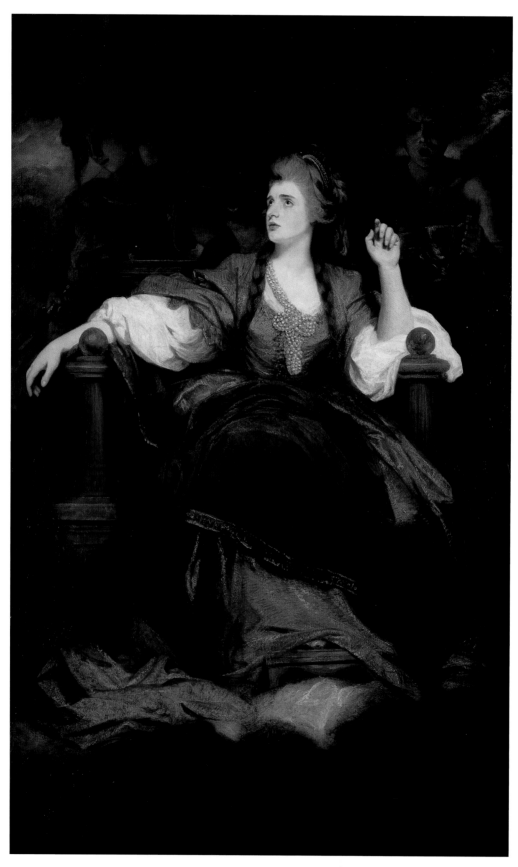

Figure 10.

Figure 11.

The recent X-ray analysis of the painting (fig. 11) indicates that Sid-
dons's pose remained unchanged, although the iconography and
details of the painting developed while Reynolds was working on the
canvas. Reynolds must have had a clear understanding of how
he wanted to position Siddons long before he began the actual paint-
ing. By placing her head with a slight turn away from the viewer and a
slight tilt upward, he was able to capture in the most favorable man-
ner her famous profile, which included the salient feature that had
prompted Gainsborough to remark, "Damn the nose—there's no end
to it."[72] Reynolds chose a visual device in the positioning of Siddons's
left hand that would have been immediately understood by an
eighteenth-century audience: she holds her upraised hand with a

Figure 10.
JOSHUA REYNOLDS.
*Sarah Siddons as the Tragic
Muse*, 1784. Oil on canvas,
239.4 × 147.6 cm
(94 1/4 × 58 1/2 in.).
The Huntington.

Figure 11.
X-ray computer composite
of *Sarah Siddons as the Tragic
Muse*.

slightly extended index finger, a gesture that suggests that she is about to speak; her slightly parted lips heighten this effect. Similar gestures can be found in eighteenth-century "Conversation Pieces," a favored form of group portraiture that showed the figures engaged in lively conversation. In such compositions, the central speaker was usually

Figure 12.

Figure 13.

Figure 12.
JOHANN ZOFFANY
(German, 1733–1810).
A Group Portrait of John, 14th Lord Willoughby de Broke, and His Family in the Breakfast Room at Compton Verney, 1766. Oil on canvas, 100.5 × 125.5 cm (39¹/₂ × 49¹/₂ in.).
Los Angeles, The J. Paul Getty Museum.

Figure 13.
Detail of head and hand at upper right center from the *Group Portrait* (fig. 12).

identified by means of his or her extended index finger, as can be seen in a detail from Johann Zoffany's 1766 portrait of *John, 14th Lord Willoughby de Broke, and His Family* (figs. 12–13).

Reynolds is known to have had a chair in his studio that elevated the sitter considerably above the floor.[73] In the case of Siddons, this physical elevation not only lent an exceptional sense of scale to the composition but also served to transport the subject into her theatrical realm: her raised throne floats aloft upon a series of clouds. We, as both viewers and audience, see Siddons from below, in much the same way as an audience in the theater.

Reynolds altered several portions of the composition, eliminating the kneeling putto at Siddons's feet who presented her with a scroll (fig. 14). By removing this cherubic figure, he minimized the celestial aspect of the allegory. To heighten the drama, he also radically altered the attendant figure flanking her on the right. Originally the figure was depicted with downcast eyes, head leaning on left hand: the standard iconographic representation of "Melancholy." Reynolds had developed this attendant (fig. 15) to a very finished level, including details of the costume, before changing it to a more dramatic, "sublime" conception. In altering the figure from morose "Melancholy" to screaming "Horror," he relied upon a pencil drawing he had made of himself in that guise (fig. 16). His own performance was thus incorporated into the production, along with Siddons's.

Figure 14.

Figure 15.

Figure 14.
X-ray detail of putto from
*Sarah Siddons as the Tragic
Muse*.

Figure 15.
X-ray detail of the figure
of Melancholy from *Sarah
Siddons as the Tragic Muse*.

Figure 16.

While he worked on the composition, visitors were in and out of Reynolds's studio. The earlier version of the composition was recorded in a drawing (fig. 17) by the young artist John Flaxman, who was probably among the students who were allowed to study in Reynolds's gallery and studio. The American artist Gilbert Stuart was also a visitor, and his daughter recorded his dismay at Reynolds's alterations:

> *Going into Reynolds's room, he found him full of anxiety and busily giving the finishing touches, his hair (or his wig) very much disheveled, his stockings rather loose, and his general appearance disordered. The instant my father looked at the picture, he caught his breath with a feeling of disappointment. Sir Joshua perceived this, and asked him if he did not think he had improved it. Stuart answered, 'It could not have been improved,' and asked, 'Why did*

Figure 17.

Figure 16.
JOSHUA REYNOLDS.
Self-Portrait as a Figure of Horror, ca. 1784. Chalk on paper, 36.8 × 25.1 cm (14¹/₂ × 9⁷/₈ in.). ©Tate Gallery, London 1998.

Figure 17.
JOHN FLAXMAN (British, 1755–1826) after Joshua Reynolds. *Mrs. Siddons as the Tragic Muse*, ca. 1784. Pencil on paper, 19.6 × 16 cm (7³/₄ × 6¹/₄ in.). Cambridge, Fitzwilliam Museum.

you not take another canvas?' Sir Joshua replied, 'That is true.' My
father immediately realized what a very great liberty he had taken,
and was exceedingly abashed; but the good Sir Joshua bore the criti-
cism very amiably, possibly thinking that the opinion of so young a
man was not of any moment.[74]

Stuart's account of Reynolds's nervous demeanor and disheveled appearance when working on this portrait was echoed by Siddons herself, who reported that "he appeared to be afraid of touching" the painting during her last visit to his studio.

Reynolds began with a standard size canvas for this portrait (as he did with most of his works); in this case, it was the largest standard size, a "whole-length" measuring 94×58 inches.[75] The stretched canvas would have been ordered from a "colourman" or materials supplier, who would have delivered the stretched canvas, attached to a wooden strainer, to the studio. The canvas might also have been primed by the colorman. In this case, a thin, light-colored lead white ground was applied to the surface of the canvas to provide a base for the painting. The canvas was one that Reynolds particularly favored— a fairly heavy fabric with a twill weave (meaning that it was woven in such a way as to give the impression of a fine diagonal pattern running through the fabric). It is easy to understand why Reynolds may have preferred this type of canvas: the pronounced weave added another element of texture to his layered brushwork, thus heightening the play of light and texture across the surface of the painting.

One feature that is difficult to explain is the presence of a break in the canvas approximately thirteen inches from the bottom. The fabric on either side of this break is clearly of the same type (in that the weight and weave are identical), but the threads are not aligned, indicating that the canvas was not originally a continuous piece. One possible explanation is that the colorman supplied Reynolds with a pieced canvas; this may have been somewhat less expensive than an unpieced standard size, and, if the portrait was indeed uncommissioned, Reynolds would quite naturally have wished to save on costs. The original method of piecing the canvas would have been lost when the picture was relined in the early twentieth century.[76]

Reynolds undoubtedly began the picture by blocking in the face, arms, and hands of Siddons. As has already been discussed, conflicting accounts have been given about the way in which the pose was determined. What seems clear from a study of the picture itself is the fact that the pose was well established right at the start; there is not even the slightest shift in the position of so much as a finger, despite the fact that nearly every other detail, both large and small, throughout the rest of the picture appears to have been dramatically reworked.[77]

Figure 18.

Reynolds began the painting of Siddons's face by laying the foundations for the basic forms with his usual method of dead-coloring; in fact, a cool, blue-gray underpaint is visible underneath all of the flesh tones. It can be seen clearly in the shadows of the arms (fig. 18) and at the end of the eyebrow, where the bluish paint lends a sense of poignancy to the expression while creating a strong sense of form in the face (fig. 19). The flesh tones were then developed with a slightly warmer series of buff-colored strokes; the final bits of modeling were added with several layers of a light pinkish-colored paint, further enhancing the warmth of the flesh tones. Reynolds's masterful handling of the flesh tones is clearly evident in the X-ray, where the strong forms of the face (fig. 20), arms, and hands (fig. 21) appear to have been virtually sculpted in paint. All of the paint layers were applied with a directness and confidence that reflect Reynolds's exceptional ability to begin carving out the illusion of the forms from the first moment that he laid brush to canvas.

Figure 18.
Detail of left arm of *Sarah Siddons as the Tragic Muse*.

Figure 19.

The flesh tones are noticeably thinner and smoother in texture than the heavily worked (and reworked) areas found throughout the rest of the picture. This is due not only to the fact that Reynolds evidently had a clear concept of how he intended these areas to read from the outset (and did not change that concept during the course of painting) but also to the fact that he employed a very straightforward method of painting in these areas. A cross-section sample from the area of the chest (fig. 22) shows a fairly conventional painting technique: several layers of oil paint, ranging in tonality from a very light pink to a darker beige, were simply laid one on top of the other, without the complicated series of intermediate resinous layers that are to be found throughout the rest of the picture. Reynolds's prediction to Siddons that the picture would not fade or change has remained true, not only as a result of his use of a very traditional manner of painting the flesh tones but also because of his choice of a stable vermilion in these areas as well. Reynolds seems to have incorporated an additional stabilizing feature by his use of walnut oil for the flesh tones.[78] Walnut oil produces a very clear paint medium (as opposed to the slightly yellow appearance of the more common linseed oil) and has traditionally been thought to discolor and crack less than linseed oil as it ages. Reynolds chose to use walnut oil in the flesh tones and in the white clouds at the base of the composition, but he did employ linseed oil throughout the rest of the picture, where future discoloration would have had a less disturbing visual effect.

The comparative smoothness of the flesh tones contrasts beautifully with the heavy textures found throughout the rest of the paint-

Figure 19.
Detail of the face of *Sarah Siddons as the Tragic Muse*.

Figure 20.

Figure 21.

ing; it is entirely possible that Reynolds intended this contrast in texture, as it heightens the sense of drama within the composition, playing off Siddons's smooth, pale skin tones against the deep, luminous textures of her costume.

We have already seen that many details of the composition were changed during the time that Reynolds worked on the painting. It is interesting to note that these changes must have taken place over a relatively long period of time. Not only did Flaxman and others see the picture in a form somewhat different from its current appearance but a study of cross-sections from some of the changed areas suggests that much of the paint had dried and been varnished before the changes were made. If we look at a detail of a cross-section from the left edge of the painting (fig. 23), which did not undergo significant changes, we can see evidence of Reynolds applying his layers of paint on top of one another while they were still wet. A detail at the center of the cross-section shows a wavelike effect created when the brownish upper layers were brushed onto the reddish lower layer, causing the still wet lower layer to yield to the brushstroke and intermingle with the upper layer. The heavy fluorescence of the upper layer under ultraviolet light suggests that it is, not surprisingly, composed of megilp, for the mastic resin in the oil/mastic mixture fluoresces strongly in contrast to the layers that contain only oil paint. However, there do not appear to be any intermediate varnish layers in this area.

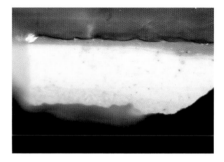

Figure 22.

Figure 20.
X-ray detail of the face of *Sarah Siddons as the Tragic Muse.*

Figure 21.
X-ray detail of arm of *Sarah Siddons as the Tragic Muse.*

Figure 22.
Cross-section sample from the chest of *Sarah Siddons as the Tragic Muse.*

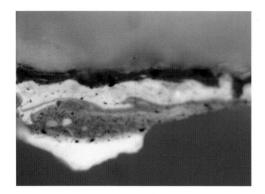

Figure 23.

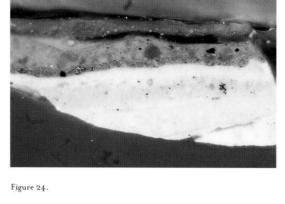

Figure 24.

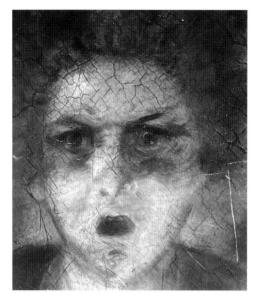

Figure 25.

Figure 23.
Cross-section sample from
the left edge of *Sarah Siddons
as the Tragic Muse* under ultra-
violet light.

Figure 24.
Cross-section sample from
area of overpainted putto in
Sarah Siddons as the Tragic Muse.

Figure 25.
Infrared reflectogram
detail of the figure of
Horror from *Sarah Siddons
as the Tragic Muse*.

This area of the picture is in marked con-
trast to areas that were changed. If, for example,
we look at a cross-section from the lower left cor-
ner (fig. 24), where the kneeling putto was origi-
nally found, we can see at least six different layers
of paint, interspersed with at least two layers of
varnish applied between the paint layers. The
lower layers of flesh-colored paint appear to have
dried thoroughly before they were reworked. The
putto was composed of numerous layers of light-
colored paint (moving from light to dark up
through the cross-section), suggesting that it was
in a very finished state before Reynolds over-
painted it. The uppermost layers of warm-brown
megilp paint are, in fact, the layers of Siddons's
costume, and they include a clear varnish layer that
Reynolds may have applied as a means of accentuating the translucent
nature of the fabric.

Even during the process of changing the figure of Melancholy
to that of Horror, Reynolds continued to develop and refine the
details of his composition. An infrared reflectogram (fig. 25) reveals
that he blocked in the new figure with the same bold, preliminary
strokes of black paint that he commonly used in his preparatory layers.
While blocking in this new figure, he also shifted the position of the
hands downward slightly and shortened the handles of the chalice.

In addition to the figural changes that were made within
the composition, Reynolds made major changes to Siddons's cos-
tume. The X-ray reveals that Siddons was originally wearing a low-cut,
light-colored bodice with incised borders that crossed over her chest;
this bodice corresponds to the costume that we have already seen in
Flaxman's sketch of the painting after his visit to Reynolds's studio (see
fig. 17). The costume is also similar to that worn by Lady Cockburn
in the portrait that Reynolds made of her and her children in 1782,

just two years before his painting of Siddons (fig. 26). Interestingly enough, Lady Cockburn's costume also included a luminous golden-colored shawl, very similar in feeling to the warm, brilliant fabric that comprises much of Siddons's costume; Reynolds also chose to inscribe his name on the broad hem of Lady Cockburn's wrap, in much the same way that his signature was used on the lower border of Siddons's robe.

 Other parts of Siddons's costume were also reworked. The X-ray reveals an extraordinary pattern of incised lines that create the impression of a wide, brocade border in a piece of fabric that would have been draped just below Siddons's knees (fig. 27). This incised technique is something that Reynolds borrowed from Rembrandt and his followers, such as Gerard Dou,[79] who simulated the textures of heavily brocaded fabrics by dragging the ends of their brush handles (or a similar blunt tool) through layers of wet paint (figs. 28–29). A

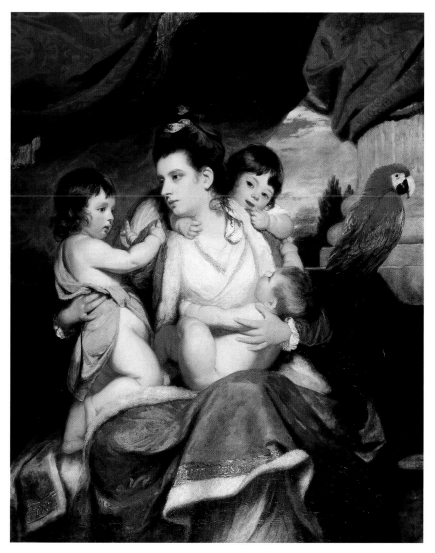

Figure 25.

Figure 26.
JOSHUA REYNOLDS.
Lady Cockburn and Her Three Eldest Sons, 1782. Oil on canvas, 141.6 × 113 cm (55³/₄ × 44¹/₂ in.). The National Gallery, London.

Figure 27.

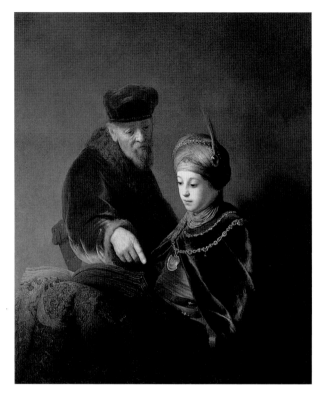

Figure 28.

Figure 27.
X-ray detail of brocade
fabric from *Sarah Siddons
as the Tragic Muse*.

Figure 28.
GERARD DOU
(Dutch, 1612–1675).
*Prince Rupert of the Palatinate
and an Older Man in Historical
Dress*, ca. 1631. Oil on
canvas, 102.9 × 88.7 cm
(40 × 34¾ in.). Los
Angeles, The J. Paul Getty
Museum.

cross-section from this area (fig. 30) surprisingly suggests that the fabric with the brocade border was originally planned to be a blue-violet color,[80] perhaps reminiscent of the blue robe that drapes the figure of Tragedy in Reynolds's famous 1762 depiction of *Garrick Between Tragedy and Comedy* (fig. 31).

There is a description from 1807 of a Reynolds sketchbook that reportedly shows a "rough sketch for the celebrated portrait of Mrs. Siddons as 'The Tragic Muse,' in which she is represented seated and clad in a flowing robe with an ornamental border."[81] Although this sketchbook is now lost, it is tempting to think that it refers to the original plan for a broad, incised brocade on the border of the blue fabric that would have been draped over Siddons's knees. This fabric was, of course, eventually painted out, along with the original plan for the bodice, when Reynolds added the cluster of pearls at her chest and painted a warm, brown drapery over her lap.

Reynolds also added the decorative knobs on the chair quite late in the development of the picture. Siddons's proper right arm and the white fabric covering her left forearm appear to have been fully painted underneath the large knobs. Like Gilbert Stuart, many contemporary critics were dismayed by Reynolds's changes. One in particular, when writing about the picture in 1798, referred to the "grandeur in the conception and execution" but went on to claim that "the sublimity of this picture is much abated by the abominable chair,

Figure 29.

Figure 30.

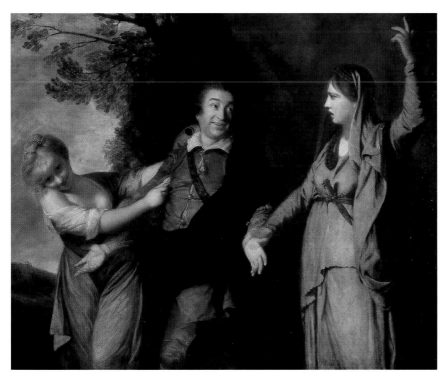

Figure 31.

Figure 29.
Detail of incised paint in
the brocade fabric at lower
left of fig. 28.

Figure 30.
Cross-section detail of
brocade fabric from *Sarah
Siddons as the Tragic Muse*.

Figure 31.
JOSHUA REYNOLDS.
*Garrick Between Tragedy
and Comedy*, 1762. Oil
on canvas, 148 × 183 cm
(58¼ × 72 in.). The
National Trust, Wadde-
ston Manor. Photo:
Richard Valencia.

which is so ugly and discordant, as to force our attention to such a subordinate circumstance—nor is that the worst for one of the odious knobs cuts the line of the arm, and substitutes a disagreeable break, where every thing should be broad and grand."[82]

But most would agree that Reynolds's extensive reworking of the picture did result in an extraordinary image. Even his choice of an extremely limited palette was recognized by Siddons herself as one of the keys to the success of the picture. In a conversation with a friend of hers in 1823, Siddons "admired the sober grandeur of the colouring—almost an absence of colour—which contributed to the sublimity of that noble composition." She went on to say that "she was almost upon her knees to [Reynolds] not to disturb those noble hues by a variety of rich and glowing colours which he would otherwise have introduced."[83]

The richly luminous character of Siddons's robes, which range in tonality from a deep, warm brown in the shadows to a brilliant, sparkling yellow in the highlights, is due not only to the use of a bright yellow ocher as a pigment but also to the numerous layers of resinous paint and pure resin that Reynolds used throughout the draperies. The complicated structure of paint and varnish layers lent a natural bulk and texture to the illusion of the fabrics while providing Reynolds with a means of building a sense of luminous translucency within the structure of the paint itself.

One conclusion seems clear: the 1784 version of *Sarah Siddons as the Tragic Muse* must have come entirely from Reynolds's own hand. This is evident in the masterful character of the handling on the surface of the picture and in the strength of the underlying forms as seen throughout the entire X-ray. Even in the preparatory layers, the brush moved across the canvas with a consistently bold energy, as Reynolds reworked and reshaped the details of the composition. This most certainly could not have been the work of a studio assistant.

THE 1789 VERSION OF THE *TRAGIC MUSE*

Reynolds exhibited *Sarah Siddons as the Tragic Muse* at the Royal Academy in 1784; as we have seen, it was received with great critical acclaim, and its fame grew over the years, even though Reynolds retained possession of the picture. In April of 1789, a London newspaper reported that Reynolds had been commissioned to produce a replica of the picture, "his payment a Reubens [sic] valued at 500 pounds. The original Sir Joshua values at 1000 pounds."[84] This may have been the replica that was commissioned by the dealer Noël Desenfans, who bequeathed it to Sir Francis Bourgeois in 1807. Donated to Dulwich College in 1811, the picture remains in the collection of the Dulwich Picture Gallery (fig. 32).

Figure 32.
Studio of JOSHUA
REYNOLDS.
Sarah Siddons as the Tragic Muse, 1789. Oil on canvas, 238.8 × 147.3 cm (94 × 58 in.). Dulwich Picture Gallery. By permission of the Trustees of Dulwich Picture Gallery, London.

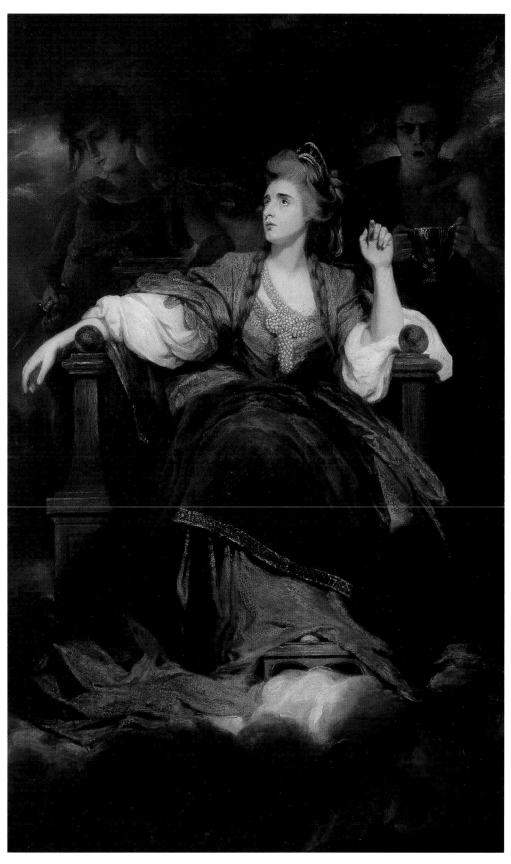

Figure 32.

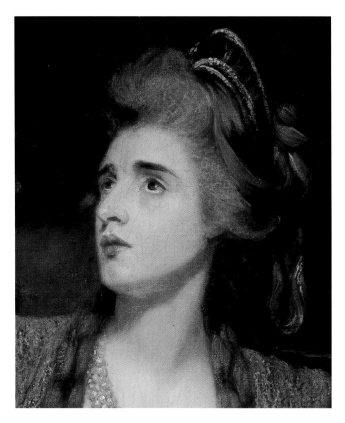

Figure 33.

Figure 33.
Detail of the face from
Sarah Siddons as the Tragic Muse
(Dulwich version).

Figure 34.
Detail of the face from
Sarah Siddons as the Tragic Muse
(Huntington version).

There are some conflicting references to the picture in the early literature. In 1824 William Hazlitt reported that the "Dulwich Gallery" version was painted by "Score," although he may have confused the Dulwich picture with another replica because he also stated that the "original is larger than the copy"; [85] the Dulwich picture is, in fact, identical in size to the original version. In 1865 Charles Leslie and Tom Taylor compounded the problem by stating that "according to Northcote, the Dulwich replica is inferior, and . . . was painted by Score, then one of Sir Joshua's journeymen." [86] In fact, William Score, a native of Devonshire who had become Reynolds's pupil by 1778, [87] does not seem to have been working in Reynolds's studio at the time that the Dulwich version was painted. Siddons herself made reference to the Dulwich picture: in 1811 she said that the original painting was "very fine & that in her opinion the one in possession of Sir F. Bourgeois was but a poor imitation of it." [88]

Further confusion occurred in the late nineteenth century, when the authors Graves and Cronin speculated erroneously that Reynolds had worked on two versions of the picture simultaneously. [89] They also inferred that Reynolds would not have signed and dated a work that was not entirely from his own hand and that Desenfans would not have paid a significant price for a studio version. None of Graves's and Cronin's inferences, however, appears to be true. It would have

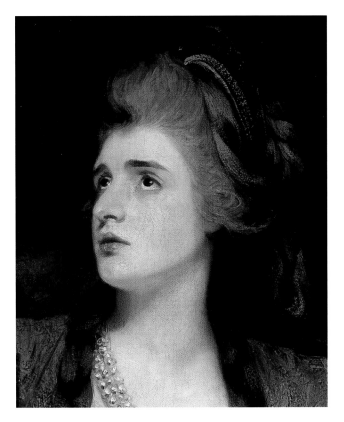

Figure 34.

been accepted practice for Reynolds to inscribe the work of his studio with his own name, as it would have still been considered an "original" production. Desenfans, as an experienced dealer, would have had no trouble accepting such a studio production and certainly would have had no problem in selling it as such. And there is simply no evidence to support the suggestion that there were two versions of the picture produced by Reynolds simultaneously. The X-ray of the Huntington picture confirms that Reynolds worked through all of the compositional changes on a single canvas.

But the question does remain: how much of a hand did Reynolds have in the production of the 1789 version of *Sarah Siddons as the Tragic Muse*? A close study of the picture suggests that, even though it was a production of Reynolds's studio, and as such its execution would have been closely supervised by Reynolds himself, most of the work must have been carried out by an assistant.[90]

If we begin by looking at the differences between the handling of the face of Siddons in the two versions, it becomes clear that the features in the later version (fig. 33) are somewhat broader and coarser than those of the earlier version (fig. 34). Reynolds's handling of the nose, eyes, and lips in the original portrait is refined and delicate, and he captures masterfully both the strength and the femininity of Siddons's character. The same features in the studio copy are fuller

and rounder, and the delicate refinement of Reynolds's brushwork has been replaced with a more heavy-handed application of highlights and shadows.

A similar contrast in handling can be seen in the painting of Siddons's hair. In the original version, the carefully articulated forms, including a number of delicately rendered strands that appear to float lightly across the surface, relate to the face in a beautiful and convincing way. The cool, blue-violet tone of Reynolds's underlying dead-coloring successfully completes the illusion of the hair at the point where it blends into the edge of the face. The hair in the later version, by contrast, is an unarticulated, fairly uniform brown mass which, because it does not join the face in a convincing fashion, gives the face a mask-like appearance.

The copyist also missed a small detail in the painting of the pearls that fall across Siddons's torso. In the original version, the strands of pearls twist subtly around one another as they drape across her chest, and again where they fall below the central knot (fig. 35). In

Figure 35.

the later version, however, these twists are missing, and the pearls read in a somewhat monotonous, clump-like fashion (fig. 36).

Another very telling detail can be found in the handling of one of the golden-ocher highlights of Siddons's headpiece. The central highlight in the original version (fig. 37) was painted with a single, masterful stroke: the loaded brush was placed confidently on the painting at the base of the crown and pulled downward across the form of the head in one continuous, elegant, and lyrical motion. This same detail in the 1789 version (fig. 38), by contrast, appears labored and hesitant: rather than painting the highlight with a single brushstroke, the painter applied a series of heavy dabs in imitation of the shape of the contour as he copied it from the original. He succeeded in repeating the superficial placement of the original detail but captured none of the underlying inspiration in Reynolds's handling.

Further differences between the two pictures can be found by comparing the images produced in the X-rays. As was previously discussed, the strong images found in the X-ray of the first version of

Figure 36.

Figure 35.
Detail of pearls from
Sarah Siddons as the Tragic Muse
(Huntington version).

Figure 36.
Detail of pearls from
Sarah Siddons as the Tragic Muse
(Dulwich version).

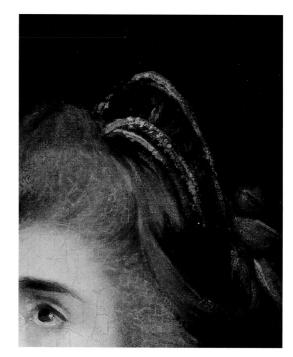

Figure 37.

Figure 38.

Figure 37.
Detail of brushstrokes from the headpiece from *Sarah Siddons as the Tragic Muse* (Huntington version).

Figure 38.
Detail of brushstrokes on the headpiece from *Sarah Siddons as the Tragic Muse* (Dulwich version).

Sarah Siddons as the Tragic Muse are the result of a bold consistency in the handling that reflects Reynolds's ability to literally sculpt the forms in paint. The X-ray of the later version reveals a very different artist at work. The face, for example (fig. 39), is barely visible, due to the fact that the painter did not first apply an underlying foundation that would have given the head a stronger sense of form and structure. Instead, he simply copied what he could see of the finished appearance of the original onto the surface of his canvas.

Similar comparisons can be made throughout the two X-ray images, particularly in the handling of the white fabric of Siddons's sleeves, which appear to have been laid in with a blizzard of brushwork in the original but were composed of a series of superficial, meandering brushstrokes in the later copy (fig. 40).

The very structure of the paint itself in the replica also presents a telling contrast to the original version. Whereas the cross-sections from the original showed that the texture, thickness, and translucency of the surface resulted from the natural bulk that developed as Reynolds applied and reworked multiple layers of paint and varnish throughout the picture (with the exception of the flesh tones), cross-sections from the later version (fig. 41) suggest that the copyist tried to re-create this texture through a very few layers of paint applied on top of a heavy layer of resinous material. Medium analysis confirms the use of linseed oil throughout the picture (without any trace of the walnut oil that Reynolds had used in selected areas of the original version), although it was mixed with substantial amounts of other materials,

Figure 39.

Figure 40.

including collophony (or rosin) and a resin such as mastic; traces of camphor were also added, perhaps in order to plasticize the paint mixture and improve its working properties.[91]

Despite the use of such transparent materials in the paint mixture, the copyist was still not able to imitate Reynolds's luminous rendering of Siddons's garments. Light appears to emanate from within the yellow and brown fabrics of the original, in Rembrandtesque fashion. The fabrics in the copy, by contrast, imitate the forms of the original but have none of their inner glow, despite the use of very similar yellow earth colors in the paint.

Finally, one small detail in the footstool appears to have been inexplicably changed by the painter of the later version. In the 1784 version, the left corner of the stool is visible. This is also the way in which it appears in Francis Haward's 1787 engraving after the picture (fig. 42). In the painting of 1789, however, the corner of the footstool has been covered with Siddons's drapery.

It is impossible to identify the studio assistant who was the painter of the Dulwich version of *Sarah Siddons as the Tragic Muse*. It is interesting to note, however, that the striking technical differences between the copy and the original do lend some credence to James Northcote's claim that Reynolds's students "were absolute strangers

Figure 41.

Figure 39.
X-ray of the face from
Sarah Siddons as the Tragic Muse
(Dulwich version).

Figure 40.
X-ray of sleeve from
Sarah Siddons as the Tragic Muse
(Dulwich version).

Figure 41.
Cross-section detail of
clouds from *Sarah Siddons
as the Tragic Muse* (Dulwich
version).

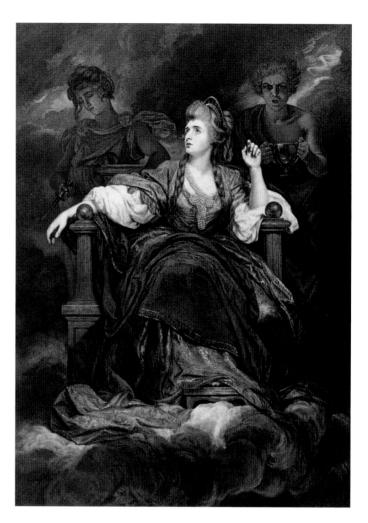

Figure 42.

to Sir Joshua's manner of working . . . and that they always painted
in a room distant from him." [92] Northcote also relates that he was
not allowed to use any pigments other than those supplied by the
colorman and that Reynolds's own experimental materials were kept
out of site under lock and key. [93] This last claim may be a bit of an exag-
geration: the fact that Reynolds's original version of *Sarah Siddons as the
Tragic Muse* was painted largely in oil, while the later copy was painted
largely with resin, would tend to discredit Northcote's memory in
this regard.

But Northcote's anecdote does remind us that Reynolds took
as much care in the shaping of his own image as an artist as he did in the
creation of the works of art that came to life in his studio. During his
own lifetime Reynolds successfully perpetuated his reputation as heir
to the great painters of the past. His collaboration with the greatest
actress of her day ensured that the legendary image of *Sarah Siddons as the
Tragic Muse* would transcend time.

NOTES

1. *Discourse XIII* (11 December 1786) in Joshua Reynolds, *Discourses on Art*, ed. Robert R. Wark (New Haven and London: Yale University Press, 1975), 244.

2. James Northcote, *Memoirs of Sir Joshua Reynolds* (London: Henry Colburn, 1813), 100.

3. Ibid.

4. See Richard Wendorf's insightful discussion of the collaborative, transactional nature of Reynolds's portrait painting, one of the principal themes of his book *Sir Joshua Reynolds: The Painter in Society* (Cambridge, Mass.: Harvard University Press, 1996).

5. Reynolds, *Discourse XII* (10 December 1784) in Wark, ed., *Discourses*, 220, and passim.

6. Reynolds, *Discourse XIII* (11 December 1786) in Wark, ed., *Discourses*, 229.

7. See Williotton, ed., *Sir Joshua Reynolds' Notes and Observations on Pictures* (London: John Russell Smith, 1859).

8. Joshua Reynolds, *A Journey to Flanders and Holland* (1797), ed. Harry Mount (Cambridge: Cambridge University Press, 1996), 126.

9. M. Kirby Talley, Jr., "'All Good Pictures Crack'": Sir Joshua Reynolds's Practice and Studio," in Nicholas Penny, ed., *Reynolds* (London: Royal Academy of Arts, 1986), 56. Interestingly enough, Parmigianino's *Philyra and Saturn in the Form of a Horse* (private collection), which is known to have been in Reynolds's collection of Old Master paintings, appears in some areas to have been fairly abraded. Reynolds may have added strips of wood to the edges of the original panel to expand the landscape; he may have also added floral garlands as another decorative feature.

10. Rica Jones, describing *The Age of Innocence*; unpublished manuscript.

11. Rica Jones and Joyce Townsend, private communication.

12. A. E. Fletcher, *Thomas Gainsborough, R.A.* (London: Walter Scott, 1904), 82.

13. Rica Jones and Joyce Townsend, unpublished manuscript.

14. Ibid.

15. A "lake" is essentially an organic dyestuff deposited on an inert base to create a pigment that may be mixed with a medium and used as a paint.

16. Talley, "All Good Pictures Crack," 65.

17. Frederick Whiley Hilles, ed., *Letters of Sir Joshua Reynolds* (Cambridge: Cambridge University Press, 1929), 111.

18. "Exhibition of the Royal Academy," *Public Advertiser*, 29 April 1784, 2.

19. *The Young Fortune Teller* represents Henry and Charlotte Spencer, two of the children of the 4th Duke of Marlborough, a preeminent aristocratic family, performing the role of fortune-telling, dressed up in "Van Dyck" costumes, set in a rustic landscape. The composition is based on an earlier painting of this famous theme by Caravaggio.

20. For the Duchess of Rutland's comments to Sir Francis Grant, RA, see Charles Robert Leslie and Tom Taylor, *Life and Times of Sir Joshua Reynolds*, 2 vols. (London: J. Murray, 1865), 1: 248.

21. Reynolds is said to have advised Siddons on the selection of her theatrical costumes, such as the dress she wore during Lady Macbeth's sleepwalking scene (see Leslie and Taylor, *Reynolds*, 2: 383–84).

22. Lady Burlington noted that Reynolds "took quite a quantity of exercise when he painted, for he continually walked backward and forward" (Wendorf, *Reynolds*, 115), while Gainsborough's friend Philip Thickness claimed "he stood, not *sat* at his Palate" (cited by John Hayes, *Thomas Gainsborough* [London: Tate Gallery, 1980], 28).

23. John Thomas Smith reported that Gainsborough "allowed me frequently to stand behind him to see him paint, even when he had sitters before him"; Hayes, *Thomas Gainsborough*, 28.

24. James Northcote, *The Life of Sir Joshua Reynolds*, 2 vols. (London: Henry Colburn, 1818), 1: 103. Gainsborough placed his canvas at right angles to the sitter and used long brushes "full six feet in length." He was

thus able to stand equidistant from his painting and the subject, in full view of his sitter. Gainsborough, like Reynolds, did not sit when painting (see Talley, "'All Good Pictures Crack,'" 58).

25. Derek Hudson, *Sir Joshua Reynolds: A Personal Study* (London: Bles, 1958), 74.

26. Northcote, *Life of Reynolds*, 1: 299.

27. For example, Mrs. Pendarves wrote to Mrs. Anne Granville, 13 July 1731: "I am grown passionately fond of Hogarth's painting, there is *more sense* in it than any I have seen. I believe I wrote you word that Mr. Wesley's family are drawn by him, and Mrs. Donnellan with them. I have had the pleasure of seeing him paint the greatest part of it" (Lady Llanover, ed., *The Autobiography and Correspondence of Mary Granville, Mrs. Delany: With Interesting Reminiscences of King George the Third and Queen Charlotte* [London: Richard Bentley, 1861], 1: 283).

28. Boswell recorded Reynolds's comments on 29 April 1771 (*Boswell's Life of Johnson*, ed. George Birkbeck Hill, rev. L. F. Powell [Oxford: Clarendon Press, 1934], 2: 234).

29. Cited by John Brewer, *The Pleasures of the Imagination: English Culture in the Eighteenth Century* (New York: HarperCollins, 1997), 306; see also Desmond Shawe-Taylor, *The Georgians: Eighteenth-Century Portraiture and Society* (London: Barrie & Jenkins, 1990), 14.

30. Wendorf, *Reynolds*, 45–52.

31. Elizabeth Anson and Florence Anson, eds., *Mary Hamilton, afterwards Mrs. John Dickenson, at Court and at Home, from Letters and Diaries, 1756 to 1816* (London: John Murray, 1925), 272.

32. William van Lennep, ed., *The Reminiscences of Sarah Kemble Siddons, 1773–1785* (Cambridge, Mass.: Widener Library, 1942), 16–18. These reminiscences were written in Siddons's seventy-fifth year, 1830.

33. Hilda Gamlin, *George Romney and His Art* (London: Swan Sonnenschein, 1894), 37.

34. Shelley Bennett would like to thank David Solkin for suggesting the possible connection between Reynolds's portraits of Lady Crosbie and Mrs. Hale.

35. Duke of Richmond to Edmund Burke, 25 November 1777, in William T. Whitley, *Artists and Their Friends in England, 1700–1799*, 2 vols. (London: Medici Society, 1928), 1: 312.

36. For example, in the design of his painting room Reynolds introduced a much smaller window than was common in a private house in order to admit only a dim, soft light, enhancing the theatrical nature of his performance (Northcote, *Life of Reynolds*, 1: 102).

37. Ibid.

38. Ibid., 1: 102–3.

39. Madame d'Arblay (Fanny Burney) wrote in her diary in 1781, "Well—it was, I think, Saturday, August 25, that Mrs. Thrale brought me back. But first, we went together to see Sir Joshua's pictures, which is always a feast to me, and afterwards to see Pine's" (Fanny Burney, *Diary and Letters of Madame d'Arblay (1778–1840)*, 6 vols. [London: Macmillan and Co., Ltd., 1905], 2: 33). In 1755 Jean André Rouquet published in *État des arts en Angleterre*: "Every portrait painter in England had a room to shew his pictures, separate from that

in which he works," noting that these galleries were popular among leisured persons (cited by Talley, "'All Good Pictures Crack,'" 60).

40. Wendorf, *Reynolds*, 48–52.

41. Van Lennep, ed., *Reminiscences of Sarah Kemble Siddons*, 17.

42. Fanny Burney wrote in her journal on 28 December 1782: "My father and I dined and spent the day at Sir Joshua Reynolds' . . . dear Sir Joshua is so pleasant, so easy, so comfortable, that I never was so little constrained in a first meeting with people who I saw came to meet me" (Burney, *Diary*, 161). John Courtney described a typical dinner at Reynolds's house: "Sir Joshua was excellently calculated for promoting lively rational conversation. His mind was active, perpetually at work . . . he was a most pleasing, amiable companion; his manners easy, conciliating, and unaffected. . . . There was something singular in the style and oeconomy [*sic*] of his table, that contributed to pleasantry and good-humour; a coarse inelegant plenty, without any regard to order and arrangement. A table, prepared for seven or eight, was often compelled to contain fifteen or sixteen. When this pressing difficulty was got over, a deficiency of knives and forks, plates, and glasses succeeded. . . . But these trifling embarrassments only served to enhance the hilarity and singular pleasure of the entertainment. . . . Temporal and spiritual peers, physicians, lawyers, actors, and musicians composed the motley groupe [*sic*], and played their parts without dissonance or discord" (cited by Wendorf, *Reynolds*, 49–50).

43. Whitley, *Artists and Their Friends*, 1: 369.

44. Reynolds's surviving pocket (sitter) books are located in the Royal Academy Library, London. Gainsborough also painted portraits of the famous demimondaines, such as Grace Dalrymple, lover of the Marquis of Cholmondeley. The 1778 *Morning Chronicle* review of the current Royal Academy exhibition noted that Gainsborough was "a favorite among the demi-reps. He has it is plain, been visited by Miss Dalrymple, Clara Haywood, and another well-known character of the same stamp" (cited by Hayes, *Gainsborough*, 35).

45. James L. Clifford, ed., *Dr. Campbell's Diary of a Visit to England in 1775* (Cambridge: Cambridge University Press, 1847), 63.

46. See Sybil Rosenfeld, *Temples of Thespis: Some Private Theatres and Theatricals in England and Wales, 1700–1820* (London: Society for Theatre Research, 1978). Reynolds attended the first performance of the Duke of Richmond's private theatrical company in 1787 (see Wendorf, *Reynolds*, 130).

47. *Times*, 28 May 1788, 5.

48. "Exhibition," *Universal Daily Register*, 10 May 1786, 2.

49. One of Reynolds's most important patrons and friends, John Parker, Lord Boringdon, hung among his family collection at Saltram portraits by Reynolds of Mrs. Abington, Kitty Fisher as Cleopatra, and Miss Fordyce, who was the mistress of a neighbor (Ellis Waterhouse, "Reynolds, Angelica Kauffmann, and Lord Boringdon," *Apollo* 112, no. 284 [October 1985]: 272).

50. Reynolds relied on paupers and beggars to serve in his studio as models for many of his "fancy" and narrative pictures (see Talley, "'All Good Pictures Crack,'" 61).

51. For a discussion of Reynolds's collection, see Francis Broun, "Sir Joshua Reynolds's Collection of Paintings," Ph.D. diss., Princeton University, 1987.

52. Philip Thicknesse, *A Sketch of the Life and Paintings of Thomas Gainsborough, Esq.* (London, 1783), 16–17. Gainsborough's portrait of Siddons, like that by Reynolds, remained on his hands (see William T. Whitley, *Thomas Gainsborough* [London: Smith, Elder, 1915], 211).

53. William T. Whitley was the first to propose the theory that the *Tragic Muse* was commissioned by Richard Brinsley Sheridan on the basis of Valentine Green's letters to Reynolds, which make clear that Siddons, Reynolds, and Sheridan formed a triumvirate of interested parties (e.g., Green stated that he had applied to Siddons, Reynolds, and Sheridan for permission to engrave the *Tragic Muse*; that Sheridan visited Reynolds to request that the engraver be given the work; that Sheridan was open to the engraving being carried out in whatever manner he, Reynolds, and Siddons mutually agreed upon). This proves, however, only that Sheridan had a proprietary interest in the engraving itself but not necessarily in the portrait. The engravings had obvious publicity value and were a focus of discussion early on. The fact that Reynolds went with Mrs. Siddons's choice of engraver indicates that she had the most say in the matter (see Whitley, *Artists and Their Friends*, 2: 7).

54. Anson and Anson, eds., *Hamilton*, 266–67.

55. Penny, ed., *Reynolds*, 35–36; see also Shearer West, *The Image of the Actor: Verbal and Visual Representation in the Age of Garrick and Kemble* (London: Pinter Publishers, 1991), 37.

56. Timothy Clayton, *The English Print, 1688–1802* (New Haven: Yale University Press, 1997), 244; note in particular Valentine Green's series *Beauties of the Present Age*. See also Penny, ed., *Reynolds*, 35–36.

57. West, *Image of the Actor*, 74–75.

58. Richard Dorment, *British Painting in the Philadelphia Museum of Art: From the Seventeenth through the Nineteenth Century* (Philadelphia: Philadelphia Museum of Art, 1986), 285.

59. Talley, "'All Good Pictures Crack,'" 57. Giuseppe Marchi was also said to have been asked by Reynolds to paint a copy of a Claude Lorrain, which Reynolds later sold to Noel Joseph Desenfans as an original, later revealing the fraud (see Hilles, ed., *Letters of Sir Joshua Reynolds*, 143, 216).

60. Brian Stewart and Mervyn Cutten, *The Dictionary of Portrait Painters in Britain up to 1920* (Woodbridge: Antique Collector's Club, 1997), 413. There does seem to be some confusion over Northcote's comments about the Dulwich picture. In 1824 Hazlitt made the following statement about the *Tragic Muse*: "While it was in the possession of Mr. Desenfans, a copy of it was taken by a pupil of Sir Joshua's, of the name of Score, which is now in the Dulwich Gallery, and which we always took for an original. The size of the original is larger than the copy. There was a dead child painted at the bottom of it, which Sir Joshua Reynolds afterwards disliked, and he had the canvas doubled upon the frame to hide it. It has been let out again, but we did not observe whether the child was there. We think it had better not be seen" [P. P. Howe, ed., *The Complete Works of William Hazlitt*, 21 vols. (London: J. M. Dent, 1930–34), 10: 55].

If Hazlitt is referring to the Dulwich version, then his claim that "the original is larger than the copy" is incorrect, as they are identical standard whole lengths, measuring ninety-four by fifty-eight inches. He may be referring to another copy that was made after Desenfans acquired the Huntington version in 1790 (the Dulwich version is inscribed 1789, a year before Desenfans acquired the original version). It is possible that Hazlitt has confused the "dead child" with the putto, which was, in fact, in the original version. No evidence suggests that the picture was folded back; instead, the putto was painted over. A break occurs in the canvas in the lower portion, but it is above the putto's knees, with most of the torso above the break. See note 76, below.

61. Reynolds, like many of his fellow artists, had a collection of clothes and pieces of material in his studio that his sitters could wear for their portraits and that could be painted by an assistant after the sitting for the face. In other cases, the sitters' own clothes were sent separately to the studio for an assistant to copy. For a discussion of the role of assistants in Reynolds's studio, see Talley, "'All Good Pictures Crack,'" 56–58.

62. For example, the Duke of Rutland wrote his uncle, Lord George Manners Sutton, 6 December 1785, "I hear from Mr. Orde that your portrait has been drawn by Sir Joshua Reynolds. May I request your permission to direct Sir Joshua to make a copy of it for me. I need not say with what affection I should prize it, and how valuable I should consider an exact resemblance of a man whose friendship has been the perpetual pride and happiness of my life" (Historical Manuscript Commission, *Fourteenth Report, Appendix, Part I. The Manuscripts of His Grace the Duke of Rutland, K.G., Preserved at Belvoir Castle* [London: Her Majesty's Stationery Office, 1894], 3: 266). Similarly James Northcote, like many portrait painters, made part of his practice to make copies of portraits by fellow artists, such as Gainsborough, Reynolds, and Romney, as well as altering and completing portraits left unfinished (see Jacob Simon, "The Account Book of James Northcote," *The Walpole Society* [London: W. S. Maney, 1996], 58: 25).

63. Reynolds to D. Daulby, 9 September 1777, in Talley, "'All Good Pictures Crack,'" 60).

64. William Mason, "Anecdotes of Sir Joshua Reynolds," in Cotton, ed., *Reynolds*, 51.

65. Ibid.

66. Talley, "'All Good Pictures Crack,'" 60.

67. James Northcote to his brother, Samuel Northcote, 19 November 1772, in Whitley, *Artists and Their Friends*, 2: 292.

68. *Morning Chronicle*, 16 April 1792, 3.

69. Ibid.

70. Van Lennep, ed., *Reminiscences of Sarah Kemble Siddons*, 16–18.

71. Whitley, *Artists and Their Friends*, 2: 5, cites Mrs. Gilbert Stuart Newton's letter of 1833 regarding a visit to Thomas Campbell. Campbell asked for Samuel Rogers's recollection of his visit to Reynolds's studio. His letter was published in *Scribner's Monthly*, ca. 1885. The recent X-ray, which indicates that the pose did not change while Reynolds was working on the portrait, does not support another account recorded by Thomas Phillips in his *Lectures on Painting*. Phillips stated: "She told me herself that it was the production of pure accident. Sir Joshua had begun the head and figure in a different view; but while he was occupied in the preparation of some colour she changed her position to look at a picture hanging on the wall of the room. When he again looked at her, and saw the action she had assumed, he requested her not to move; and thus arose the beautiful and expressive figure we now see in the picture" (Leslie and Taylor, *Reynolds*, 2: 422).

72. Whitley, *Gainsborough*, 237.

73. Rica Jones and Joyce Townsend, unpublished manuscript.

74. George C. Mason, *The Life and Works of Gilbert Stuart* (New York: Charles Scribner's, 1879), 13.

75. For a discussion of Reynolds's standard canvas sizes and prices, see Talley, "'All Good Pictures Crack,'" 58.

76. The picture currently has a glue lining, which, as with many of the paintings at the Huntington Art Collections, may have been applied by a restorer working for the dealer Joseph Duveen just before the picture's sale to Henry Huntington in 1921. The restorer may have removed whatever evidence of a seam or join remained on the reverse of the original canvas prior to lining. Similar, somewhat inexplicable joins can be found on other pictures in the Huntington (which Duveen may also have had lined prior to sale), including Thomas Gainsborough's *Cottage Door*.

77. A drawing in a German private collection has been associated with the Siddons pose (see Renate Prochno, *Joshua Reynolds* [Weinheim: VCH, Acta Humaniora, 1990], 91).

78. Organic-material analyses using pyrolysis-mass spectrometry and gas liquid chromatography-mass spectrometry were conducted by Michael Schilling and Narayan Khandekar of the Scientific Discipline Group of the Getty Conservation Institute.

79. Some of Gerard Dou's paintings were often misidentified as by Rembrandt, including the picture in fig. 28 (p. 126), which was in the Craven Collection at Combe Abbey in England during the eighteenth century.

80. Prussian blue and red ocher comprise the blue paint layer.

81. James Grieg, ed., *The Farington Diary*, 8 vols., 2d ed. (London: Hutchinson, 1922), 4: 157 (19 June 1807, regarding Robert Lovell Gwatkin, of Kellrow, Cornwall, who married Theophilia Palmer, niece of Reynolds).

82. William Jackson of Exeter, *The Four Ages: Together with Essays on Various Subjects* (London: Cadell and Davies, 1798), 171.

83. Leslie and Taylor, *Reynolds*, 1: 646.

84. This copy is generally identified as the one acquired by Robert Harvey, M.P. of Langley Park (now in the collection of The Cobbe Foundation, Surrey, England) or as the one that ultimately entered the Dulwich Picture Gallery (Algernon Graves and William Vine Cronin, *A History of the Works of Sir Joshua Reynolds* [London: H. Graves, 1899], 898–99); Whitley, *Artists and Their Friends*, 2: 12. Another copy, reputedly painted by a Reynolds pupil with his assistance, is in the collection of Lord Normanton at Somerley Hall, England. A reduced head-and-shoulders version was destroyed in the Second World War. For the painting by Rubens, see Broun, "Reynolds's Collection of Paintings," 37.

85. Howe, ed., *Hazlitt*, 10: 55. See also note 60, above.

86. Leslie and Taylor, *Reynolds*, 2: 424.

87. Northcote, *Life of Reynolds*, 2: 81.

88. Add. 7621/481, Cambridge University Library. In a journal entry Miss C. Fanshawe claims that Siddons said "she does not think he [Reynolds] painted the duplicate now in the possession of Lord Grosvernor. The original is at Dulwich College" (Whitley, *Artists and Their Friends*, 1: 646). Fanshawe is probably confused.

89. Graves and Cronin, *Works of Sir Joshua Reynolds*, 897. Gilbert Stuart had advised Reynolds to begin a second version rather than altering the original canvas, although Reynolds's response suggests that he had not done so.

90. It may also be relevant to note that Reynolds began to lose sight in one eye in July 1789 and had lost it entirely by October of the same year. He was nearly blind in both eyes by 1791 (see Penny, ed., *Reynolds*, 16).

91. Triterpenoid resins were identified and were most likely due to the presence of mastic. The use of camphor as a plasticizer may help explain the paint film's current rubbery texture (see John S. Mills and Raymond White, *The Organic Chemistry of Museum Objects* [London: Butterworths, 1987], 85).

92. Rica Jones and Joyce Townsend, unpublished manuscript.

93. Talley, "'All Good Pictures Crack,'" 57.

INDEX